EXPLORING
ART

D0886227

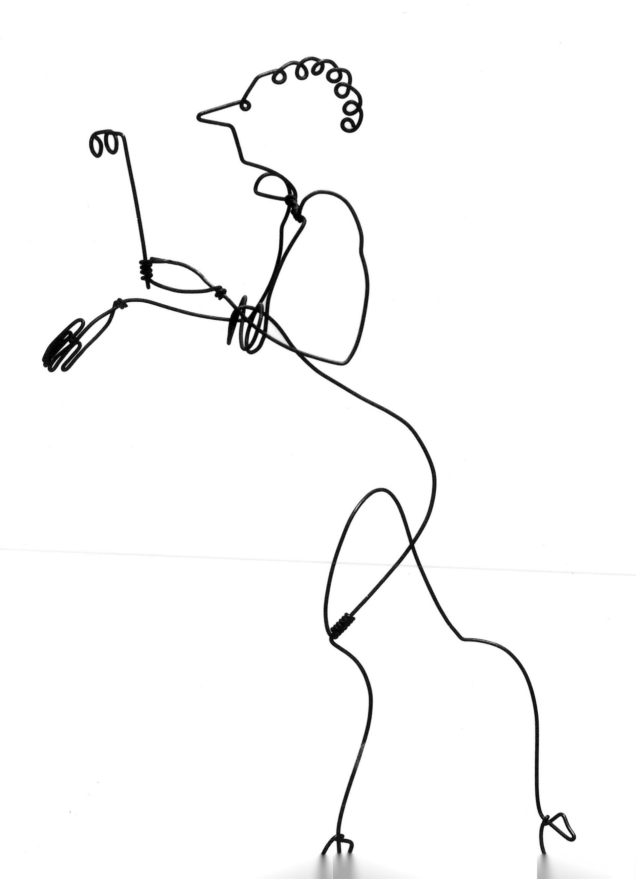

CONTENTS

PREFACE

T HE VISUAL ARTS affect our lives whether or not we ever set foot in a museum. Billboards use images to advertise products; pictures and sculptures stimulate our senses and decorate our urban and rural spaces. These, along with the buildings we inhabit, are manifestations of the visual arts.

This is a book of eight brief essays on different aspects of the visual arts. It is designed to engage readers with the nature of imagery and its relevance to their lives. Illustrations are drawn from Western and non-Western art to give readers a range of the artistic possibilities in widely diverse societies.

Chapter 1 considers the universal appeal of images, while Chapter 2 addresses some of the culturally determined reasons for creating works of art. In Chapter 3, the relationship between form and meaning is surveyed, and Chapter 4 situates the artist in two kinds of context—prevailing aesthetic convention and practical training. The recurring formal theme of the circle, the column as a structural theme, and two iconographic themes—mother and child, and the artist's confrontation with death—are the subjects of Chapter 5.

When we view works of art today, we may not be seeing them in their original setting. In Chapter 6, therefore, we consider art in and out of the context intended by the artist. Since works of art have been analyzed from several different viewpoints, Chapter 7 introduces the major theoretical ways of interpreting imagery, focusing primarily on van Gogh's painting *A Pair of Wooden Clogs*. The final chapter challenges readers to come to grips with some of the controversies in which the visual arts have been involved.

I would like to thank Lee Ripley Greenfield, who first proposed this project, Nell Webb, who oversaw its development, Karen Stafford, who designed the book, and Carol Flechner, who, as always, did a great job of copyediting. For the quality of the illustrations I have to thank Sue Bolsom and Judy Rasmussen. John Adams read the text in manuscript and offered many helpful suggestions along the way. In addition, the manuscript was read and improved by Cordelia Menges, Leola MacDonald, and James Brandi. For pointers on Egyptian art, I am grateful to Ellen Davis.

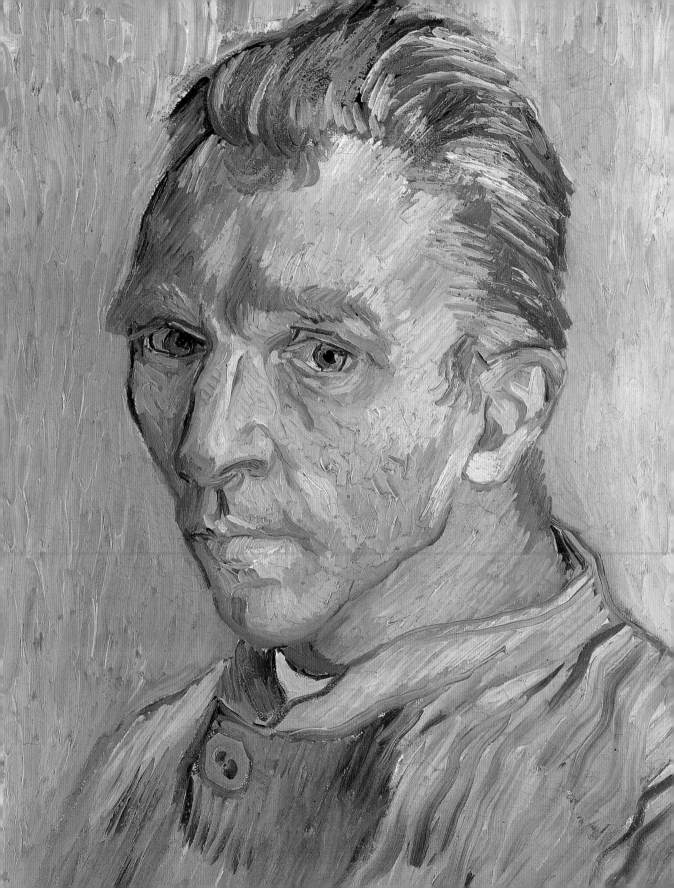

1

THE APPEAL
OF ART

T HE VISUAL ARTS, comprising pictures, sculptures, and archi-
tecture, are important because we live in a world in which images
are everywhere, a resounding confirmation of their enormous impact.
We see images all day, and at night we dream in images. When we walk down
a city street, we see advertising images in store windows enticing us to spend
our money. The art of packaging, whether it be food labels or book cov-
ers, more than just announces the contents of a product. When we drive down
a highway, billboards tell us where to eat, where to shop, and where to
stay. The logos of filling stations vie with each other to sell us gasoline for
our cars. Our daily newspapers are illustrated with journalistic photographs
designed to create particular impressions. Glossy magazines advertise every-
thing from real estate to underwear. Political posters try to influence our
votes. Moving images entertain us when we see a film. And when we turn
on our television sets or our computers, we are inviting images into our homes
and offices. People are talking to us through all of these pictures, and the bet-
ter we understand their visual and verbal messages, the more control we have
over our lives.

The importance of being able to read an image has been constant
throughout history, and artists have created images for various cultural
and aesthetic purposes. In medieval Europe, when only the elite could
read words, artists used imagery to communicate the Christian message to
the masses. Architects built huge cathedrals with towers that pierced the sky,

OPPOSITE
Vincent van Gogh,
Self-Portrait (unsigned),
c. 1888–89.
(see also fig. 1.14).

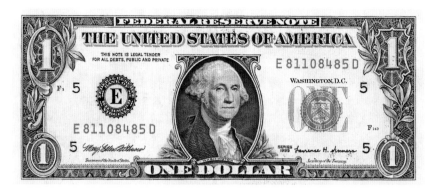

reflecting the aspiration to reach heaven. Stone sculptures and stained-glass windows illustrated Bible stories and legends of the saints. Carved on church entrances were images of the end of the world and the Last Judgment, warning worshipers to follow the teachings of Christ or face eternal damnation.

In most cultures, rulers commission works of art designed to project their political image and enhance their power. When the third-century-B.C. Indian ruler Ashoka embraced Buddhism, for example, he erected stone pillars decorated with Buddhist symbols and texts proclaiming the new religion. Likewise, in the fourth century A.D., after the Roman emperor Constantine issued the Edict of Milan, which legalized Christianity, he presided over the construction of churches throughout Rome. In eighteenth-century America, images of George Washington were painted repeatedly by the leading artists of his time. His personal fortitude and military intelligence are reflected in the well-known painting showing him crossing the Delaware River. And he was sculpted in marble in the guise of the Greek god Zeus to show his affinity with the republican spirit of Classical Athens.

Today we are familiar with George Washington's image on the U.S. $1 bill and 25¢ coin. If we consider for a moment the American $1 bill, we can see how complex some of the political imagery we take for granted can be (fig. 1.1). The very fact that Washington is represented on one side of the $1 bill reflects his role as the first—the number 1—president of the United States. On the other side of the bill, the large "ONE" is flanked by the obverse and reverse of the Great Seal, which was designed in 1782 but placed on the $1 bill only in 1935.

As with all emblems, the Great Seal condenses words and images in a meaningful way. At the left, a radiant eye surmounts an Egyptian pyramid, the former signifying God, the latter, durability and power. Forming a

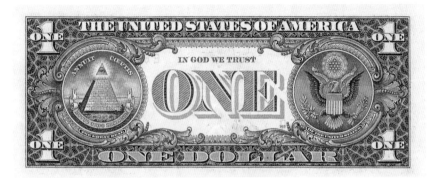

curve around the eye is the Latin phrase "ANNUIT COEPTIS," which comes from Virgil's *Aeneid* (the epic poem describing the events leading to the founding of Rome) and means that "God [the eye] approves what has been begun [that is, the establishment of the United States of America]." Below the pyramid, on the base of which is inscribed in Roman numerals the date 1776, there is another Latin phrase, also from Virgil. It reads "NOVUS ORDO SECLORUM," meaning "a new order of generations." This refers to the birth of an independent America in 1776.

To the right of the "ONE," an American bald eagle holds thirteen arrows (representing the thirteen original states) in one claw and an olive branch (signifying peace) in the other. A strong ruler—the eagle being a traditional attribute of sky gods such as Zeus and Jupiter—according to the emblem, controls the balance between war (the arrows) and peace. The motto "E Pluribus Unum" ("From many, one") alludes to the United States' legislative structure that distributes authority between the individual states and the federal government. The thirteen stars above the eagle's head and the thirteen stripes below are displaced from the design of the American flag (the Stars and Stripes), the former becoming a halo and the latter a shield.

In the most effective images, as in the Great Seal, there is always more than meets the eye. Their many layers of meaning contribute to the universal power of imagery. Consider, for example, the American poster in which the determined figure of an elderly, white-haired man wearing a short blue coat and a top hat points directly at the viewer (fig. 1.2). The text written across the poster reads: "I WANT YOU…" In this case, text and image are again combined, but the image is by now so familiar that most Americans can read its message without the words. It has become an icon of American imagery.

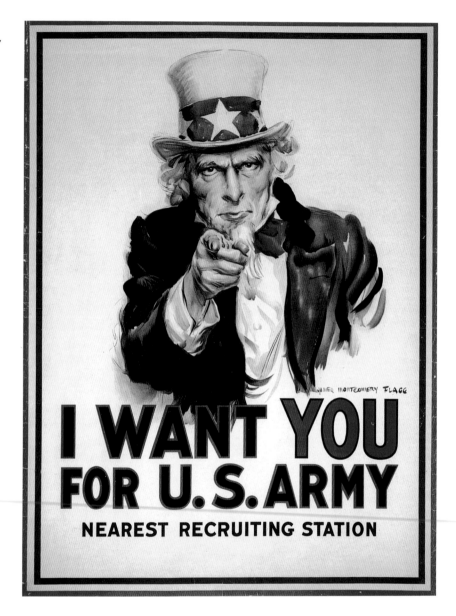

"UNCLE SAM" is a kind of code or sign rather than an actual person and, like the Statue of Liberty, is a mythic image. It stands for the United States of America—"U...S AM". The figure is a personification of the idea of the United States as a decisive nation, a nation that knows what it wants. And Uncle Sam is coded by virtue of his outfit—a red-white-and-blue color scheme and stars on his hat band, which allude to the American flag.

But the text "WANT YOU" does not mean "want you" in the colloquial sense of wanting someone—Uncle Sam is not romantically interested in you, nor does he want your friendship or your incarceration (as in a law-enforcement "wanted" poster). What this rather stern figure actually wants is for you to join the United States Army or some other branch of the military. He wants your service, which in reality means he wants you to risk your life for your country. In other words, the image is appealing to your sense of patriotism and self-sacrifice.

An important aspect of any image is its context, whether it be social, religious, political, or personal. We are unlikely, for example, to encounter the *UNCLE SAM* poster in a church. If we were from another planet and unable to read English, we might mistake "Uncle Sam" for a god. Or, if we saw the poster on someone's living-room wall, we might think that "Uncle Sam" was a member of the family—the poster might even be an ancestor portrait. In fact, we are most likely to find the *UNCLE SAM* poster in the context of military recruiting offices.

The *UNCLE SAM* poster is a form of advertisement, and we tend to distinguish advertising from the arts. But, since the late eighteenth century, with the development of lithography in Europe, artists have also made posters. And with the rise of journalism, artists have caricatured the professions in the media. The nineteenth-century French artist Honoré Daumier (1808–1879) was particularly celebrated for his caricatures, which were published in the press; on one occasion he and his editor were jailed for satirizing the king. His *Louis-Philippe As Gargantua* of 1831 (fig. 1.3), for example, shows the obese king growing ever fatter by depriving his starving subjects of their hard-earned money.

1.3 Honoré Daumier, *Louis-Philippe As Gargantua*, 1831. Lithograph, 8⅝ × 12 in. (21.9 × 30.5 cm). Private collection, Paris.

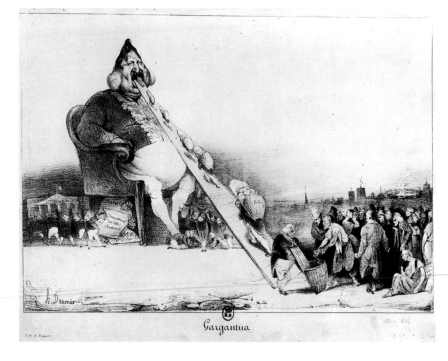

Gargantua

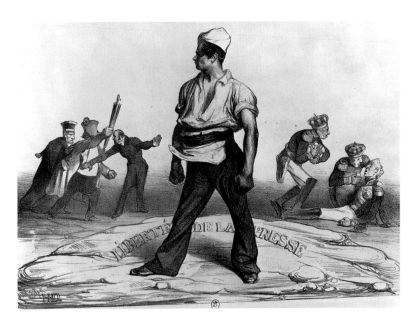

1.4 Honoré Daumier, *Freedom of the Press, Don't Meddle with It (Ne vous y frottez pas)*, 1834. Lithograph, 12 × 17 in. (30.5 × 43.2 cm). Bibliothèque Nationale de France, Paris.

In response to Daumier's caricatures, the French government enacted a law forbidding pictures, but not written text, that publicly criticized the monarchy. This legislation reflected the power of images and the government's fear that their dissemination would adversely influence its citizens. As one might expect, another of Daumier's images, produced three years after the *Gargantua*, defended freedom of the press (fig. 1.4).

Daumier has manipulated these caricatures for political purposes. In the *Gargantua*, he directs the viewer's anger at the monarchy by emphasizing its greedy, bestial nature. The king, Louis-Philippe (ruled 1830–48), is well dressed, his elevation above his poverty-stricken subjects creating the impression that he is aloof and uninterested in anything but his own enormous appetite. Overseeing the citizens as they pour their money into a barrel is a smaller obese figure resembling a pig. Since he is dressed in a suit like the king's, he invites through visual association a comparison between the king and a pig.

The poor, in contrast to the king and his supporters, are thin and bony. To further evoke our sympathy with the victims of Louis' greed, Daumier has depicted at the far right a woman who seems too undernourished to feed the infant on her lap. At the far left, in the distance, we can see the façade of the Assemblée Nationale, the seat of the French government, which is flying a French flag. Ironically, the entrance to the Assembly is modeled on Greek and Roman temple fronts, which in the nineteenth century were associated with republican government rather than with monarchy. Parading before the Assembly is a group of porcine figures also dressed like the king and equally obese. And, to add insult to injury, Louis-Philippe's head resembles a pear—in French slang, the word for pear (*poire*) also means "simpleton."

In *Freedom of the Press, Don't Meddle with It*, Daumier arranges for the viewer to identify with the determined worker in the foreground. The

figure's firm stance and upright posture denote his moral rectitude; he literally "stands" for freedom of speech. This is explicit in the text—*Liberté de la Presse*—shown on the ground in raised printer's type. In contrast to the heroic worker, members of the middle class are flailing at the left, while two weak kings rush to the aid of a third dying king at the right. Power, according to Daumier, resides in the freedom to express oneself in both word and image, and with that freedom, he argues, comes real power.

The power of identification with imagery accounts for much of its effectiveness. Children recognize and identify with pictures before they understand words and, like adults, are fascinated by mirror reflections and shadows, which are pictorial. Note the poem "My Shadow" by Robert Louis Stevenson, which begins: "I have a little shadow that goes in and out with me." The fascination with shadows and reflections has informed the legends tracing the origins of art to drawing a line around a reflection or shadow. Such legends derive from the fact that reflections and shadows, like the one in the poem, are replicas of ourselves.

In sixteenth-century Italy, Giorgio Vasari (1511–1574), the biographer of Renaissance artists and an artist himself, described in his *Lives of the Most Eminent Painters, Sculptors, and Architects* his obsession with creating an accurate replica of the reflective surface of a suit of armor. He was painting the portrait of Duke Alessandro de' Medici and reported that "in seeking to make the burnished surface of the armor bright, shining and natural, I was not very far from losing my wits, so much did I exert myself in copying every least thing from the reality."[1] Vasari then showed his picture to the artist Jacopo da Pontormo (1494–1557), who advised him as follows: "As long as this real lustrous armor stands beside the picture, your armor will always appear to you as painted. ... Take away the real armor, and you will then see that your counterfeit armor is not such poor stuff as you think it."[2]

This anecdote speaks to the artist's struggle to depict accurately an observed reflection. But it also illustrates the fact that artists have to suspend reality and enter a world of their own creation. Pontormo's assertion that Vasari's painted armor was "counterfeit" emphasizes the artistic interplay between reality and fiction, and highlights the artist's job of creating a readable visual fiction. Reading pictures requires that we be able to see. But for as long as we are alive, most of us are endowed with four more senses—hearing, taste, touch, and smell—and these interact with sight and contribute to our identification with imagery.

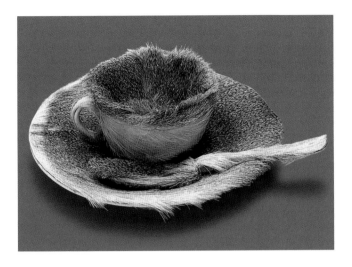

1.5 Meret Oppenheim, *Fur-Covered Cup, Saucer, and Spoon* (*Le Déjeuner en Fourrure*), 1936. 2⅞ in. (7.3 cm) high. The Museum of Modern Art, New York. Purchase.

Images of food, such as we might see in advertisements, are designed to evoke the experience of eating and of tasting what we eat. The act of tasting something can itself bring back images from our past. This phenomenon—known as *déjà vu* (literally, "previously seen")—was memorialized by the French novelist Marcel Proust in his account of tasting a biscuit (a madeleine) that he had eaten as a child, which evoked a flood of memories from his past.

The Swiss artist Meret Oppenheim (1913–1985), on the other hand, created a sculpture that has a different effect than Proust's madeleine. Her *Fur-Covered Cup, Saucer, and Spoon* (*Le Déjeuner en Fourrure*) (fig. 1.5) of 1936 arouses revulsion at the very idea of drinking from her cup or of putting her spoon to our lips. At the same time, however, we are amused by the cup which defies our expectations. That is one of the many important, and often difficult, aspects of the arts—namely, jolting us out of the expected and showing us new ways of perceiving and thinking. The arts have the capacity to expand our mind and our senses—and, therefore, our experience and enjoyment of life.

In contrast to evoking what is familiar or creating humor by a sudden dose of the unfamiliar, the arts can be disturbing. Since we experience pleasure in recognition, we can become upset by the unfamiliar. This is one reason why Picasso caused such a stir when he painted figures with noses in the wrong place, eyes arranged vertically rather than sideways, lopsided lips, and ears descending to the level of a chin (see fig. 4.6). Since we grow up seeing faces organized in the usual way, it disrupts our expectations when the features of a face are reconfigured.

Picasso's images are often deadly serious, but he also possessed a remarkable genius for humor. His *Bather with a Beach Ball* (fig. 1.6), dated August 30, 1932, for example, depicts an inflated female bouncing along a Mediterranean beach as if she herself were the beach ball. She carries a small, round object, presumably a ball, but it does not resemble a beach ball nearly as much as she does. Picasso has conflated the woman and the ball, making the former a metaphor for the latter and creating a visual pun. Metaphor can be a powerful way to convey meaning by making the viewer respond to content through form. In other words, Picasso's viewer

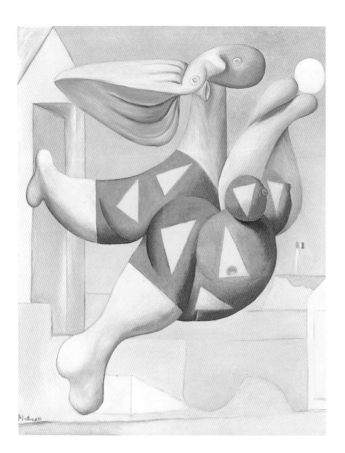

1.6 Pablo Picasso, *Bather with a Beach Ball*, Boisgeloup, August 30, 1932. Oil on canvas, 57⅜ × 45⅛ in. (1.46 × 1.15 m). Zervos VIII, 1147. The Museum of Modern Art, New York. Partial gift of an anonymous donor and promised gift of Jo Carole and Ronald S. Lauder.

1.7 (*below*) James Abbott McNeill Whistler, *Arrangement in Black and Gray (Portrait of the Artist's Mother)*, 1871. Oil on canvas, 4 ft. 9 in. × 5 ft. 4½ in. (1.45 × 1.64 m). Musée d'Orsay, Paris.

understands the woman as if she were the beach ball. Reading metaphor is thus another important aspect of comprehending what we see.

In the world we inhabit, there are natural images and man-made images. Examples of the former include the natural environment insofar as it is untouched by human hands. A type of image that is transitional between the natural and the man-made is the mental image. Mental images are conjured up under certain conditions; they may be described orally or written down, but they are not necessarily translated into concrete visual form. Examples of mental images include sleep dreams and daydreams, visions, hallucinations, and fantasies.

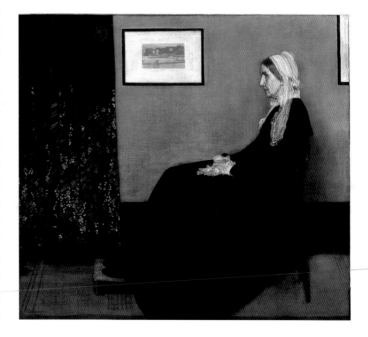

1.8 Hans Holbein the Younger, *Anne of Cleves*, 1539. Parchment on canvas, 25⅝ × 18⅞ in. (65.1 × 47.9 cm). Musée du Louvre, Paris.

Mental images are often the inspiration for works of art. For example, when someone complimented James McNeill Whistler (1834– 1903) on the famous portrait of his mother (fig. 1.7), he replied that "one does like to make one's mummy just as nice as possible." This indicates that Whistler had a mental image of his mother prior to transforming her into paint and that he wanted her to appear particularly "nice." The mind and hand of the artist thus act as a kind of filter through which an idea becomes a material product.

Sometimes a patron influences the way the artist transforms reality into art. In sixteenth-century England, when King Henry VIII was preparing to marry the German princess Anne of Cleves—wife number 4—he commissioned his court artist, Hans Holbein the Younger (c. 1497–1543), to paint her portrait. Henry had never seen this particular bride-to-be, and he wanted a picture of her before the wedding. Holbein produced an image of Anne that pleased the king (fig. 1.8). She is shown as a young woman with delicate features and an agreeable demeanor. In his eagerness to see her, Henry rode to the English coast to welcome her ship. But he was sorely disappointed, for the real Anne did not measure up to her painted likeness.

Similarly, in the case of Whistler's mother, "nice" is probably not the characterization that would occur to the average viewer. Mrs. Whistler is represented as a dour Puritan, colorless (black and white are not among the colors of the spectrum) except for the flesh tones of her face and hands. She is prim, proper, possibly a bit stern, almost certainly pious, and well over the hill. Nor did Whistler's friends describe her as "nice"—one noted sarcastically that she occupied the top floor of her son's London house in order to be closer to God. Of course, Whistler is entitled to his own idea of "nice," and it seems that his mother was it—he did not marry until the age of fifty-four, after her death.

In contrast to natural and mental images, the images made by artists are first envisioned and then formed. These, like the pictures of Whistler's mother and Anne of Cleves, generally replicate nature in some way; but they also transform nature. It would seem that Holbein's portrait transformed Anne into a more attractive woman than she actually was and that Whistler represented his mother according to an image consistent with her personality.

In addition to figures of humans and animals, artists create landscapes and seascapes. Here, too, artists see the real thing, but they have to transpose it into an image. Works of art, even ones that attempt to replicate nature exactly, as Pontormo explained to Vasari, always differ from the original.

Consider the nineteenth-century landscape by Camille Pissarro (1830–1903) entitled the *Seine at La Grenouillère* (fig. 1.9). The artist has captured a view of the river Seine at sundown. The yellows in the sky are reflected in the yellow-brown of the water and are echoed in the trees. The fall colors contribute to the mood of the painting, which is imbued with the gradual changes of nature, a subject that appealed to the Impressionists. A small boat has left the boathouse at the right and drifts across the water. Its leisurely pace contrasts with the energy inherent in the factory at the far side of the river. This, too, is an image of change—in this case, the changing times and the economic and social transitions brought about by the Industrial Revolution. Thus, while Pissarro has depicted aspects of

1.9 Camille Pissarro, *Seine at La Grenouillère*, c. 1869. Oil on canvas, 13¾ × 18⅛ in. (35 × 46 cm). Collection of the Earl of Jersey.

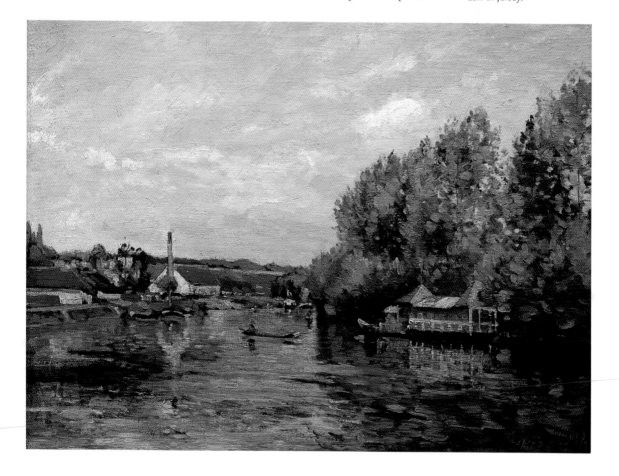

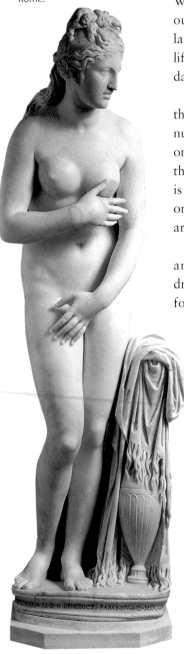

1.10 *Capitoline Venus*, Roman copy of a Greek statue of Aphrodite, c. 250–150 B.C. Marble, 6 ft. 4 in. (1.93 m) high. Museo Capitolino, Rome.

reality—that is, of the way in which light, dark, and color are perceived in nature—he has, like Daumier, arranged his image to convey a particular mood.

We can see from even these few examples of imagery that there are various categories of subject matter in the visual arts. Pissarro's picture is a landscape. Images of individual objects arranged on a surface are called still lifes, illustrations of historical events are history pictures, and those of everyday life are known as genre.

One of the most prevalent subjects in Western art is the nude. In 1956, the noted English art critic Kenneth Clark published his famous study of the nude in art.[3] He begins by distinguishing between nude and naked, which one could transpose into ideal and actual, fiction and fact, respectively. If we think about this distinction, we realize that a real person without clothes is quite different from a nude figure made of paint, marble, bronze, wood, or plastic. Nudes in art, as in reality, come in all shapes, sizes, and ages; some are represented individually, while others participate in narratives.

The *Capitoline Venus* (fig. 1.10) represents the Roman goddess of love and beauty modestly covering herself after a bath. Her garments are draped over a large water jar. She is a type of nude first formulated by the fourth-century-B.C. Greek sculptor Praxiteles, but now known only in later Roman copies such as this one. Even though the figure conveys a sense of immediacy and we can identify with her reaction to being seen without clothes, we also realize that she has been idealized.

If we compare the *Capitoline Venus* with the famous *Venus of Urbino* (fig. 1.11) by the sixteenth-century Italian Renaissance painter Tiziano Vecellio (c. 1485–1576), known in English as Titian, we are struck by the relative particularity of the latter. Titian's Venus reclines in a Venetian bedroom, a sleeping dog lies at her feet, two servants remove clothes from a chest, and a flowerpot stands on the windowsill. Whereas the *Capitoline Venus* is not seen in a context, the *Venus of Urbino* is. And yet we do not know the identity of the woman in Titian's painting, although we can see that her seductive pose is derived from the more modest pose of her ancient Greek ancestor. Furthermore, Titian's figure gazes directly at us, as if aware that we are looking at her. Whereas the viewer has caught the attention of Titian's Venus, the Greek figure seems distracted by something or someone other than the viewer. She is shown in conflict, at once covering her nudity and turning from it; the Italian Venus, on the other hand, is unambivalent and even flirtatious.

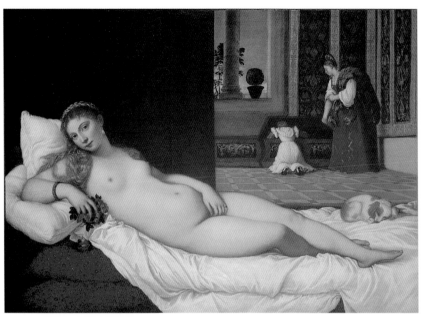

1.11 (*left*) Titian, *Venus of Urbino*, c. 1538. Oil on canvas, 3 ft. 11 in. × 5 ft. 5 in. (1.19 × 1.65 m). Galleria degli Uffizi, Florence.

1.12 (*below*) Leonardo da Vinci, *Mona Lisa*, c. 1503–5. Oil on wood, 30¼ × 21 in. (76.8 × 53.3 cm). Musée du Louvre, Paris.

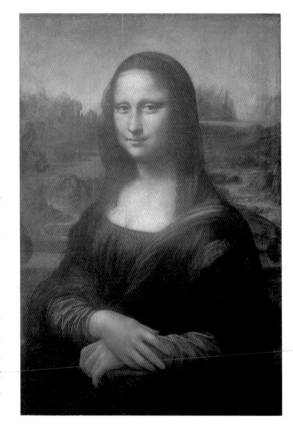

Another popular category in Western art is portraiture, such as the painting of Whistler's mother. Perhaps the world's most famous portrait is the *Mona Lisa* (fig. 1.12), which Leonardo da Vinci (1452–1519) painted in the early sixteenth century. Many viewers are convinced that they know the painted woman. She has been the subject of an enormous literature and has been described as a vampire, a metaphorical mountain, a memory of the artist's mother, a pregnant woman smiling complacently, a self-portrait of the artist in female guise, and simply the wife of a Florentine nobleman. She may even be a combination of her proposed identities, reflecting the fact that an image can have many layers of meaning. This is especially true of a great image such as the *Mona Lisa*. Its visual complexity and the absence of explanatory documentation have given rise to numerous interpretations. This indicates that viewing art is a two-way process, that viewers bring to it their own bias and their own mental and social context, and that they have personal, aesthetic, and culturally determined responses to imagery.

1.13 Rembrandt van Rijn, *Self-Portrait at the Age of 34*, 1640. Oil on canvas, 3 ft. 4⅛ in. × 2 ft. 7½ in. (1.02 × 0.80 m). National Gallery, London.

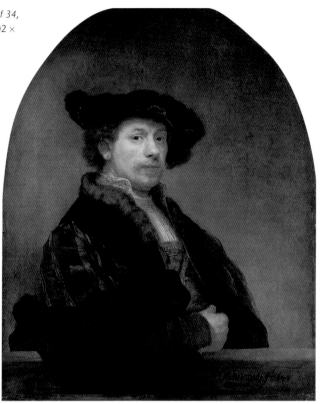

1.14 (*below*) Vincent van Gogh, *Self-Portrait* (unsigned), c. 1888–89. Oil on canvas 15¾ × 12½ in. (40.0 × 31.0 cm). Private collection, Great Britain.

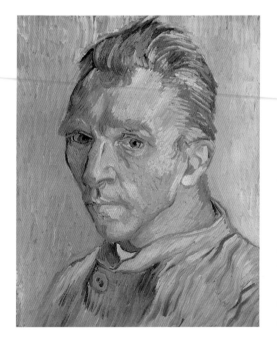

Some artists use themselves as models. Two Dutch artists, Rembrandt van Rijn (1606–1669) and Vincent van Gogh (1853–1890), painted many self-portraits (figs. 1.13 and 1.14) that seem to reveal their character. As with the *Mona Lisa*, we tend to feel we know the person represented. In figure 1.13 the thirty-four-year-old Rembrandt appears self-confident; he wears a velvet hat and fur-trimmed, silk-sleeved cloak. Subsequent self-portraits are not as optimistic and seem to reflect the personal misfortunes and financial reverses that Rembrandt suffered. Van Gogh's *Self-Portrait* (fig. 1.14), painted at the age of thirty-six, was his last. He made it for his mother's seventieth birthday, and, although he shaved off his beard for the occasion, the picture reveals his troubled mind as well as his power as an image maker. The self-portrait also conveys the intensity of van Gogh's concentration and his passion for dynamic color and line.

In addition to representing and transforming aspects of physical reality, artists have also represented mental images such as dreams and visions. In Western art, dreams were originally depicted as external phenomena sent by the gods. In Piero della Francesca's (active 1439–1492) *Dream of Constantine* (fig. 1.15) of around 1452, for example, we see the Roman emperor Constantine asleep in his tent. If we are familiar with the legend, we know that this is the night before he goes into battle against his rival emperor, Maxentius. We also know that the angel in the upper left corner of the picture is Constantine's dream image and that the angel is telling him to carry the sign of the Cross before him when he confronts his enemy. "In this sign, you conquer," according to the dreamed angel. Constantine obeys and conquers. This event is credited by the Church with having inspired Constantine to become a Christian. Constantine's dream exemplifies the power of imagery, for it was a dream that changed the course of history—and dreams are nearly always remembered in pictorial form. The content of the dream, which includes the sign of the Cross, informed Constantine of the power of the Cross. Because it is a "sign," it is also an image, and it was thus the *image* of the Cross that was imbued with the power to rout the enemy and insure Constantine's victory.

In 1910, the French painter Henri Rousseau (1844–1910) produced his landmark picture *The Dream* (fig. 1.16). Painted eleven years after Sigmund Freud published *The Interpretation of Dreams*, Rousseau's image reflected new discoveries about the mechanisms of dream formation. Here the dreamer and the dream are superimposed—that is, the dreamer is shown as a character in her own dream. The dream is erotic, filled with symbolic forms such as foliage, sexually suggestive flowers, a serpent, and a curious musician who is part human and part animal. As in a dream, the details are both literal and symbolic, meaning that they stand for something other than what

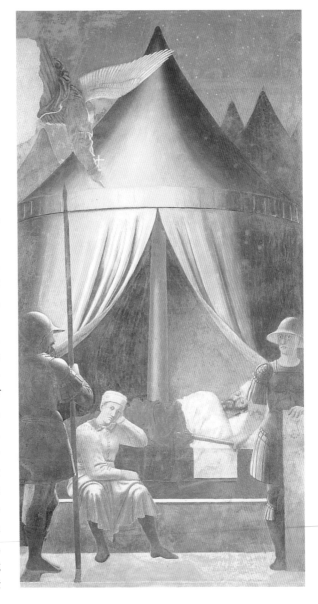

1.15 Piero della Francesca, *Dream of Constantine*, c. 1452. Fresco. Bacci Chapel, San Francesco, Arezzo.

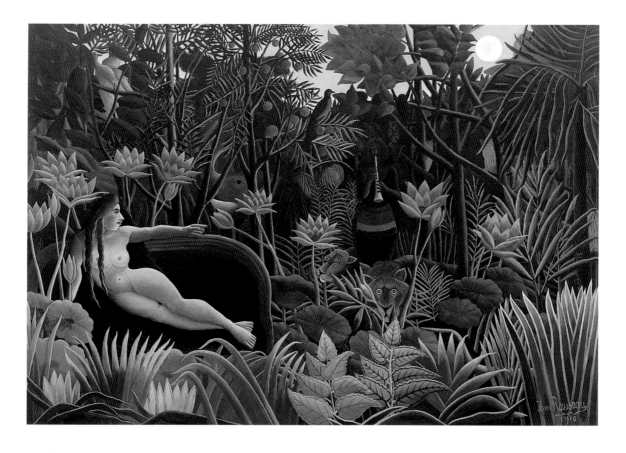

1.16 Henri Rousseau, *The Dream*, 1910. Oil on canvas, 6 ft. 8½ in. × 9 ft. 9½ in. (2.05 × 2.99 m). The Museum of Modern Art, New York, gift of Nelson A. Rockefeller.

they depict. The dreamer is agitated by her dream picture; she is nude, pointing anxiously, and surrounded by erotic symbols, and wild animals. The latter, contrary to expectation, are tame and oddly static.

As with dreams, Rousseau's painting combines time and place in an unlikely way. An upholstered French settee has been displaced to the middle of a jungle, while a moon, rather than the sun, occupies a daytime sky. And just as dreams can rearrange times and locations, defy gravity, and superimpose pictures, so artists decide on the arrangements of their own images. The difference, of course, is that artists make such decisions consciously, and they work in the context of a prevailing style. The imagery of dreams, on the other hand, is produced privately and unconsciously; it is not the result of conscious artistic work, in which an artist creates images with a history and a cultural audience in mind.

Related to dreams, myths have provided subject matter for imagery since people began producing art. All cultures create mythologies, which are generally framed in terms of metaphor and thus are pictorial. As such,

they appeal to the artistic mind and can be manipulated by artists and patrons alike. The sculpture *Apollo and Daphne* (fig. 1.17) of 1622–25 by the Italian Baroque artist Gianlorenzo Bernini (1598–1680) is an example of a mythological image. It illustrates the Greek myth in which the sun god conceives a passion for Daphne, a woodland nymph and the daughter of a river god. When Apollo pursued Daphne, she rejected his advances by her transformation into a bay tree, which then became sacred to the sun god. In this case, the myth reflects the Greek view of their gods as endowed with human form and personality, and engaging with mortals. Bernini's Apollo conforms to the god's mythological image as a beautiful youth with a sense of sexual entitlement and a love of the chase. Daphne values her chastity and preserves it by becoming impenetrable. Bernini unifies the figures by the similarity of their curved forms and graceful, dancelike motion. As leaves and branches begin to sprout from Daphne, they seem to reach back toward her pursuer. Daphne is shown in the very process of change; she is literally becoming one with the woods.

In contrast to images designed to replicate or express aspects of the natural world, some images represent conscious efforts to eliminate allusions to nature. This is a difficult undertaking because artists, like other humans, exist in the real world and identify with it. Nevertheless, beginning in the twentieth century, some of the most innovative artists produced what has come to be called abstract art. In abstraction, formal arrangements of color, line, and/or shape (see Chapter 3) take precedence over the representation of recognizable objects. Other terms related to, but not the same as, abstraction are *nonrepresentational* (meaning that there is no recognizable subject matter in the work) and *nonfigurative* (which means roughly the same thing, but with special emphasis on the absence of figures).

Very few artists have achieved pure abstraction. Around 1910–13, the Russian artist Wassily Kandinsky (1866–1944) painted *Untitled (First Abstract Watercolor)* (fig. 1.18). Both nonfigurative and nonrepresentational, it is widely believed to have been the

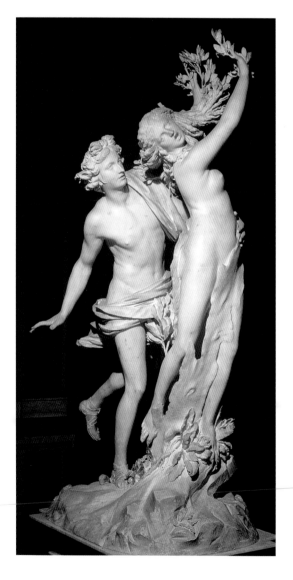

1.17 Gianlorenzo Bernini, *Apollo and Daphne*, 1622–25. Marble, 8 ft. (2.43 m) high. Galleria Borghese, Rome.

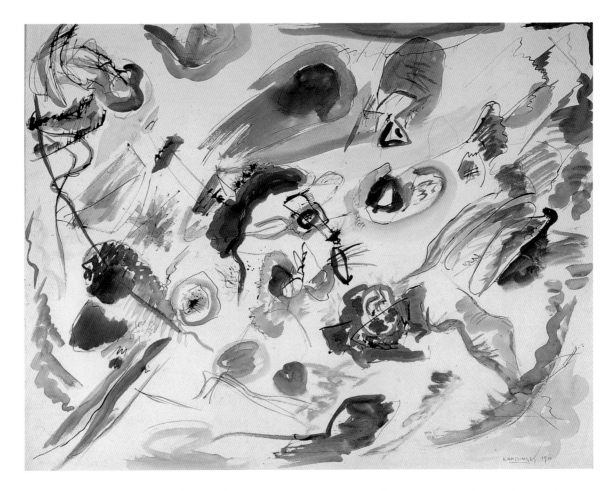

1.18 Wassily Kandinsky, *Untitled (First Abstract Watercolor)*, c. 1910–13. Pencil, watercolor, and ink on paper, 19½ × 25½ in. (49.6 × 64.8 cm). Musée National d'Art Moderne, Centre Georges Pompidou, Paris.

first such image. It reflects Kandinsky's view that abstraction could provide a route to a spiritual renewal of the arts in the early twentieth century. He explained this in his book *Concerning the Spiritual in Art* (1912). And while it is true that there are no recognizable images in Kandinsky's painting, it does contain elements that can be associated with our experience of nature. For one thing, it has color, which is part of nature. It also has energetic movement, varieties of space, rhythm and spontaneity, form, light, and dark; various textures of lines and brushstrokes evoke a tactile response in the viewer. These are among the so-called formal elements of art and are the subject of Chapter 3.

In 1915, another Russian artist, Kazimir Malevich (1878–1935), exhibited his famous *Black Square* (fig. 1.19) in St. Petersburg. Malevich was also interested in spirituality and evolved the artistic theory of Suprematism, which he presented in his book *The Nonobjective World. (Nonobjective*

is another term used to describe pure abstraction, but it is no longer considered by art writers to be as apt as *nonrepresentational* and *nonfigurative*). Malevich has eliminated color and curves, both of which are among the natural qualities of Kandinsky's *Untitled*. But Malevich retains form, space, light, and dark, which are aspects of nature. Nevertheless, we do get the point—Malevich is seeking a new way to express spirituality by avoiding references to the material world with which we are familiar. Artists such as Kandinsky and Malevich were attempting to take viewers beyond the expectation that an image should be figurative.

Since the ultimate in pure abstraction is nothingness, which is virtually impossible to experience and, therefore, to reproduce, it can only be approximated in concrete artistic form. The same could be said of efforts to replicate nature. So, in fact, art can only be imperfectly abstract, just as it can only be imperfectly natural. It can, however, stretch our minds and our experiences further and further in both directions, depending on the skill of the artist. And, finally, art offers a perfection of its own and on its own terms, as Pontormo explained to Vasari when discussing the painting of Duke Alessandro's armor. The terms of art are considered in what follows.

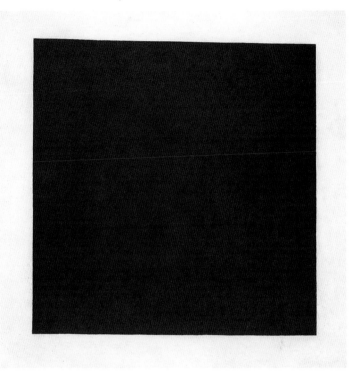

1.19 Kazimir Malevich, *Black Square*, repainted version of 1929 (original 1913). Oil on canvas, 31¼ × 31¼ in. (79.4 × 79.4 cm). State Tretiakov Gallery, Moscow.

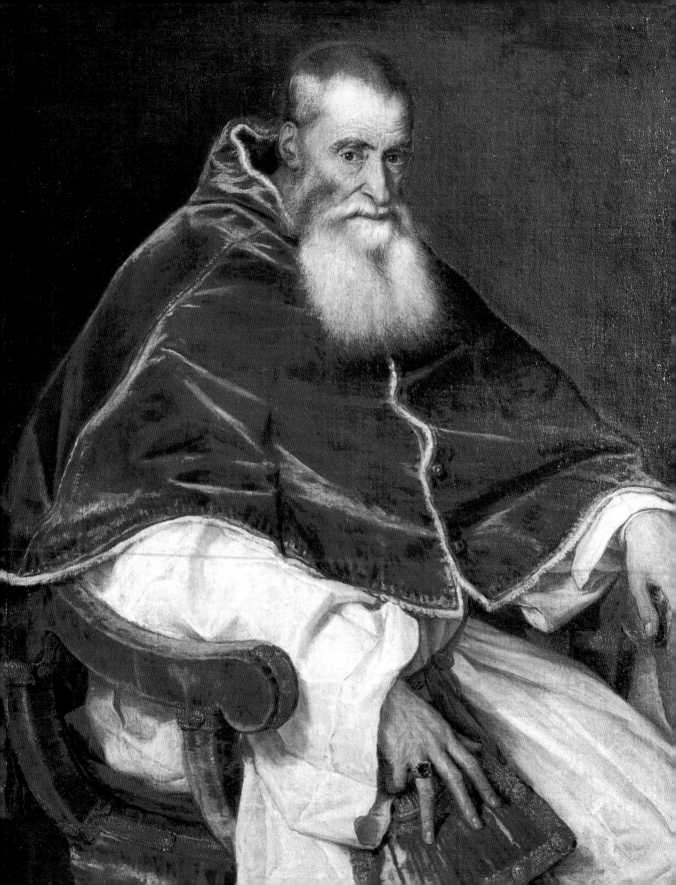

2

THE AIMS
OF ART

P EOPLE CREATE ART for many reasons. Children, given the chance, will naturally begin to draw as soon as they have the muscle control to do so. They, like adults who make images, are expressing something personal. But art usually has a cultural meaning as well. This chapter considers some of the cultural reasons why people make and commission works of art. To a large degree, the purposes of imagery define the power of imagery.

DECORATING THE ENVIRONMENT

One motive for making art is to decorate the environment. People decorate their homes in a variety of ways: they hang pictures on the walls, plan color combinations, and place statues in their gardens. A particularly elaborate example of interior design can be seen in the Art Nouveau (literally "new art") staircase of 1892 (fig. 2.1) created for the Tassel family of Brussels by the Belgian architect Victor Horta (1861–1947). It is composed of slender, curvilinear designs reminiscent of plants, peacock tails, and insect wings. This is characteristic of Art Nouveau imagery, which evolved in opposition to industry and mechanization in nineteenth-century Europe and reflected a preference for the organic forms of nature.

In addition to private spaces, public spaces are decorated with architectural projects, outdoor sculptures, signs and billboards, painted exterior walls, and other expressions of urban design. Town halls, for example,

OPPOSITE
Titian, *Pope Paul III*,
c. 1543–46 (see also fig. 2.3).

2.1 Victor Horta, staircase of the Maison Tassel, 1892. Brussels.

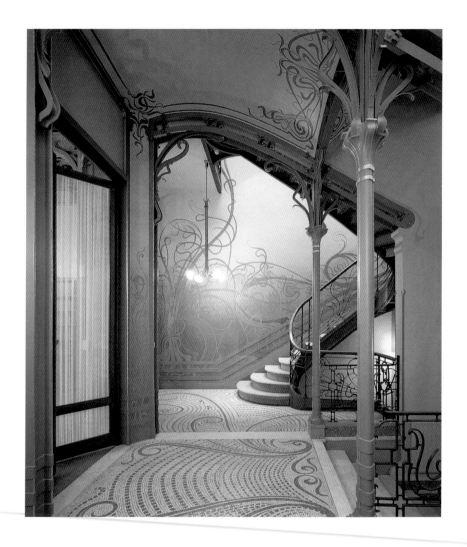

are public buildings designed to convey a certain image of a city. The seventeenth-century Baroque Town Hall—later the residence of the king—in Amsterdam is an imposing four-story structure and Holland's biggest civic building (fig. 2.2). The lowest story resembles a modern office building, but the upper stories are united visually by giant Corinthian columns. They appear to support an entablature with a decorative frieze, a central pediment, and a projecting cornice. These features are derived from Classical temple fronts and have been superimposed over the seventeenth-century building. The effect of the design is to dominate the street and create an image of wealth and power following the end, in 1609, of the Eighty Years' War between Spain and the Netherlands.

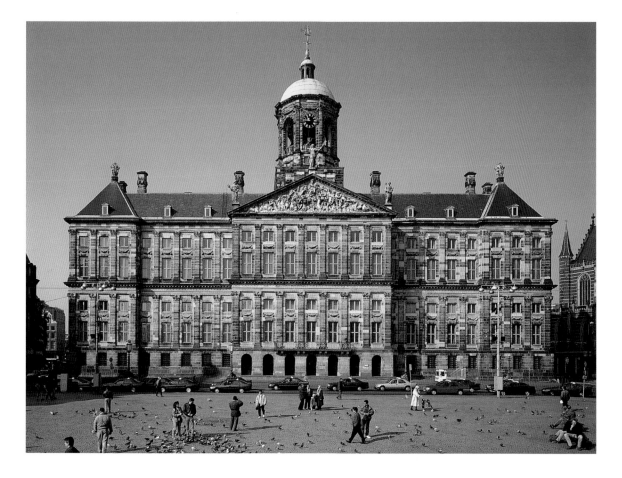

RECORDING THE PAST

2.2 Jacob van Campen, Town Hall/Royal Palace, 1648. Amsterdam.

Images are a way of recording the past and can seem to arrest time. The moment we stop to look at something and spend time considering it, we begin to become acquainted with it. And the longer we do so, the more familiar it becomes. If the image is a portrait, we may feel that we are getting to know the person represented. We have seen that Leonardo's *Mona Lisa* (see fig. 1.12) is such a portrait and that Mona Lisa's memory has been preserved through her image. But despite the fact that many viewers have the impression that they know who she is, they actually do not know her at all. This, then, is an illusion. We do, however, know something about the *painting* of Mona Lisa. We know that Leonardo bathed the woman in a rich yellow light and that she is seated on a balcony overlooking a distant, misty blue landscape. But the identity of both the woman and the landscape, which is imaginary, and the actual location of the balcony are unknown.

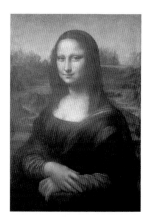

Leonardo da Vinci, *Mona Lisa*, c. 1503–5 (see also fig. 1.12).

2.3 (*below*) Titian, *Pope Paul III*, c. 1543–46. Oil on canvas, 3 ft. 5¾ in. × 2 ft. 9½ in. (106.0 × 85.0 cm). Museo Nazionale di Capodimonte, Naples.

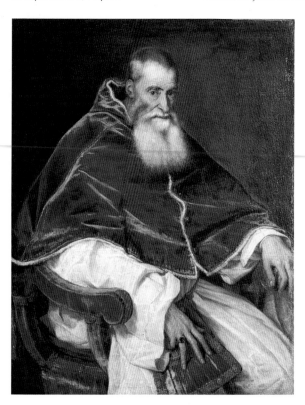

The *Mona Lisa* has become a mythic image, one that has engaged viewers in many different interpretations. According to Vasari, Mona Lisa was the wife of the Florentine nobleman Francesco del Giocondo, who commissioned the painting. Vasari reports that Leonardo hired jesters to keep her amused while she sat for her portrait—hence the impression of a slight smile. For the nineteenth-century English art critic Walter Pater, the smile was sinister, and Mona Lisa was like a vampire who had lived and died many times. As such, she embodied the current view of the aloof, deadly woman that appealed to the Romantic aesthetic. For Freud, she evoked a memory of the artist's mother, which explained her enigmatic smile. More recently, a medical doctor attributed the smile to her knowledge that she is pregnant. A computer analyst claimed, based on a computer-generated image, that Mona Lisa is actually a self-portrait of Leonardo. The proliferation of such readings confirms the illusory nature of imagery as well as its power to engage us. Of course, in many cases we do know the identity and character of the model. On such occasions, we might admire the artist's ability to capture these features in the image.

Consider, for example, Titian's *Pope Paul III* (fig. 2.3), painted in the 1540s. In reality, the pope was a prominent patron of both Titian and Michelangelo, indicating that he was a connoisseur of the arts. He, like many other Renaissance patrons, recognized genius when he saw it. In 1534, Paul III commissioned Michelangelo to paint the monumental fresco of the *Last Judgment* (fig. 2.4) on the altar wall of the Sistine Chapel in Rome. In his understanding of the visual arts, Pope Paul III surpassed his successor, Pope Paul IV, who wanted the *Last Judgment* removed from the chapel on the grounds of indecency. Responding more to the political and religious atmosphere of the Counter-Reformation and to the increasing influence of the Inquisition than to the intrinsic value of the work of art, Paul IV objected to the display of nudity in Michelangelo's figures.

Titian shows Paul III as a man of advanced age, slightly bowed, and endowed with a full gray beard. The depiction of the pope's craggy face, sparkling eyes, and air of knowing projects the

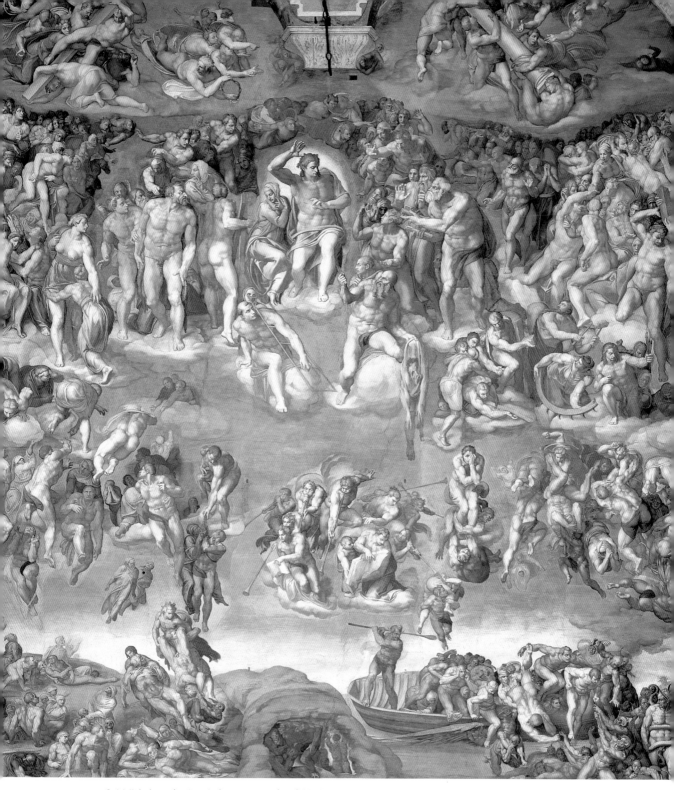

2.4 Michelangelo, *Last Judgment*, completed 1541. Fresco. Altar wall of the Sistine Chapel, Rome.

image of wisdom and experience. Interestingly, Walter Pater also referred to Mona Lisa as knowing—"She is older than the rocks among which she sits," and she has "learned the secrets of the grave."[1] But Pater's characterization of Mona Lisa is mythic and malevolent, whereas Titian's visual description of Paul III is respectful. Furthermore, the expansive, bulky nature of the pope's image signifies the weight and profundity of his thought.

With the development of photography in the nineteenth century, as images were first fixed to light-sensitive surfaces, an elaboration of the illusion created by paintings evolved. When we look at a photograph, we assume that we are seeing exactly what the photographer saw through the lens of the camera when the shutter was released. We have the impression that a segment of reality has been framed by the lens and recorded in light on a light-sensitive surface. In fact, however, photographs can be manipulated to create certain impressions or to convey certain messages.

This is what Mathew Brady did when he made *On the Antietam Battlefield* (fig. 2.5). Since we know that Brady was Lincoln's photographer

2.5 Mathew Brady, *On the Antietam Battlefield*, 1862. Photograph. From *Mathew Brady's Lecture Book*, no. 84.

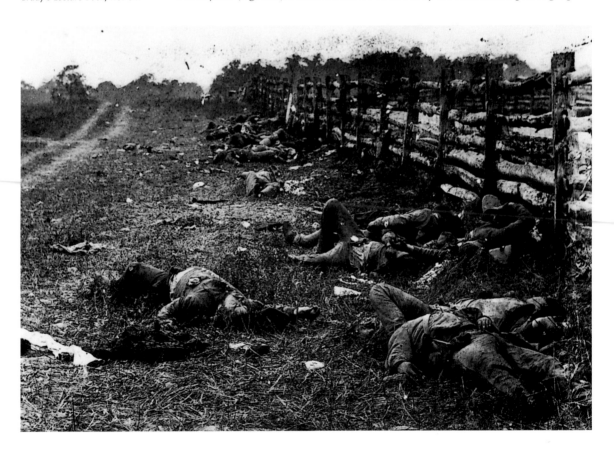

and that he photographed the American Civil War, we assume that he accurately documented the progress of the conflict. But this does not mean that he did not have a point of view that he wished to convey through his images. In *On the Antietam Battlefield*, Brady appears to have captured a view of dead soldiers whose bodies are lying where they fell on September 17, 1862. They are shown along the fence west of Hagerstown Road, which recedes toward the horizon. As a result, we have the impression of a long stretch of dead young men in contorted poses beginning to merge into the earth. Brady's message? Wars may be fought for a good cause, but they are wasteful of young lives.

Using images to record historical events did not begin with the development of photography and photojournalism. People have always been able to find ways to document their history. The Plains Indians, for example, used articles of clothing to record pictographic images of battle (fig. 2.6). The buffalo robe shown here was painted by Lakota Indians and depicts a battle with the Crow. Scenes of combat are enlivened by the painted shields, colorful horses, feathered headdresses, bows and arrows, and a few rifles; the horses are distinguished from each other by color. There

2.6 Painted War Record, c. 1880. Painting on hide, 98 × 93 in. (248.9 × 236.2 cm). West Lakota Culture. Thaw collection, Fenimore House Museum, Cooperstown, New York.

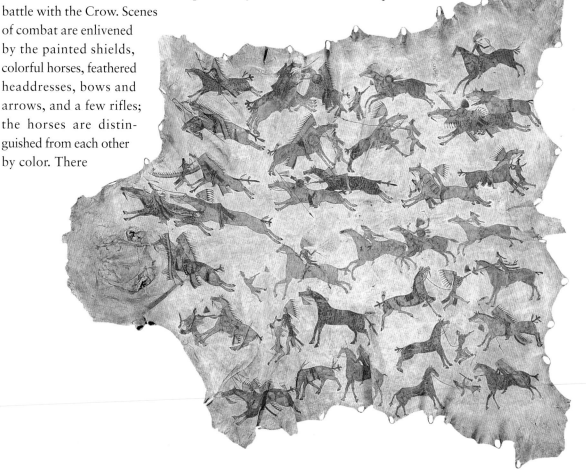

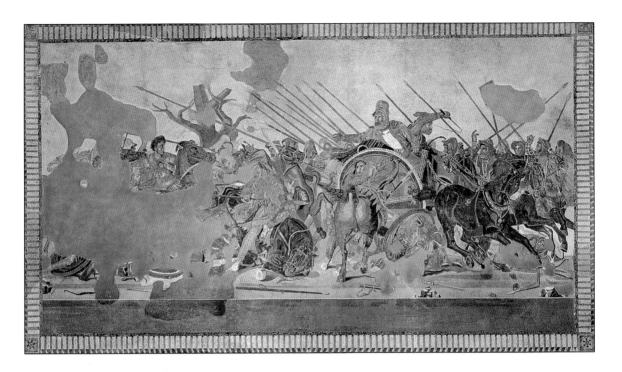

2.7 *Battle of Issos*, 2nd century B.C. Mosaic, 8 ft. 10¾ in. × 16 ft. 9½ in. (271.0 × 512.0 cm). Copy of a Greek fresco of c. 300 B.C., from the House of the Faun, Pompeii. Museo Archeologico Nazionale, Naples.

are specific encounters between single combatants as well as the fighting of groups. Such an image would have served as an aid to anyone recounting the story of the battle, drawn upon by oral tradition as a way of preserving the cultural memory.

A much earlier example of a battle can be seen in figure 2.7, which depicts the Greek conqueror Alexander the Great defeating the Persian king Darius at the Battle of Issos (333 B.C.). In contrast to Brady's photograph, the mosaic shows the heat of battle, the clashing of spears, the frenzied horses, and the dying soldiers. Unlike the Lakota painting, the style of the mosaic is naturalistic rather than pictographic. At the far left, we see Alexander himself, a youthful figure with wavy hair, charging forward on his famous warhorse, Bucephalus ("the ox-headed one"). (This portrait type was to become characteristic of portraits of rulers in Western art.) Alexander's brave demeanor is enhanced by the series of diagonal spears confronting him. At the center of the mosaic, Darius turns to look toward Alexander, but the Persian king is actually retreating, for his charioteer is whipping the horses away from the battle.

In the foreground, the action is arrested by the foreshortened horses and by the detail of the fallen Persian soldier watching himself die in the reflection of a shield. The artist accentuates the individuality of the soldier

and invites identification with his predicament. Whereas Brady's photograph records a harsher "reality" of war, focusing only on its aftermath, the Hellenistic scene, like the Lakota image, shows both the heroism and the pathos of war. At the same time, however, all three artists convey the sense of two sides in their respective conflicts. The Greek artist, siding as he would have with the victorious Alexander, can still sympathize with the death throes of the fallen Persian. The Lakota pictographs include vignettes of death as well as of bravery. And although Brady worked for Lincoln, he shows the human cost of war to both the Union and the Confederate armies. His image records death, silence, and the waste of human life.

RELIGIOUS ART

Whereas history is primarily about the past, sometimes in relation to the present, religious beliefs involve the future. Many cultures engage in ancestor worship, which is a means of keeping alive the memory of one's forebears and creating a transition between religion and recording the past. In ancient Rome, ancestor worship served a genealogical purpose and thus merged religious and historical purposes of art. To this end, Roman artists made wax death masks, which they copied in marble.

The marble sculpture entitled *Roman Patrician with Two Ancestor Busts* (fig. 2.8) of the first century A.D. is such a work. The head of the patrician is a later substitution, but the ancestor busts are original. They are carved as living heads, despite being detached from their bodies and representing deceased members of the patrician's family. By their depiction as alive, these heads form a transition between life and death, and also remind descendants of their lineage.

Religious architecture creates a related transition, particularly when the religion in question includes a belief in an afterlife. The Gothic cathedrals of Western Europe embody the high point of Christian architecture from the late twelfth through the sixteenth century (depending on the region). In the cathedral at Chartres (fig. 2.9), begun around 1140 to 1150, we are impressed by the soaring movement of the towers and their pointed spires. In this case, the verticality of the façade is symbolic: it refers to the belief that heaven is up, and it reflects the worshiper's aspiration to attain salvation after death.

2.8 *Roman Patrician with Two Ancestor Busts*, 1st century A.D. Marble, 5 ft. 5 in. (1.65 m) high. Palazzo dei Conservatori, Rome.

2.9 Chartres Cathedral, west façade, c. 1140–50. Chartres, France.

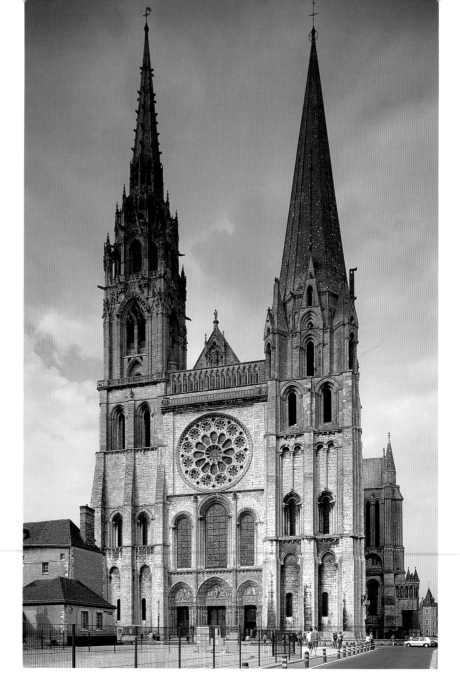

Verticality also characterizes the interiors of Gothic cathedrals, which convey the same message. As such, the buildings are metaphors in stone and glass. Figure 2.10 shows the interior of Amiens Cathedral in northern France, which was begun around 1220, somewhat later than Chartres. In this illustration, we are standing with our backs to the entrance at the west, looking toward the apse at the eastern end of the building. Here we can see

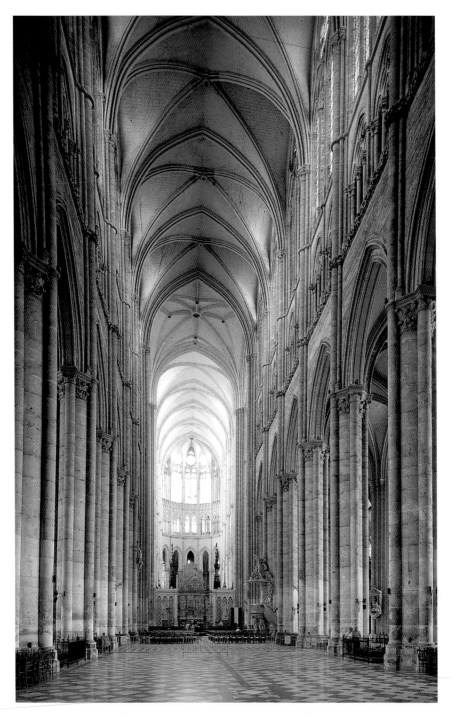

2.10 Amiens Cathedral, view of the nave looking east
(Robert de Luzarches, architect), begun 1220. Amiens, France.

the immensity of the piers supporting the pointed arches that lead our vision upward toward the ceiling vaults. The sensation of awe-inspiring height, and with it the notion of the loftiness of faith, is achieved.

Most Gothic cathedrals were dedicated to the Virgin Mary, who was believed to be an intercessor with Christ on behalf of mankind. At Chartres, she was particularly venerated, for the cathedral owned a relic of her tunic. Her importance is reflected in the stained-glass window depicting her image in silver on the main altar of the cathedral (fig. 2.11). People are shown bringing offerings to her, which was intended to encourage worshipers to donate money to the church. The image is thus designed to exalt the Virgin, to show her intimate relationship with the general population, and to raise funds for further construction.

The transition, not only between life and death and between divinity and mortality but also between past and present and future, is characteristic of religious imagery. In the case of the Virgin Mary, her own role in the Christian narrative participates actively in such transitions. For example, on the façade of the entrance to the late fourteenth-century Carthusian monastery of Champmol near Dijon, France, the Netherlandish sculptor Claus Sluter (active 1379–1406) depicted Mary's relationship to humanity as well as her maternal devotion to Christ.

Sluter carved Philip the Bold and his wife, Margaret of Flanders, as if they are being presented to the Virgin and infant Christ by their respective patron saints, John the Baptist and Catherine of Siena (fig. 2.12). This type of imagery, in which donors, or patrons, are included in a work they financed, became popular in Europe from the Late Middle Ages. The donors' place-

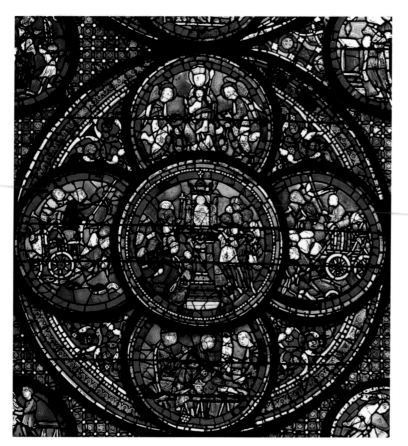

2.11 *Miracles of the Virgin*, Chartres Cathedral, c. 1220. Stained glass. Chartres, France.

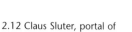

2.12 Claus Sluter, portal of the Chartreuse de Champmol, 1385–93. Dijon, France.

ment at the entrance to the building, which was to be their burial place as well as a place of worship, allies them with the sacred figures. All are rulers: Philip the Bold and Margaret rule on earth whereas Mary and Christ rule in heaven. The spatial and temporal disjunction between these two pairs of rulers and their domains is thus bridged by the image. It also implies that, through their piety and their generosity, Philip and Margaret will be rewarded in heaven.

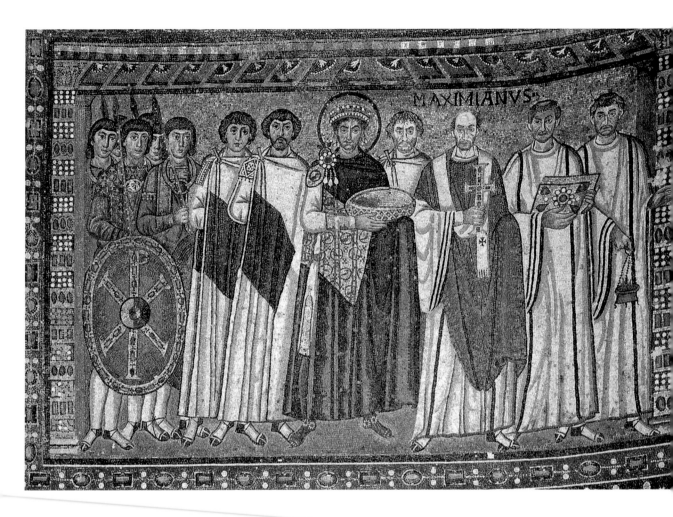

2.13 *Court of Justinian*, c. 547. Apse mosaic, 8 ft. 8 in. × 12 ft. (2.64 × 3.65 m). San Vitale, Ravenna, Italy.

POLITICAL ART

The use of imagery for political purposes is found throughout the world. Sometimes, as in the sixth-century Byzantine mosaics representing the courts of Justinian and Theodora in the apse of the church of San Vitale, the religious and political purposes of art merge (figs. 2.13 and 2.14). San Vitale is in the port city of Ravenna, on the east coast of Italy, which, in the sixth century, was a strategically important part of the vast Byzantine Empire. Neither the emperor nor the empress, who ruled from Constantinople (modern Istanbul), in Turkey, had ever been to Ravenna. But Justinian commissioned churches throughout the empire as a sign of his own piety and as a confirmation of his legitimate power.

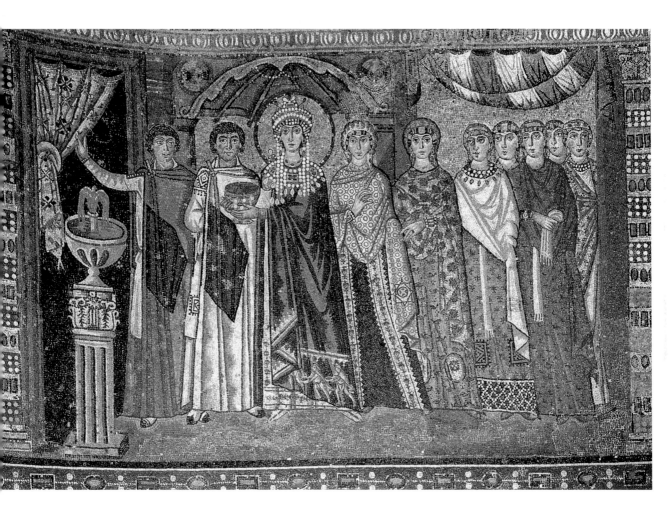

2.14 *Court of Theodora*, c. 547.
Apse mosaic, 8 ft. 8 in. × 12 ft.
(2.64 × 3.65 m). San Vitale,
Ravenna, Italy.

Justinian's mosaic (see fig. 2.13) shows him flanked by clergymen and soldiers. Wearing a golden cloak and holding a jeweled cross is Maximian, archbishop of Ravenna. Justinian wears a purple robe and a crown denoting his royal status; framing his head is a halo that signifies divinity. At his right stand two court officials and a military guard. The latter carry a shield inscribed with the Chi-Rho, the first two letters of Christ's Greek name. These were the letters that Constantine placed on his own shield after recognizing the power of the sign of the Cross.

Theodora's mosaic (see fig. 2.14) shows her standing in an abbreviated apse between clergymen and ladies-in-waiting. She is presenting an offering, as are the three kings embroidered on the lower part of her purple robe. Like Justinian, she is crowned, and her halo is a sign of her saintliness

(despite her having been a courtesan before becoming empress). The baptismal font at the far left of the mosaic reminds viewers of the rite by which one becomes a Christian.

The message of these mosaics is that Justinian is the legitimate heir of Constantine and that Theodora is his co-regent. Justinian's piety, like Theodora's, is indicated by his proximity to officials of the Church and by signs of divinity. From the political point of view, the mosaics are substitutes for the rulers and project the image of a wealthy, powerful empire sustained by the Church and the army.

Another type of political image that has persisted in Western art is the equestrian portrait—a ruler on horseback. One of the most impressive—and

2.15 Jacques-Louis David, *Napoleon at Saint Bernard Pass*, 1800. Oil on canvas, 8 ft. × 7 ft. 7 in. (2.44 × 2.31 m). Musée Nationale du Château de Versailles.

mythic—examples is Jacques-Louis David's (1748–1825) *Napoleon at Saint Bernard Pass* of 1800 (fig. 2.15), which depicts Napoleon in an idealized way. He is mounted dramatically on a rearing horse (in reality, he rode a mule). In contrast to his elaborate uniform and commanding presence, his army is barely visible in the mist-shrouded distance. Prominently inscribed on the rocks in the foreground below Napoleon is "BONAPARTE" (his own name). Less distinctive, as if overshadowed by the fame and presence of Napoleon, are the names of his illustrious military predecessors—Carolus Magnus (Charlemagne), who was the first Holy Roman emperor, crowned in the year 800, and Hannibal, the Carthaginian general who, in the third century B.C., reportedly led a troop of elephants across the Alps during the First Punic War between Rome and Carthage.

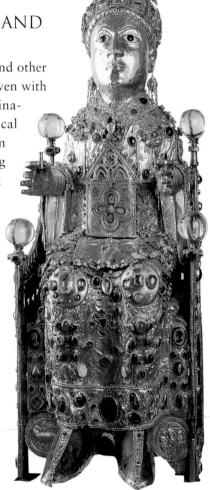

2.16 Reliquary statue of Sainte Foy, late 10th–early 11th century. Gold, silver, gems, and cameos over a wooden core, 34 in. (85.0 cm) high. Church treasury, Conques, France.

IMAGES THAT HEAL, DESTROY, PROTECT, AND WARN

The platitude "Healing is an art" has ancient origins. Shamans and other types of medicine men are in evidence in every known society. Even with modern science and the discovery of bacteria and viruses, vaccinations and antibiotics, and the development of sophisticated medical procedures, we still think of healing as an art. This derives from an awareness that there is more than hard science at work in dealing with certain kinds of disease. History has shown that the line between science and what cannot be explained empirically is sometimes blurred. This hard-to-define area is one in which the visual arts have traditionally played a role.

The silver statue of the Virgin illustrated in the stained-glass window of Chartres is a case in point (see fig. 2.11). It is a type of reliquary, or container for relics, believed to have miraculous healing powers. An example from the Romanesque period (c. 1000–1200) is found in the abbey church of Sainte Foy (Saint Faith, in English) at Conques, in southern France. Pilgrims traveled to the church to venerate the relics of the third-century virgin who defied the Roman emperor by refusing to sacrifice to the pagan gods. Sainte Foy's reliquary (fig. 2.16) contained a relic of her skull, kept in an opening at the back. Contemporary accounts describe the riveting effect of the figure's gaze on viewers and their conviction that the saint would answer their prayers. Prominent among such prayers was the wish to be healed.

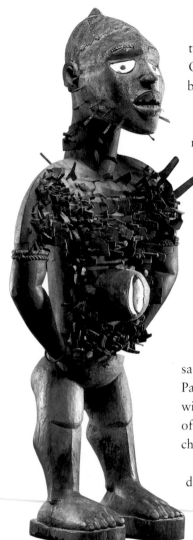

2.17 *Nail Fetish from the Congo*, 1875/1900. Mixed media, wood with screws, nails, blades, and cowrie shells, 3 ft. 10 in. (1.17 m) high. Detroit Institute of Arts, Founders Society Purchase, Eleanor Clay Ford Fund for African Art, 76.79.

Another approach to the art of healing can be seen in the late nineteenth-century wooden nail fetish from the Congo, in Africa (fig. 2.17). Objects such as this, like the shamans, were ambivalent—that is, they could both heal and cause disease. The interior of this figure contained medicines whose power to cure was released when the shaman pierced the figure with nails. In a sense, then, the image not only functions as a kind of intermediary between sickness and health, but also stands for the patient who is being treated.

The Greek myth of Medusa, the mortal Gorgon with snaky hair who turned to stone any man who looked at her, is about the dangers of seeing a certain kind of image. Medusa was beheaded by the hero Perseus, who looked only at her reflection in his shield. He then gave the head, or Gorgoneion, to Athena, goddess of war, wisdom, and weaving, and the patron of Athens. Athena placed the head on her breastplate, where its function was symbolically to "petrify" her enemies. As a result, the Gorgoneion became a protective device on Western shields and armor.

Figure 2.18 is a second-century Roman marble copy of the colossal lost gold-and-ivory Classical statue of Athena originally housed in the Parthenon. It shows the goddess in full armor, standing by her large shield, with a small Gorgoneion on her breastplate. This image served as a reminder of Athena's power in battle and was a warning to those who would dare challenge her or threaten the city of Athens, over which she stood guard.

The history of art abounds in exemplary imagery—that is, images designed to warn viewers of the consequences of certain actions. A politically motivated exemplary image became popular in late fifteenth-century Florence, in Italy. Several conspiracies had attempted to overthrow the Medici family, whose control of the city lasted from the early fifteenth century until 1494, when the fanatic Dominican monk Girolamo Savonarola assumed power. In order to warn against anti-Medicean activity, prominent artists were commissioned to paint large banners depicting condemned rebels who had participated in the Pazzi Conspiracy of 1478; they were to be shown hanging upside down. None of the original paintings survives, but a few drawing studies still exist (fig. 2.19). These were intended to warn of the danger of disrupting the political status quo. By being represented upside down, the depiction of the conspirator is a visual metaphor of his transgression—namely, to overturn the government and reverse its power structure. The drawing is also a talion image—an "eye for an eye," or punishment in kind—because the rebel's punishment symbolically fitted his crime.

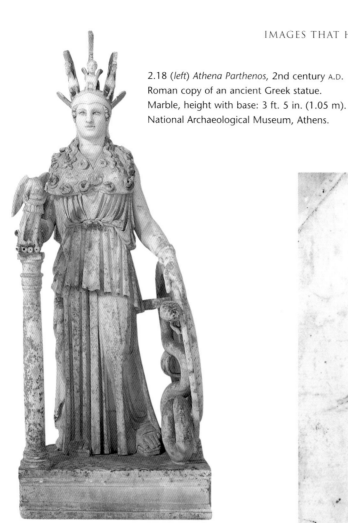

2.18 (*left*) *Athena Parthenos*, 2nd century A.D. Roman copy of an ancient Greek statue. Marble, height with base: 3 ft. 5 in. (1.05 m). National Archaeological Museum, Athens.

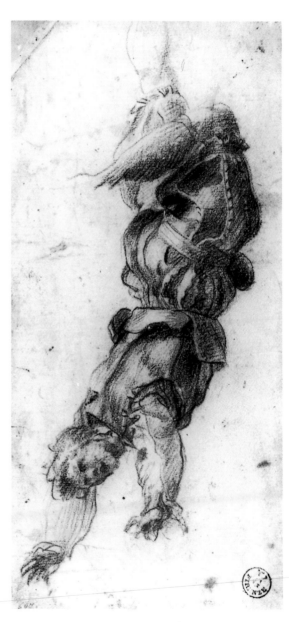

Savonarola, like Louis-Philippe of France, understood the power of imagery and used his authority to control the visual arts. He presided over the "bonfires of the vanities," gathering up articles of luxury along with books and paintings that he considered morally corrupting and burning them in the public squares of Florence. Among the destroyed paintings were mythological works, some containing nudes, by leading Renaissance artists. Savonarola's rule was shortlived, for he was executed in 1498. Nevertheless, during his four years in power, he destroyed a number of important works of art.

2.19 Andrea del Sarto, drawing of a man hanging upside down, 1530. Galleria degli Uffizi, Florence.

ADVERTISING IMAGES

We have seen that images are designed to convey messages. In the contemporary world, advertising images are used to persuade people to buy something. The Pop Art pictures of Andy Warhol (1928–1987) reflect the impulse of advertisers to repeat their messages over and over again. His famous paintings of Campbell's soup cans are a case in point. In figure 2.20, he has arranged two hundred soup cans with their trademark red-and-white labels in ten neat rows of twenty. All are identical except for the designation of their contents—vegetable, tomato, chicken, beef, and so forth.

Warhol, one of the founding artists of 1960s Pop Art, was interested in the rote character of American consumerism. He typically applied paint to canvas so that the smooth surfaces replicated the flat character of advertising copy. The same effect is created by his many screen prints, which are themselves made in multiples. As in advertising, the multiplication of

2.20 Andy Warhol, *Campbell's Soup Cans*, 1962. Synthetic polymer paint and silkscreen ink on canvas, 6 ft. × 8 ft. 4 in. (1.83 × 2.54 m). Tate, London.

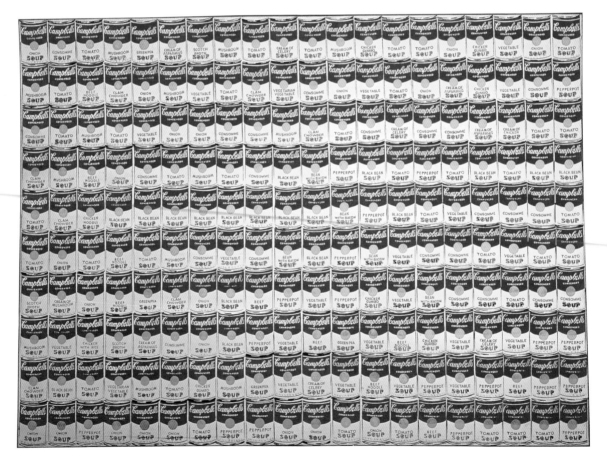

imagery and its sameness can mesmerize viewers. In so doing, advertisers hope to produce the subliminal recognition of a product and thus encourage its purchase.

In contrast to most advertising images, however, Warhol's pictures are works of art. What, we may ask, is the difference? The answer lies in the nature of the image and the intention of its creator. Whereas the designer of the Campbell's soup labels had in mind the sale of a product, Warhol (who also wanted to sell his pictures) was creating imagery with a cultural message and an aesthetic quality. He was commenting visually on an aspect of American life and re-creating the advertising image in a new context—that is, as an image distinct from the manufactured object (the soup can). He also, on occasion, elevated the everyday object to the status of an American icon—for example, Coca-Cola bottles and Heinz ketchup boxes. The same may be said of his portraits, including those of Marilyn Monroe, Jackie Kennedy, and Mao Zedong, which he also repeated and of which he made multiples, and of his American cultural heroes—Elvis Presley, Superman, and Mickey Mouse, among others.

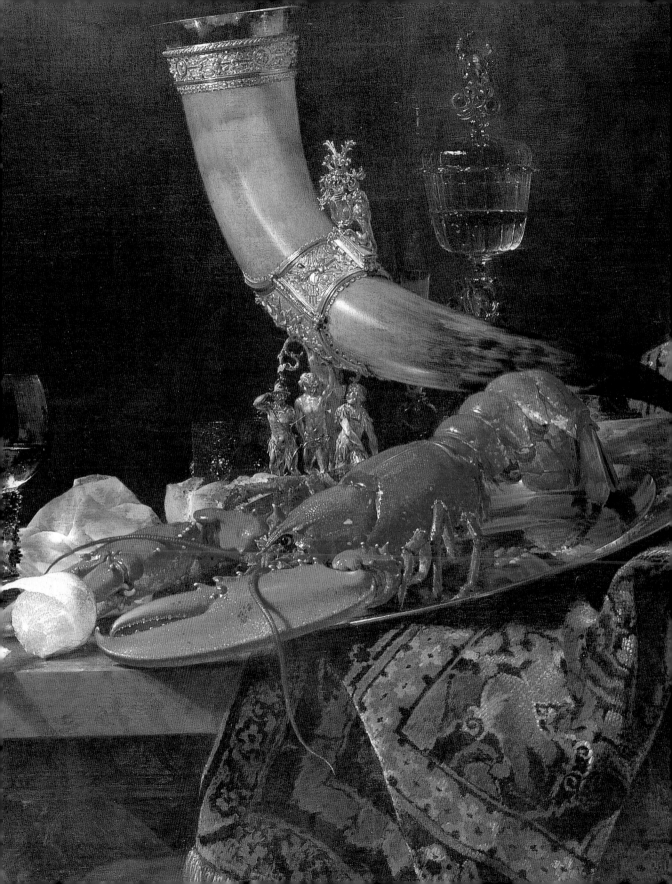

3

STYLE AND THE FORMAL ELEMENTS OF ART

THE TERM *STYLE* is a household word. We speak of style in relation to clothing and furniture, and we call people stylish if they dress in the latest fashion. We also speak of style when describing types of behavior. For example, we might say that a shy person has a withdrawn style or that an outspoken person has an assertive style.

When applied to the visual arts, *style* refers to the way in which an artist arranges the formal elements comprising the syntax of imagery. Among these elements are line, shape, color, light and dark, texture, and space. Works of art have been organized by historians in various ways, but the most usual way is according to style. Styles have been named according to period (Neolithic), culture (the Renaissance), and formal categories (Impressionism). Although distinct from content, subject matter, and theme, style is the means by which these are conveyed to the viewer.

LINE AND SHAPE

A basic formal element of imagery is line, which can be rendered in different expressive ways. Line can provide a shape with structure, and it can define

OPPOSITE
Willem Kalf, *Still Life with the Drinking-Horn of the Saint Sebastian Archer's Guild, Lobster, and Glasses*, c. 1653 (detail; see fig. 3.17).

3.1 Rembrandt van Rijn, *Woman Sewing (Titia, Sister of Saskia)*, 1639. Pen and brown wash, 7 × 5¾ in. (17.8 × 14 cm). Nationalmuseum, Stockholm.

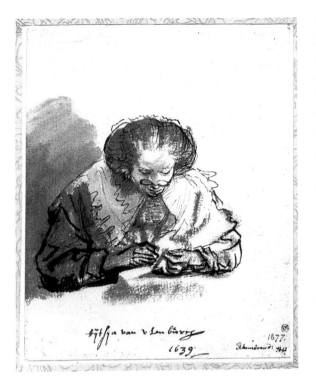

the shape, if it is an outline. Line can also reinforce the spatial direction of a form. If we compare two works in which line plays an important part, we can see some of the variety that is possible when an artist controls line.

In drawings, line tends to predominate. Rembrandt's *Woman Sewing* of 1639 (fig. 3.1), a portrait of his sister-in-law, Titia, depicts a woman leaning over a table, intently sewing. The blackest lines define Titia's hands and sleeves. Nearly all these lines are diagonals that accentuate the movement of her fingers as they manipulate the needle. Heavy lines structure the sleeves, by comparison with the lighter, more fluid lines of the shawl covering Titia's shoulders. The curves defining her hair are somewhat broader than the shawl lines and create the impression that her hair is neatly pulled back behind her head. Titia's concentration on her work is enhanced by her hunched shoulders, downward gaze, and the spectacles resting on her nose. She does not seem aware of a viewer, or of the artist drawing her, because she is absorbed in her task. As such, she may be a metaphor for the artist—in this case, Rembrandt himself—who, throughout his career, depicted themes of seeing and not seeing, of introspection, blindness, and intense focus such as Titia's.

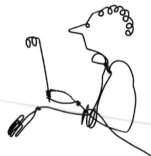

3.2. Alexander Calder, *The Hostess*, 1928. Wire, 11½ in. (29.2 cm) high. The Museum of Modern Art, New York. Gift of Edward M.M. Warburg.

Line is also the primary element used by the twentieth-century American artist Alexander Calder (1898–1976) in his wire sculptures. His *The Hostess* of 1928 (fig. 3.2), like Rembrandt's *Woman Sewing*, peers through a pair of glasses, apparently inspecting a guest as she extends her right hand in a gesture of greeting. Because of the diagonal that extends from the hostess' head to her feet, Calder creates the impression that she is stepping forward. He has also endowed her with various humorous details such as tightly curled hair, a pointed nose, and high-heeled

shoes. Her affectation is emphasized by the limp quality of her right hand and the sense that she is "looking down her nose" at her social unequals. Using only a wire, Calder has ingeniously captured the ambivalence of the hostess, who is required to appear welcoming but considers herself socially superior.

SCULPTURE: *DAVID* BY DONATELLO AND BY BERNINI

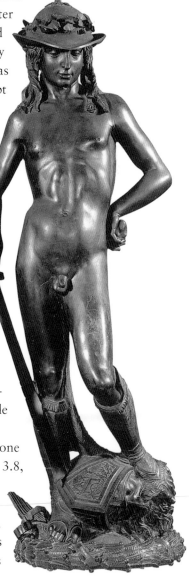

3.3 Donatello, *David*, c. 1420–40. Bronze, 5 ft. 2½ in. (1.58 m) high. Museo Nazionale del Bargello, Florence.

Now consider two sculptures in the round that represent the biblical hero David, the youth who killed the Philistine giant Goliath and who later became a powerful king of Israel. According to the Bible, David declined the offer of armor and weapons, slew the heavily armed Goliath with only a stone and a slingshot, and then decapitated him. David's victory was thus a triumph of intelligence and skill over brute force. He literally "kept his head," whereas Goliath lost his.

In the bronze statue of around 1420–40 by the Italian Renaissance sculptor Donatello (1386–1466), the deed has been done, and a relaxed David stands triumphantly over Goliath's severed head (fig. 3.3). In Bernini's marble *David* of 1623, in contrast, the young hero is shown as he is about to release the stone from his sling (figs. 3.4 and 3.5). These two artists have represented different moments in the same story, the result being that the nature of their images differs. The sculptures can be analyzed formally by considering the elements of the artist's language.

If we begin our analysis of these two sculptures with line, we might produce the following four diagrams (figs. 3.6–3.9). In figure 3.6, a long, central line moves in a slow, graceful curve that defines the main spatial direction of the statue. The outer edges of the statue define its contour, or rounded form. The spaces—that is, the open areas between the arms and the torso, and between the legs— are enclosed, and the general shape of the figure fits into a vertical rectangle (see fig. 3.7).

Bernini's *David* is composed of a series of diagonals, the main one beginning at the head and ending at the left foot. But if we look at figure 3.8, we see that the central curved diagonal ends not at the left foot, but in between the feet. This is because our viewpoint has shifted. Whereas we can see the entire front of Donatello's *David* from a single viewpoint, we cannot in the case of Bernini's *David*. Bernini's figure twists sideways at the waist, the left arm crosses to the right side, and the head turns

in the opposite direction. The legs, instead of fitting within the overall vertical rectangle of Donatello's implied outline, are extended diagonally.

The general outline of Bernini's *David* forms an irregular shape rather than an approximate rectangle (see fig. 3.9). This is consistent with the fact that the figure is shown in motion and that a number of spaces around the figure are not enclosed by the statue. Such open spaces tend to produce more formal movement than closed spaces. The diagonal planes and open spaces of Bernini's *David* are consistent with the figure's muscular tension. These formal differences between the works of Donatello and Bernini conform to the general characteristics of fifteenth-century Renaissance style and seventeenth-century Baroque style, respectively. Each artist is thus a product of his time and place as well as an individual creator with a personal style.

3.4 Gianlorenzo Bernini, *David*, 1623. Marble, life-size. Galleria Borghese, Rome.

3.5 Side view of figure 3.4.

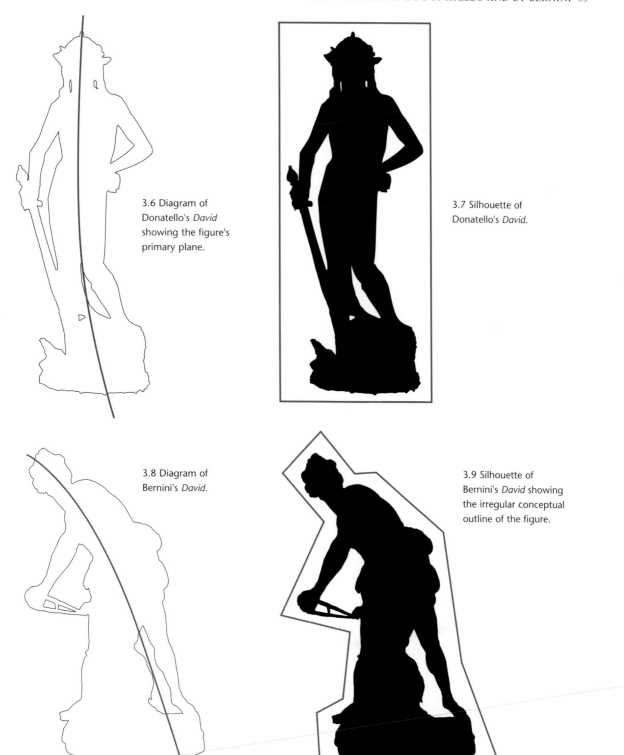

3.6 Diagram of Donatello's *David* showing the figure's primary plane.

3.7 Silhouette of Donatello's *David*.

3.8 Diagram of Bernini's *David*.

3.9 Silhouette of Bernini's *David* showing the irregular conceptual outline of the figure.

One area in which a personal element can be identified is the choice of medium, or material. Donatello's preferred medium was bronze, while Bernini's was marble, as is the case with these particular statues of David. The nature of bronze and marble, especially when polished, affects the texture of a work. Because bronze is a metal and marble a stone, Donatello's *David* has a more reflective surface than Bernini's, despite the fact that both statues are polished. This distinction, in turn, is consistent with the more rugged character of Bernini's *David* and the more effete quality of Donatello's. The latter David is relaxed as he looks smugly down at the head of his defeated enemy. He can afford to be complacent, for he has achieved a stunning victory over Goliath. He even allows his toe to play lightly with Goliath's mustache, and the wing rising from Goliath's helmet caresses the inside of David's right leg. The erotic interplay implied in the relationship between Donatello's David and Goliath is possible because of the moment represented. The battle is over, and its aftermath is shown as being without a time limit. It is leisurely, familiar, and somewhat nonchalant. Donatello's David seems to have all the time in the world to enjoy his triumph.

Bernini's David, in contrast, is pressed for time. He is shown in the midst of action, at the crucial point when he begins to propel the stone. His facial expression reveals his concentrated effort as he simultaneously sights his foe and focuses on his target. His entire body appears tense, every muscle participating in the launch of the stone. In addition to the sense that the figure is thoroughly engaged in the action of the moment, the sculpture's heroic quality is enhanced by larger proportions than those of Donatello's *David* and by the greater weight of marble as compared with bronze.

Donatello's figure is slim and graceful, and areas of the surface are decorated with elegant patterning—the shepherd's hat and the trim on the boots. In Bernini's statue, surface patterns are confined to the armor lying on the ground and the pouch at the waist. In place of the sensuous, relaxed, fleshy surface of the Donatello, Bernini's figure displays tension made visible through bulging muscles, veins, and bone structure.

These differences in formal character reinforce not only the content of the works, but also the way they are perceived by viewers. The closed space of Donatello's *David* is formed in part by the large sword of Goliath. This is consistent with David's self-absorption, for his slight smile suggests a silent, inner "dialogue" with his enemy. He communicates not with the viewer, but with the head of Goliath. In a sense, then, both David and Goliath's head are designed to be passive objects of our gaze; we look at David looking at the head by his feet.

Our relationship to Bernini's *David* is different. The two views illustrated in figures 3.4 and 3.5 indicate that the notion of front, back, and side is not as clearly distinguished as in the Donatello. This is because the figure turns abruptly, its diagonals opening and animating the spaces around it. Rather than gazing at Bernini's *David* from a specific viewpoint— that is, from the front, back, or side—we are invited to participate in the figure's dramatic action. We notice armor that has been placed on the ground behind him, reflecting the narrative—that David has "turned his back" on the armor and decided to fight without it. We, as viewers, assume the position of Goliath, for in order to observe the work directly, we have to confront the force of David's determination. In this way, we are drawn into the action, which is a characteristic of the Baroque style, and the presence of Goliath is implied rather than literal, as it is in Donatello's sculpture.

PAINTING: CASTAGNO'S *DAVID*

If we compare Castagno's (c. 1418–1457) painting of *David* (fig. 3.10) of around 1450 with the sculptures by Donatello and Bernini, we can observe some of the differences between two- and three-dimensional images. For one thing, we have no choice but to view the Castagno from the front. Castagno's *David* is painted on a leather shield that was probably carried in ceremonial processions in fifteenth-century Florence. There is no reason to examine the back or sides of the shield unless we are interested in the shield itself rather than in the image painted on it. We see the picture in its entirety without going around it. This saves viewing time and, in contrast to the sculptures in the round, confronts us with the whole image at once. This point was made by Leonardo in his *Paragone*, in which he argued for the superiority of painting over sculpture (see Chapter 8).

The compression of time that is possible in a picture is a feature of Castagno's image. He shows two moments in the narrative as if they are one: David straddles the severed head of Goliath and also prepares to hurl the stone from his sling. David has both killed and not killed Goliath in this image, which means that Castagno has merged future and present into a single time frame.

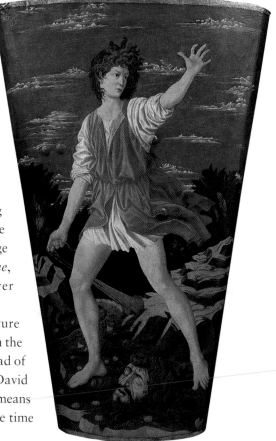

3.10 Andrea del Castagno, *The Youthful David*, c. 1450. Tempera on leather mounted on wood, top width 45½ × 30¼ in. (115.6 × 76.9 cm). National Gallery of Art, Widener Collection, Washington, D.C.

As with the *David*s of Donatello and Bernini, Castagno's *David* merges form with content. Castagno's David has wavy hair blowing in the wind. As a result of its form, the hair has been compared to the snaky hair of Medusa, which it resembles. This coincidence is consistent with the fact that the image is painted on a shield and evokes the Greek myth in which Perseus slays Medusa and gives her head to Athena. Just as Athena had been the protector of ancient Athens, so in fifteenth-century Florence David was regarded as a symbol and defender of that city. His image was regularly used to project the republican self-image of Florence, which maintained its independence despite continual threats from despots such as the Visconti and the Sforza of Milan. In so doing, Florence, like David and Perseus, used intelligence and skill to outwit and prevail over its more powerful enemies.

COLOR

Castagno's *David* is not made of bronze or marble, but of paint applied to a flat surface. Paint is made by mixing pigment, or color, with a binder that liquifies it, and color is often the most striking element of a painting. The type of paint used by Castagno is tempera, in which pigment is bound in an emulsion of egg yolk and can be thinned with water.

Hue refers to the name of a color, such as red or green. When light strikes an object, some wavelengths are absorbed by the surface of the object while others are reflected. We see a particular hue when it is reflected and the other hues are absorbed. (Think of a prism: when light is passed through it, the light is broken up into its component hues, which are the seven colors of the visible spectrum [fig. 3.11].) If more than one hue is reflected, we see a combination of hues. In order for us to see a single pure color—such as blue, red, yellow, or green—all the other hues must be absorbed and only one reflected.

3.11 Visible spectrum.

The hues of the visible spectrum are diagrammed in the conventional color wheel (fig. 3.12), which is constructed around the three primary colors—red, yellow, and blue. These are the colors from which all other colors are made and that cannot themselves be made by mixing other colors. The secondary colors fall between the two primaries of which they are composed. Thus yellow and blue produce green, yellow and red produce orange, and red and blue produce purple. Separating a primary from a secondary color on the color wheel is the tertiary color, which is produced by mixing the primary and secondary colors on either side of it.

Colors opposite each other on the color wheel are complementary colors. These create strong contrasts when placed side by side and are often paired when a striking effect is desired. In Castagno's *David*, there is an orange tint to the flesh of the figure. Because orange and blue are complementaries, this accentuates David in contrast to the blue sky.

Color is not only a formal element. As with line and space, color also has meaning. In the work of the African-American painter Bob Thompson (1937–1966), colors were associated with issues of race in the 1960s. In his *Crucifixion* of 1963–64 (fig. 3.13), Thompson represents himself as a red Christ, crucified between a yellow and a light-orange thief. At Christ's

3.12 Conventional color wheel.

3.13 Bob Thompson, *Crucifixion*, 1963–64.
Oil on canvas, 5 ft. × 4 ft. (1.52 × 1.22 m).
Private collection, New York.

right stand a blue Mary with red hair, who resembles Thompson's Caucasian wife, and a dark-orange Saint John. By using these sharp color contrasts and swirling clouds and curvilinear tree branches, Thompson has energized a somber event, creating a sense of turbulence accompanying the Crucifixion. He has depicted his figures as flat areas of color, and himself as both a man of color in a racial sense and a colorful man in a pictorial sense. He has also made a social point—namely, that skin color is literally only "skin-deep," for it can be painted onto the surface of any figure. By painting skin colors, Thompson uses his art to take control of certain racial characteristics, combining a sense of play with an important social message.

The conventional color wheel illustrated in figure 3.12 is by no means the only method of diagramming color. Artists have devised different types of diagrams, depending on which aspects of color

3.14 Josef Albers, color triangle.

3.15 Josef Albers, study for *Homage to the Square*, 1963. Oil on masonite panel, 30 x 30 in. (76.2 x 76.2 cm). Tate, London.

they want to emphasize. The German-born artist Josef Albers (1888–1976) created a color triangle (fig. 3.14) that he used when teaching color theory at the Bauhaus, in Dessau, Germany, and later at Yale University. In contrast to the conventional color wheel, which places the primary colors in every fourth spot, Albers placed them at the three angles of the triangle.

As with the conventional wheel, Albers's secondary colors are placed between the primaries of which they are composed, but gray is included as well. For example, between the pure green and yellow triangles, the inverted triangle contains a shade of yellowish gray. Albers was interested in interactions between colors or between gradations of the same color, especially when their edges are adjacent to each other. These relationships occur in Albers' famous series of paintings entitled *Homage to the Square*, of which one example is illustrated in figure 3.15. In this instance, squares of blue and blue-green are juxtaposed in such a way that they seem to advance and recede in space as viewers shift their focus from one to another of the tones.

The earliest spherical color model had been devised by another German artist, Philip Otto Runge (1777–1810), to demonstrate the transition of color from white to black (fig. 3.16). The diameter of the sphere was composed of nine hues between the pure red, yellow, and blue primaries—twelve in all. Near-white and near-black are located opposite each other at the equivalent of the northern and southern poles of the sphere. The progress of each hue toward white or black is indicated along an individual series of shapes extending from one pole to the other.

3.16 Philip Otto Runge, color sphere.

LIGHT AND DARK

Black and white are not included in the conventional color wheel. According to color theory, mixing complementary colors produces black or gray because all the hues are absorbed and thus are not reflected. In white, on the other hand, all the hues are reflected to the same degree. Black, gray, and white, therefore, do not have the property of hue, or color. They are experienced as gradations of light and dark, which, in nature, allow us to perceive form.

If we are in a totally dark room or in one that is flooded with pure light and contains only surfaces that reflect every hue, we see nothing. The transitions between light and dark are called shading, and when an object blocks a source of light, a shadow is cast. We see the shadow by contrast with the lighter area surrounding it.

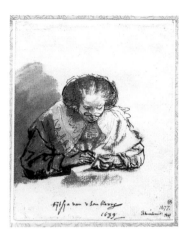

Rembrandt van Rijn, *Woman Sewing (Titia, Sister of Saskia),* 1639 (see also fig. 3.1).

Consider these elements of light and dark in Rembrandt's drawing of the woman sewing (cf. fig. 3.1). Shading is conveyed by the hatched (parallel, or near parallel) lines, which create the impression of a raised surface on which Titia rests her left arm. Shading also creates the illusion of creases in the folds of the shawl and in the planes of the face. Behind Titia on the wall to the left, we see a shadow that is cast because she blocks the light that appears to enter from the right. The wall at the right, on the other hand, is a flat area of white because there are no gradations in its surface.

TEXTURE

Another element at the disposal of the visual artist is texture. Tempera paintings, such as Castagno's *David,* generally have a smooth surface. Oil paintings can have a smooth or a rough surface, depending on how the paint is applied. The application of paint, like the surface treatment of bronze and marble, affects the appearance of an object. Simulated texture is the illusion of texture, independent of the actual paint surface, although some media,

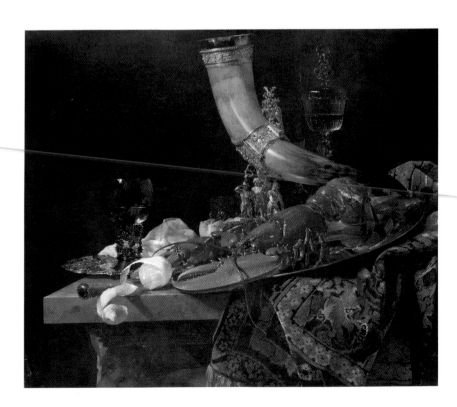

3.17 Willem Kalf, *Still Life with the Drinking-Horn of the Saint Sebastian Archer's Guild, Lobster, and Glasses,* c. 1653. Oil on canvas, 34 × 40¼ in. (86.4 × 102.2 cm). National Gallery, London.

such as oil (which is thicker than tempera), are more conducive to textural illusion than others.

The mid-seventeenth-century oil painting *Still Life with the Drinking-Horn of the Saint Sebastian Archer's Guild, Lobster, and Glasses* by the Dutch painter Willem Kalf (fig. 3.17) contains several areas of convincing simulated texture. Consistent with the tastes of seventeenth-century Dutch still life, this work portrays a richness of textures that creates a feast for the eye, just as the content depicts the literal elements of a feast. A rumpled and richly textured carpet supports a tilted, shiny silver plate barely holding a bright red lobster. We can almost feel the lobster's hard crustacean surface as we observe its reflection in the shine of the plate. Tiny points of light identify the protrusions of the claws, the antennae, and the reflection in the single, black eye. Drinking goblets, half filled with liquid, are highlighted with ornate glass details. Rising majestically from this feast of tactile illusion is the drinking horn, the sign of the patron. Supporting the horn are figures of members of the Archer's Guild; they are rendered in intricate silverwork.

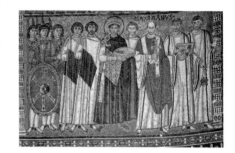

Court of Justinian, c. 547 (see also fig. 2.13).

SPACE AND SHAPE AS CONTEXT AND ILLUSION

In contrast to the mosaic of the Court of Justinian (see fig. 2.13), Castagno's *David* (see fig. 3.10) depicts the natural world. Whereas Justinian stands on an unidentified green surface against a flat gold background, Castagno's figure occupies a landscape. The space of the painting resembles a three-dimensional setting so that the figure appears to turn freely as in real-world space. Castagno has created air space, which is minimal in Justinian's mosaic.

The figure of David is not frontal, as that of Justinian is; instead, David turns and raises his left arm to sight his adversary. In so doing, he directs his arm toward the picture plane—that is, toward both the surface of the painting and the presumed viewer. There is no such movement in the Byzantine image because there is no air space to accommodate an extended arm. Notice that the halo around Justinian's head is defined by a line and is composed of a flat gold surface.

As with line and color, space can also convey meaning. Justinian's mosaic, like other Byzantine works, depicted space according to a spiritual rather than a natural ideal. For the Early Christian and Byzantine Church, earthly life was but an imperfect shadow of eternity. By flattening space,

Andrea del Castagno, *The Youthful David*, c. 1450 (see also fig. 3.10).

therefore, the artists alluded to eternal timelessness and a future perfection. Castagno, on the other hand, pursued the artistic ideal current in fifteenth-century Florence—namely, the three-dimensional reality of nature.

LINEAR PERSPECTIVE

3.18 Diagram of one-point perspective.

The term used to describe the position of David's arm in space is *foreshortened*, meaning "rendered in perspective." During the Renaissance, artists developed a system of constructing a visual context that permitted them to create the illusion of three-dimensional forms on a flat surface. This fulfilled the Renaissance view of painting as a window through which the natural world was made visible, in contrast to the Byzantine view that imagery should have a more spiritual context. Figure 3.18 is a simple diagram of Renaissance one-point, linear perspective. The horizon is shown as if we are viewing it from a distance and standing in the center of a railroad track. We notice that the long sides of the track (called orthogonals because they are at right [*orth*] angles [*ogonal*] to the picture plane) appear to converge at a point (the vanishing point) on the horizon. We also notice that both the railroad ties and the trees at the side of the track appear to diminish in size as they approach the horizon. This illusion reflects the fact that in nature objects appear smaller the farther away they are from a viewer.

Figure 3.19 depicts the railroad track as if we are directly above the track looking down on it. There is no question but that the long sides of the track are perpendicular to the picture plane and that they do not, in fact, meet at the horizon. Furthermore, neither the width of the railroad ties nor the size of the trees diminishes. Figure 3.19 is flat and makes no pretense of showing depth.

In Castagno's *David*, there are no identifiable orthogonals because there is no line or plane demonstrably perpendicular to the picture plane. Nevertheless, Castagno's use of linear perspective is clear from the large size of David compared with the rocks, foliage, and clouds. Also contributing to the illusion that David is in the foreground is his placement at the lower part of the picture plane (like the larger railroad ties in figure 3.18). This impression of nearness, in addition to the fact that David

3.19 Diagram of figure 3.18 as seen from above.

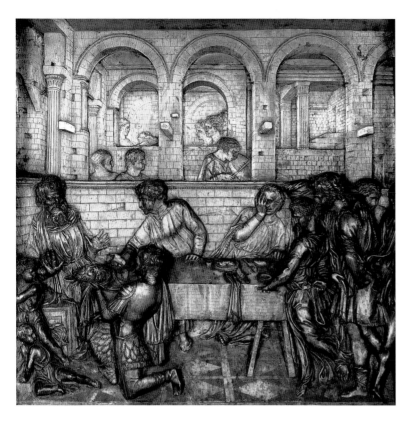

3.20 Donatello, *Feast of Herod*, mid-1420s. Bronze, 23½ × 23½ in. (60.0 × 60.0 cm). Baptistery, Siena.

overlaps the landscape, is enhanced by the relative brightness of the light striking his figure.

3.21 (*below*) Figure 3.20 with perspective lines (orthogonals) superimposed on the figure, leading to a vanishing point.

Many Renaissance works, particularly those with architectural features, do retain the original orthogonal construction in the final image. A good example of this can be found in Donatello's relief sculpture the *Feast of Herod* (fig. 3.20), which he made for the baptistery in Siena in the mid-1420s. Here, as in a Renaissance painting, the scene appears as if viewed through a window or on a stage. The event, which is shown in the left foreground of the relief, is the presentation of the head of John the Baptist to King Herod

The tile decoration on the floor of Herod's palace provides orthogonals that appear to recede into the background (fig. 3.21). Donatello thus controls the viewer's line of sight, which tends to follow the direction of the orthogonals. Donatello, like Castagno, diminishes the scale of background forms.

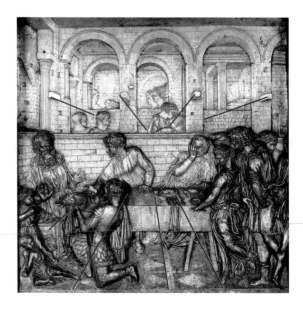

3.22 Hua Yan, *Conversation in Autumn*, c. 1732. Hanging scroll, ink and color on paper, 45⅜ × 15⅝ in. (115.3 × 39.7 cm), Qing dynasty. Cleveland Museum of Art, 2001, John L. Severance Fund, 1954.263.

But, because this is a relief, Donatello had another method at his disposal, one that he himself invented—namely, diminishing the degree of relief as well as the scale. As a result, the figures behind the wall of Herod's feast are in lower relief than those in the foreground.

EASTERN PERSPECTIVE SYSTEMS

Another system for creating the illusion of distance—atmospheric (or aerial) perspective—diminishes the clarity, rather than the scale, of forms. Leonardo used this technique in the *Mona Lisa* (see fig. 1.12) and combined it with linear perspective. Short orthogonals are visible at the corners formed by the base of the columns and the horizontal ledge of the balcony. In the landscape, however, the mountains become hazier rather than smaller as they approach the horizon.

Atmospheric perspective is prevalent in Far Eastern art, particularly that of China. The eighteenth-century scroll painting *Conversation in Autumn* by Hua Yan (1682–1756) (fig. 3.22) illustrates a Chinese prose poem of the eleventh century describing the landscape of autumn. The tall, distant mountains, compared to the foreground, are lacking in detail and covered in mist. The same is true of the tree branches, which are distinctly delineated in the foreground but merge into a mist and become less precise as they recede toward the rising mountain.

In late fifteenth-century Persian manuscript painting, the perspective system combines two- and three-dimensional spatial designs that shift according to color and pattern. In *Iskandar and the Seven Sages* (fig. 3.23), at least two different viewpoints are created. The scene illustrates an episode from the *Iskandanameh*, a narrative account of the life of Iskandar Sultan, who was a great patron of the arts. Politically, however, his rebellion in the early fifteenth century against the Timurid Shah Rukh (ruled 1409–1447) caused his downfall. He was blinded, and, in 1415, executed.

In the episode shown here, Iskandar wears a rich green robe and consults the seven sages as he is about to embark on a journey westward. He sits on a raised platform with three sages on his right and four on his left. Below,

the gatekeeper chats with two kneeling figures outside the palace. At the center, a soldier in red and green is talking with a man in blue holding an orange teapot, and at the far right a pair of figures seems absorbed in conversation.

We see the figures from a head-on viewpoint, but the architecture shifts so that we look down on the gray rug in front of Iskandar and on the bright-red roof of the palace. Thus, whereas in Donatello's *Feast of Herod* the architecture is structured according to a single, consistent viewpoint, the Persian space is dominated by vivid color and intricate patterning. Notice, for example, the strong color contrasts—red and green, blue and orange—that are opposites on the conventional color wheel (see fig. 3.12). In addition to the designs enlivening the carpets and architectural elements, the garden has the effect of a woven tapestry and the trees echo the linear quality of the Arabic script at the upper left.

3.23 Attributed to Bihzad, *Iskandar and the Seven Sages*, c. 1494–95. Illumination from a *Khamseh* of Nizami, Timurid, 9½ × 6⅔ in. (24.1 × 16.8 cm). British Library, London. OR.6810 214V.

ARCHITECTURE AS FORM AND FUNCTION

With architecture, buildings that organize and enclose space for a human purpose, we encounter additional challenges to reading imagery. Architecture is thus "useful" in a different, more "practical" way than pictures and sculptures. At the same time, however, buildings have styles consisting of the same formal elements as other works of art.

We now consider three examples of architecture—each from a different culture and time period—that serve very different purposes: the Egyptian pyramid, the Greek theater, and the Gothic cathedral.

The Egyptian Pyramid

The third-millennium-B.C. Egyptian pyramids at Giza (figs. 3.24 and 3.25), on the outskirts of modern Cairo, were numbered among the Seven Wonders of the Ancient World. As tombs, they were sealed, and, because they housed the deceased pharaohs, the pyramids were colossal in scale. The plan of the pyramid was a simple square with four triangular walls slanting inward. The walls met over the center of the square, forming a regular pyramidal shape. Made of limestone blocks that were precisely cut according to the advanced engineering techniques of ancient Egypt, the pyramid walls were originally smooth and the spaces between the blocks not visible. A layer of gold capped the peak of the pyramid, and gold descended the walls, resembling rays of light, which conveyed the pharaoh's identification with the sun god Re.

3.24 Pyramids of Khufu, Khafre, and Menkaure, c. 2500–2475 B.C. Limestone. Giza, Egypt.

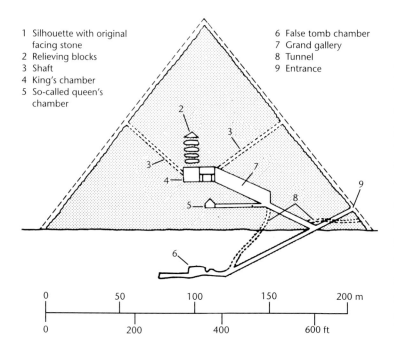

1 Silhouette with original
 facing stone
2 Relieving blocks
3 Shaft
4 King's chamber
5 So-called queen's
 chamber

6 False tomb chamber
7 Grand gallery
8 Tunnel
9 Entrance

3.25 (*above*) Diagram of the interior of Khufu's pyramid.

The Greek Theater

In contrast to the pyramids, the Greek theater was an open-air structure; its origins lie in the worship of the wine god Dionysos (fig. 3.26). These rites were conducted by a hillside and gradually developed into an established type of theater, first using only one actor and then expanding to three actors plus a chorus. Stone seats were constructed in ascending curves on the hillside and the space below was marked out for a stage. Actors entered from the sides, and painted scenery provided the backdrop for the play.

3.26 Theater at Epidauros, 4th century B.C. Stone, 373 ft. (114.0 m) diameter. Greece.

The Greek theater, like the Egyptian pyramid, benefited from a warm, dry climate. In Egypt, the belief in the necessity of preserving the physical body of the deceased was aided by the arid desert as well as by the way in which the pyramid was constructed and by the lengthy process of mummification. In Greece, mild weather facilitated the open-air character of the theater and evoked its association with the rites of Dionysos. The superior acoustics of Greek theater design has inspired similar types of theaters throughout the world, although many are now indoors.

The Gothic Cathedral

An entirely different purpose was served by the Gothic cathedrals we considered in the previous chapter. As a place of Christian worship, the medieval cathedral—like many smaller churches—was constructed on a plan shaped like a Latin cross (figs. 3.27 and 3.28), reminiscent of the Cross on which Christ was crucified. The entrance towers visually announced the presence of the cathedral, just as their monumental bells rang to summon the faithful. In contrast to the pyramid, which was designed to keep people out, the cathedral was designed to invite people in.

The generic plan in figure 3.28 illustrates the division of the longitudinal space into a central nave flanked by side aisles. These direct the visitor toward the far end of the building, past the transept (corresponding to the arms of the Cross) and into the ambulatory. From here, visitors continue around the chevet (the eastern end of the building, including the choir, ambulatory, and radiating chapels). This orientation is symbolic, for the site of the main altar in the east corresponds to the site of Christ's Crucifixion (outside of Jerusalem, to the east of Europe). The altar itself is a symbolic site; it alludes to the

3.27 View of Amiens Cathedral, 13th century. France.

table on which the Crucifixion and Resurrection of Christ are reenacted during Mass (the Eucharist).

To illustrate the elevation of the cathedral (that is, the organization of the building from the ground up), architects make cross sections, or section drawings. The section drawing of Amiens Cathedral (fig. 3.29) shows the tall central nave and shorter side aisles of the interior as well as the exterior supporting buttresses. The nave wall is divided into three levels; the nave arcade corresponds to the height of the side aisles. The second level is the triforium, and the upper level (the clerestory) is the main source of interior color and light.

Architects also make perspective drawings (fig. 3.30), which show the interior and exterior of a structure in a three-dimensional format.

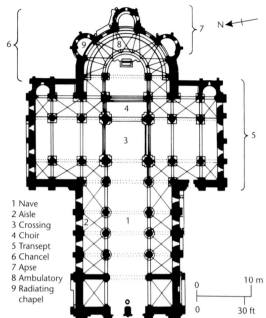

1 Nave
2 Aisle
3 Crossing
4 Choir
5 Transept
6 Chancel
7 Apse
8 Ambulatory
9 Radiating chapel

3.28 Generic diagram of a Latin-cross plan.

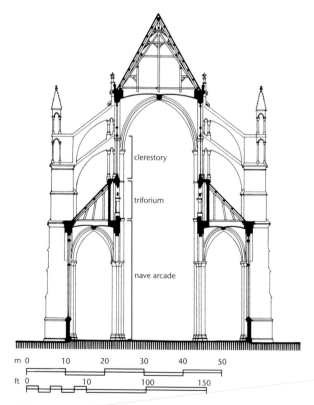

clerestory

triforium

nave arcade

3.29 Section drawing of Amiens Cathedral.

3.30 Perspective drawing of Chartres Cathedral.

1 Bay
2 Nave
3 Side aisle
4 Nave arcade
5 Clerestory
6 Cluster pier
7 Triforium
8 Buttress
9 Flying buttress
10 Wooden roof
11 Colonnette

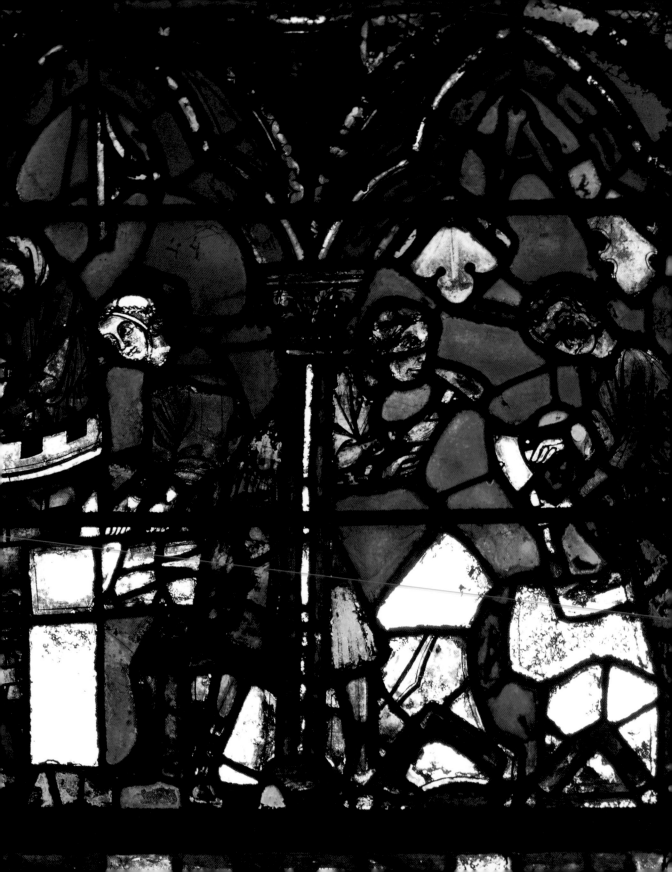

4

THE ARTIST AT WORK: CONVENTION AND TRAINING

A RTISTS WORK in both aesthetic and cultural contexts. This means that they are influenced by their time and place, and by the work of their contemporaries as well as of their predecessors. In this chapter, we consider two aspects of the artist's context—the aesthetic conventions of style and the nature of practical artistic training. Related issues include the artist's position in society and the way in which artists and their products are viewed.

Our ability to address such matters depends on what we know of a society—whether from artifacts, written records, or first-hand experience. The absence of a writing system in prehistoric cultures, for example, makes it difficult to be precise about the social or economic role of artists. Nor do we know much about their artistic training or even the purposes of the art they produced. It is generally assumed that our modern views of art and artists are relatively recent, and, as we shall see, perceptions have changed considerably over the course of Western history.

THE AESTHETIC CONTEXT: CONVENTION

The term *convention* refers to a standard way of doing things. In the West it is conventional for men to remove their hats when they enter a house;

OPPOSITE
Sculptors and Masons at Work,
c. 1220 (detail; see fig. 4.9).

in a traditional Japanese house, however, a man removes his shoes. In church, men are expected to remove their hats, whereas women keep their hats on. When two Western businessmen meet, they shake hands; in Japan, they bow. When introduced to the king or queen of England, a man bows and a woman curtsies, and no one turns his or her back on the monarch. And so on. We are familiar with such behavioral conventions, and we perform them automatically.

Convention, also an aspect of the visual arts, sets up specific expectations in the viewer and creates a common visual language shared by artists and viewers. In order to read certain images, it is necessary to be familiar with the conventions of style within which the artist is working. In the West, for example, white is a bridal color, but in China the bridal color is red. In China, white is the color of mourning, whereas in the West it is black. In order to make sense of a Chinese painting showing mourners, therefore, Westerners would have to know that the conventional color is white rather than black. And Chinese viewers of a Western wedding picture might mistake it for a funeral if they were unfamiliar with Western conventions.

Egypt

The royal arts of ancient Egypt were tightly controlled by conventional systems of form and proportion. As a result, the artist's personal preferences were largely subordinated to the requirements of convention. Consider the Nineteenth Dynasty vignette from a Book of the Dead (fig. 4.1). This shows Hapy, the god of the Nile, holding a palm rib, which is the hieroglyph for *year*. Hapy himself is a well-fed, slightly rotund blue figure. His blue color and wavy black lines allude to the waters of the Nile, and his corpulence refers to seasons of plenty caused by the annual flooding of the Nile.

The ancient Egyptians were not interested in creating three-dimensional illusions of naturalistic space. Instead, as with Byzantine art, the Egyptians preferred flat space as a sign of timelessness. Hapy sits on a thin black line, and the space that his body would occupy in reality is not indicated.

In Egypt, certain conventions of pictorial representation, such as a figure's pose, were derived from hieroglyphs. Hapy's head is rendered in profile, but the eye, like the hieroglyph for the eye, is frontal. Hapy's shoulders and chest are also frontal, which affords us a clear view of his elaborate necklaces. His legs, like those of the standing figure, are in profile. Thus the parts of the body are not in a natural, organic relation to each other, but are represented as we conceive of them individually. The only indication of depth

4.1 Vignette from Any's Book of the Dead, Nineteenth Dynasty, c. 1250 B.C. Painted papyrus, 3⅞ in. (10.0 cm) high. British Museum, London.

in this painting is through overlapping of form. Hapy's right arm overlaps his torso and appears to be in front of it. The absence of a left leg can be attributed to the fact that it is behind the right leg and, therefore, blocked from view.

Another convention of Egyptian painting (and relief sculpture) is shifting perspective. Not only does our viewpoint shift between the individual parts of a whole, but it also shifts from one area of the painted field to another. We see Hapy from the side, but we see the small rectangular pools of water from a bird's-eye view. These multiple viewpoints flatten space and contribute to the timeless quality of Egyptian art.

The Egyptians achieved the static, rectilinear character of their art, particularly royal and ritual art, by the use of grids. Because these were used primarily in the planning stages of a work, most grids have disappeared, although some survive on unfinished paintings and reliefs. Adherence to the grid reinforced the persistence of convention for over three thousand years and provided a system whereby if one artist left a work unfinished, a successor could continue the work according to established convention.

The diagram in figure 4.2 has been reconstructed from a Twelfth Dynasty relief containing traces of the original grid. It shows the conventional

4.2 Example of an Egyptian grid.

proportions for a standing male, which are indicated by the relationship of the parts of the body to the squares on the grid. Vertically, there are 18 squares from the feet to the hairline just above the eyebrow; this is because crowns and wigs could alter the proportions arbitrarily and, therefore, were not included in the grid. The shoulders are 6 squares across, tapering to 2½ squares at the waist, which corresponds to the small of

4.3 *Menkaure and Queen Khamerernebty*, from Giza, c. 2548–2530 B.C. Slate, 4 ft. 6½ in. (1.39 m) high. Museum of Fine Arts, Boston.

the back. Legs, not including the feet, were generally 5 squares long. They are slightly wider than the arms which are 1 square wide. The fist usually fits into a single square, while the feet are 3 squares or slightly more than 3 squares across. The pose corresponds to the conventions followed in the painting of Hapy: profile head, frontal eye and shoulders, profile from the waist down, and clenched fists.

In the monumental sculpture of ancient Egypt, the presence of the grid is also felt in the shape and proportions of the finished work. The Old Kingdom statue of the pharaoh Menkaure and his queen Khamerernebty, for example, remains attached at the back to the original rectangular block of stone (fig. 4.3). The king's shoulders are broad and squared; he steps forward with his left leg, clenches his fists, and gazes straight ahead. The queen is more curvilinear; she places one arm around the king, her garment reveals her form, her extended foot is behind the king's, and she herself is slightly shorter than he. These conventional differences between each member of the royal couple indicate the relatively greater importance of the king compared with the queen. In addition, it was conventional in Egypt to use hard stone—in this case, black slate—for royal figures as a metaphor for their enduring power.

The Canon of Polykleitos

In the Archaic period (seventh–sixth centuries B.C.), the Greeks learned from the Egyptians how to carve monumental stone sculpture. But they soon evolved a new approach to the human figure. In other words, the conventions of Egyptian art were appropriated by the Greeks, who then developed their own conventions of style. During the Classical period (450–400 B.C.), the sculptor Polykleitos wrote a treatise, called the *Kanon*, in which he advanced his theory of *symmetria*, or symmetry. Although the *Kanon* itself has not survived, it is known to have proposed an ideal system for representing the parts of the human body in relation to the scale of the whole. Possibly derived from the philosophy of Pythagoras, who believed that numerical relationships explained the harmony of the universe, Polykleitos's canon was embodied in his bronze statue *The Doryphoros*, or *Spear Bearer* (fig. 4.4).

4.4 Polykleitos, *Doryphoros* (*Spear Bearer*), Roman copy of a bronze original, c. 450–440 B.C. Marble, approximately 6 ft. 11½ in. (2.12 m) high. Museo Archeologico Nazionale, Naples.

Today the work is known only in marble Roman copies, which required support that had not been necessary in the lighter bronze original. But even in the copy, the *Spear Bearer* retains the transitional harmony of stance and movement for which it was celebrated in antiquity. An idealized youth without blemish, expression, or personality, the figure leans on a spear, relaxes his weight, and at the same time seems to be taking a step. The head turns to the right, while a gradual curve bisects the torso, flowing into the static right support leg. Every feature of the statue seems to form a perfect unity with the whole. Repose and motion, tension and relaxation work harmoniously; and this harmony, together with the idealized forms, has made the statue one of the most influential images in the history of Western art. In the *Spear Bearer*, Polykleitos created a work that corresponds literally and figuratively to the Pythagorean maxim "Man is the measure of things."

Polykleitos's statue resonated with the tastes of his time and place, and has become an icon of aesthetic perfection associated with the Classical style. To some degree, it may be said that the notion of Classical has tyrannized Western art. On the other hand, however, classicism has also provided something of a springboard against which many artists rebel in their search for innovation.

The Persistence of Classical

A good example of the effort to rebel against the Classical ideal and its conventions of representing the human figure can be seen in Picasso's disruptions of the harmonious—and expected— relationships between parts of the human body. As with other artists of his generation, Picasso turned to African (and Egyptian) sculpture both for inspiration and for liberation. By studying and collecting objects from non-Western cultures, Picasso and his contemporaries hoped to achieve new kinds of form. We can see this by comparing Picasso's 1923 portrait of Sara Murphy, entitled *Woman in White* (fig. 4.5) and painted during his so-called Classical period, with the 1939 portrait of his friend and biographer Jaime Sabartés (fig. 4.6).

As is typical of his "Classical" works, Picasso idealized Sara Murphy, altering her upturned nose to resemble the profile of a Greek statue. Her dress, as with Classical Greek garments, falls over her form and defines it. In contrast, Jaime Sabartés, as rendered sixteen years later, no longer conforms either to Classical idealization or to the canonical (or natural) relationships of parts to each other and to the whole. His features zigzag back and forth from one side of his face to the other in defiance of the symmetry achieved by Polykleitos. The result is eyes at the right of the head, nose at

4.5 (*left*) Pablo Picasso, *Woman in White (Sara Murphy)*, 1923. Oil on canvas, 39 × 31½ in. (99.1 × 80.0 cm). Zervos V, I. Metropolitan Museum of Art, New York.

4.6 (*below*) Pablo Picasso, *Jaime Sabartés*, October 22, 1939. Oil on canvas, 18½ × 15 in. (45.7 × 38.0 cm). Zervos IX, 366. Museo Picasso, Barcelona.

the left, chin below and to the right of the lips, and glasses balanced on the cheek instead of on the bridge of the nose.

Despite repeated efforts by artists to dethrone the Classical tradition and its conventional proportions, however, classicism has a way of reasserting itself. In 1972, for example, the American Photo-Realist sculptor Duane Hanson created *Artist with Ladder* (fig. 4.7), the pose of which echoes that of the *Spear Bearer*. Hanson molded the parts of the body separately and then, in contrast to Picasso's portrait of Sabartés, assembled them into a natural relation to each other. He painted the figure, added hair, and dressed it in real clothes splattered with paint. Hanson's figure is shown leaning on a ladder rather than on a spear, with the relaxed leg resting on the ladder's lowest step. In the relaxed right hand, the figure holds a spray can.

4.7 Duane Hanson, *Artist with Ladder*, 1972. Polyester resin polychromed in oil, life-size.

Of course, Hanson's assimilation of the Classical tradition also alters it somewhat. His figure is more specific than the *Spear Bearer*, having an expression, an identifiable profession, and an outfit suggesting that he is taking a break from a paint job. In contrast to the *Spear Bearer*, Hanson's artist is in a static pose, seemingly tired, and has slightly disheveled hair. The mask has been temporarily removed as if to give the figure a chance to breathe freely. In *Artist with Ladder*, Hanson has created a witty visual comment on the Classical tradition, while also reconfiguring it in the idiom of the American Photo-Realist style of the 1970s. He has retained aspects of the Classical tradition, using the conventional Classical stance denoting relaxation. The humor of Hanson's statue resides in the superimposition of a specific modern personality onto a culturally recognized convention of the male ideal.

THE CULTURAL CONTEXT: HOW ARTISTS LEARN

Today we have art schools. But this was not always the case. Nevertheless, throughout history, artists in the West have been trained to pursue their profession. Traditionally, artists learned as apprentices to older artists, joined guilds, entered family workshops, worked in convents and monasteries, and studied in academies. In nineteenth-century Europe, after the French Revolution (1789), certain artists began to break with traditional training methods, especially as court patronage declined. They turned to old-master paintings in museums and to the natural and urban landscapes around them for inspiration. In Paris and later in New York, the more progressive artists, most of whom had had formal academic training, gathered privately to exchange ideas.

Artists in antiquity were celebrated in their own day, and they, in turn, were entrusted with the task of celebrating cultural heroes—such as victorious athletes—by creating statues of them. When the first-century-A.D. Roman

author Pliny the Elder wrote his compendium of natural history, he included accounts of individual artists and their works. In the Early Christian period (fourth–sixth centuries) and during the Middle Ages (seventh–thirteenth/fifteenth centuries), biographies of saints supplanted accounts of artists. As a result, whereas the names of quite a few medieval artists are known, we have very little biographical information about them. In the Middle Ages, artists were thought of as craftsmen, and tax records indicate that they were paid accordingly.

Guilds and Monasteries

Medieval artists worked for two main patrons: the courts and the Church. A few artists became "familiars" (*familiares*), or members of the household, at certain courts, a position of privilege earned by their talent. Some were appointed to the position of official court artist. Those working under Church patronage included the sculptors, painters, and makers of stained-glass windows engaged on cathedral projects. Others were monks or nuns illuminating manuscripts—that is, illuminating the Word of God—in the *scriptoria* of monasteries and convents. Figure 4.8 shows the twelfth-century monk Eadwine painting a page of the *Canterbury Psalter*. He holds a pen in one hand and a brush in the other, indicating that he wrote and illuminated the psalter himself. The elaborate architecture of his chair and the domes in the upper corners of the picture stand for the Church building and reflect the notion that texts comprise a foundation on which the Church is built.

Outside the monasteries, especially during the Romanesque and Gothic periods, an enormous amount of artistic activity revolved around the construction of huge cathedrals, which brought economic prosperity to their towns. These projects employed thousands of workers under the control of a master mason, or supervising architect. As craftsmen, most of the workers belonged to a guild—an association of workers, similar to a modern trade union, organized to establish and uphold standards of workmanship and to regulate salaries and working conditions. Guilds also protected workers in times of unemployment and contributed to the support of their families when they died.

4.8 *Eadwine Painting*, mid-12th century. Illumination, *Canterbury Psalter*, MS. R. 17.1, fol. 283v. Trinity College, Cambridge, England.

4.9 *Sculptors and Masons at Work*, c. 1220. Stained-glass window. Chartres Cathedral, France.

Figure 4.9 is a detail of a stained-glass window from Chartres Cathedral (see fig. 2.11). It is known as a Guild signature window because it records the professional activity of guilds that worked on the building. At the left, builders work on sections of a wall; to the right, sculptors carve doorjamb statues. To a large extent, the medieval artist's identity was subsumed by his craft and by the guild to which he belonged.

Among the artists, the highest status was accorded the master masons, and this increased during the Gothic period. Since it generally took a long time to complete a cathedral, more than one master mason might have been in charge of a project. In order to facilitate the succession as well as to insure a consistent style, medieval builders used templates. These served a purpose similar to the Egyptian grids—that is, the templates permitted a smooth stylistic transition from one mason to another and also maintained conventional usage.

Guilds persisted into the sixteenth century, and most artists learned their trade through a system of apprenticeship. But the evolution from Gothic to Renaissance (c. 1150–1550) brought with it new ideas about the status of the artist. With the rise of humanism, an intellectual movement in which ancient Greek and Latin texts were revived and translated, the literacy rate increased, and a Classical curriculum was developed in the most progressive schools. Artists began to have a different sense of themselves; they signed their works, wrote autobiographies (which was consistent with an increase in self-portraiture), and became educated in the manner of intellectuals and gentlemen. More and more, the artist was the intellectual equal of the patron, and some artists advocated the elevation of art

to the status of a Liberal Art. By the end of the Renaissance in Italy, with Vasari's *Lives*, the cult of the "divine" artist had evolved.

Academies

One of the most significant developments in elevating the artist from the status of a craftsman to that of a gentleman was the establishment of academies. Modeled on Plato's informal academy of fourth-century-B.C. Athens, these were conceived as a more intellectual training ground than apprenticeship. The origins of the academy can be found in the Company of Saint Luke (who was believed to have been a painter and to have depicted the Virgin during her lifetime). Established in Florence in 1361, the Company of Saint Luke was a confraternity of artists that included women as well as men.

In 1616, the Company of Saint Luke became the Florentine Academy of Design, which inspired the establishment of the Roman Academy. The latter was emulated by academies throughout Europe. In 1648, Jean-Baptiste Colbert, chief minister to Louis XIV, founded the French Royal Academy of Painting and Sculpture with a view to subjecting artists to state control. Louis XIV's view of absolute monarchy inspired the assertion "L'état, c'est moi!" (I am the state!) and was reflected in the Academy's insistence on strict conventions of style and content. A hierarchy of subject matter was established, with Christian content at the highest level. Next, in descending order, were history painting, portraiture, genre, landscape, and still life. Students drew from plaster casts of ancient statues as a means of absorbing the prevailing ideal based on Classical and classicizing Renaissance style.

At the court of Louis XIV—as at courts throughout history—the arts functioned in the service of the state. And in seventeenth-century France, the state was inseparable from the person of Louis himself. In 1665, Bernini carved a marble bust of Louis XIV (fig. 4.10) with a view to linking him to two traditions of royal portraiture. One was the association with the sun that derived from ancient Egypt, where the pharaoh was conceived of literally as the sun god on earth. Bernini has achieved this by the way in which Louis' smooth face seems to shine forth from the heavier

4.10 Gianlorenzo Bernini, *King Louis XIV*, 1665. Marble, life-size. Versailles.

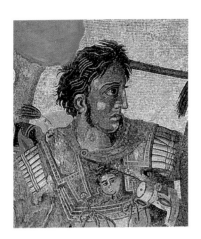

Battle of Issos, 2nd century B.C.
(detail; see fig. 2.7).

mass of deeply carved curls cascading from the top of his head to below his shoulders. Identification with the sun also projected Louis' political image as "le roi soleil" (the sun king). As such, Louis was implicitly associated with Christ and, in the decoration of his palace at Versailles and in the design of its park, explicitly with Apollo, the Greek sun god. In theatrical performances regularly held at court, Louis also danced the role of Apollo.

The other tradition on which Bernini drew for his bust of the French king was royal portraiture of antiquity, which was based on images of Alexander the Great. Well aware of the taste for Classical imagery at Louis' court, Bernini used the portrait type of Alexander evident in the *Battle of Issos* (see fig. 2.7). Bernini has endowed the king with the energetic movement, flowing hair, and dynamic character of the Hellenistic conqueror. And this, together with the solar associations of Louis, projects an image of a beneficent, life-giving, but absolute monarch, a warrior and a king endowed with the divine status of ancient rulers.

Bernini himself exemplifies the heights to which great artists could rise, following their emergence from the guilds and the establishment of the academies. The son of a minor artist with good connections, Bernini was able to gain the patronage of the Vatican and its highest officials, of aristocratic families, and of the powerful French court. His genius was recognized during his lifetime, and he grew wealthy and influential.

Eventually, what had begun as a means of liberating artists from the status of crafts workers became restrictive. In the course of the nineteenth century, especially in France, modernist artists began to rebel against the aesthetic principles of the Academy and its system of training. From around 1822 to 1824, the French painter Théodore Géricault (1791–1824) wrote a resounding critique of the French Academy and its effect on artists. Its schools, he asserted,

keep their students in a state of constant emulation by means of frequent competitions. ... I observe with regret that, from the time of their establishment, these schools have had a quite unforeseen effect: instead of giving service, they have done real harm, for while they have produced a thousand mediocre talents, they cannot claim to form the best of our painters. ...

The man of true avocation does not fear obstacles, because he feels in himself the strength to overcome them. Often they are an additional stimulus to him. ...

I shall go even further and assert that obstacles and difficulties which repel mediocre men are a necessity and nourishment to genius. ... The Academy, unfortunately, ... extinguishes those who, to begin with, had a spark of the sacred fire; it stifles them by keeping nature from developing their faculties at its own speed. By fostering precocity, it spoils the fruit which would have been made delicious by a slower maturation.[1]

THE CULT OF BOHEMIA AND THE ARTIST AS REBEL

From the second half of the nineteenth century, artists expanded subject matter to include the broad panorama of contemporary society; they also began to experiment with new approaches to light, color, and form. By the latter part of the nineteenth century, rebellion against the Academy became associated with a rejection of classicism and led to the early twentieth-century modernist notion of the avant-garde.

The most innovative artists from around the 1850s in France were responsible for the evolution of the so-called cult of Bohemia. Rejected by the French Academy, which set prevailing taste in art, the artists who worked in the Impressionist and Post-Impressionist styles created an informal community apart. The notion of the bohemian artist, one who is outside the bourgeois norm, begins with the Impressionist painters in Paris, who regularly gathered at the Café Guerbois in the artists' quarter of Montmartre.

If we compare Claude Monet's *Interior of Saint-Lazare Station* of 1877 (fig. 4.11) with David's *Napoleon at Saint Bernard Pass* (see fig. 2.15), we are struck by the differences in both subject matter and style. In the tradition of equestrian portraits of Roman emperors, David's picture idealizes the emperor, who was also his patron. Napoleon is shown as an exalted, triumphant warrior, and he is depicted in a clear, Neoclassical style. The paint itself strikes us less than what it portrays—namely, the simulated textures of Napoleon's uniform, the sheen of the horse's coat and mane, and the hazy details of a distant army hauling cannons up a hill.

Monet's picture represents an everyday scene, one that reflects the advances in industry that were changing the face of urban life. There is no attempt on Monet's part to glorify a ruler, to revel in the fabrics of aristocratic dress, or to create the precise edges

Jacques-Louis David, *Napoleon at Saint Bernard Pass*, 1800 (see also fig. 2.15).

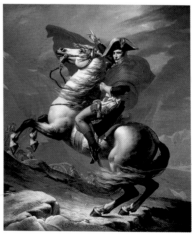

4.11 Claude Monet, *Interior of Saint-Lazare Station*, 1877. Oil on canvas, 29¾ × 40⅞ in. (75.5 × 104.0 cm). Musée d'Orsay, Paris.

and clear form preferred by academic, Classical, and Renaissance artists. The railroad station has supplanted the triumphal arch, replacing it with steam billowing from the smokestack of the iron engine. The absorption of light and color by modern pollution has entered the vocabulary of painting. In addition, the textures of depicted objects are now subsumed by the paint, which has become manifest to the viewer.

And what of the status of the artist? The Impressionists and Post-Impressionists who did not come from wealthy families suffered financially. Rejected by official French juries, these artists were finally permitted, under a special decree of Napoleon III, to exhibit in the so-called Salon des Refusés (Salon of the Rejected Artists). But they were not popular with the general French public and, in the absence of official patronage, had difficulty making ends meet. Artists now had to rely on new sources of patronage—dealers and private collectors—which could be hard to come by.

THE ARTIST AS INDIVIDUAL: JACKSON POLLOCK

The innovations of Impressionism and Post-Impressionism set the stage in the twentieth century for further expansion of subject matter, experimentation with the visible nature of paint, and new approaches to the picture surface. By the 1950s, paint itself had become a subject of art, and modes of applying paint were associated with particular artists. The prevailing style in which these features were most thoroughly explored is Abstract Expressionism, which developed in New York City in the 1940s and 1950s—hence the designation "New York School." But Abstract Expressionism, like nineteenth-century "Bohemia," was not a school or even a locale in the formal sense. It was an artistic movement in which Europeans emigrating to the United States during World War II influenced American-born artists with new approaches to painting and sculpture. The New York School was a community of artists without institutional patronage and with very little private patronage. These artists had both the advantages and disadvantages of an artistic freedom that was new to the twentieth century.

Taking as an example the American painter Jackson Pollock (1912–1956), we follow the stylistic evolution of a twentieth-century artist who had some formal art schooling and found his own visual voice in his famous "drip" paintings. We consider four works from different periods of his development. But first, something of his background.

Paul Jackson Pollock was born in Cody, Wyoming, the fifth son of a stone mason and cement worker. The family moved to San Diego when Jackson was ten months old, and he grew up in California and Arizona. He attended the Manual Arts High School in Los Angeles, from which he was expelled several times. In September 1930, he moved to New York and enrolled at the Art Students League, where he studied for two years with the American Regionalist painter Thomas Hart Benton (1889–1975).

It was the midst of the Depression, and Benton extolled America as subject matter. He was best known for his large-scale mural paintings depicting regional aspects of American life. In *Mural No. 2, Arts of the West* (fig. 4.12), Benton shows a series of lively vignettes juxtaposed in a single space. Cardplayers, musicians, dancers, and two men roping horses are dominated by a figure aiming his rifle toward the left of the picture. Increasing the dynamic tension of the work is the tilted ground plane that compresses space even as it creates a strong sense of foreground and background.

4.12 (*above*) Thomas Hart Benton, *Mural No. 2, Arts of the West*, 1932. Tempera glazed with oil, 7 ft. 5 in. × 13 ft. 3⅛ in. (2.26 × 4.04 m). New Britain Museum of American Art, Connecticut, Harriet Russell Stanley Fund.

4.13 (*right*) Jackson Pollock, *Camp with Oil Rig*, 1930–33. Oil on gesso board, 18 × 25⅜ in. (45.7 × 64.5 cm).

Benton had studied in Europe before World War I and became interested in the dynamic use of color and line, which was to influence Pollock throughout his career. Pollock's early *Camp with Oil Rig* of 1930–33 (fig. 4.13) has a Regionalist quality in that it depicts a recognizably American setting. Rather than having the illustrative and optimistic character of Benton's Regionalism, however, this work is imbued with the desolation that swept America in the 1930s. The stark presence of the rig, the houses, and the pickup truck accentuates the absence of human figures. These man-made structures stand deserted and idle, a metaphor for workers out of work and the economic despair of the Great Depression. The undulating color-as-line envelops the picture plane in a swirl of formal motion that ironically belies the scene's inactivity.

During the later 1930s, Pollock came into contact with avant-garde developments entering America from Europe, including Cubism, Surrealism, and Expressionism. Consistent with the Surrealist interest in unconscious phenomena, he also underwent a Jungian psychoanalysis. In 1942, Pollock painted *The Moon-Woman* (fig. 4.14), which reflects the influence of mythic imagery and the modernist search for liberation from the figure. In the black face of the Moon Woman, it is possible to discern the ancient Egyptian convention of combining a profile head with a frontal eye that was also adopted by Picasso. But Pollock animates the surface with thick brushstrokes, sinuous lines of color, and small elements that have the quality of secret signs. As in a dream, we have the impression that the signs may be readable; but on closer inspection, we find that they elude our comprehension. The figure itself seems to dissolve into the textured paint and to merge with the rich colors of the surrounding imagery.

Surrealism and psychoanalysis originated in Europe, and both movements influenced the Abstract Expressionists. The Surrealist and psychoanalytic interest in automatic writing—that is, writing without editorial control (note the psychoanalytic instruction to "say whatever comes into your mind")—influenced Pollock. At that point, his famous all-over drips took the art world by storm, giving rise to both critical praise and hoots of ridicule.

4.14 Jackson Pollock, *The Moon-Woman*, 1942. Oil on canvas, 69 × 43 in. (1.75 × 1.09 m). The Solomon R. Guggenheim Foundation, New York. Peggy Guggenheim Collection, Venice. 1976 76.2553.141.

4.15 Jackson Pollock, *Number 13A, 1948: Arabesque*. Oil and enamel on canvas, 37½ in. × 9 ft. 8½ in. (0.95 × 2.96 m). Gift of Richard Brown Baker, Yale University Art Gallery, New Haven.

In *Number 13A, 1948: Arabesque* (fig. 4.15), Pollock dispenses with figuration and narrows the picture's depth to the actual space of paint and canvas. He develops the undulating line and rich color of Thomas Hart Benton and his own earlier works beyond representation. On a rust-colored background, he has superimposed swirls of exuberant black, white, and gray lines that seem to dance across the surface of the picture. Hence the title *Arabesque*, which evokes both the movements of dance and the curvilinear patterns of Islamic design.

Pollock's technique in creating such works is by now well known—it has been described, photographed, and filmed from various angles. He placed the canvas on the ground and, using a stick or a stiff brush, dripped or poured house painter's paint onto the canvas as he moved around it. In some places, he also spattered the paint, creating individual drops, and in others he spread out the paint to make irregular patches of color. The motion of the artist's body is thus integrated with the work, and the energy of the color lines reflects the action of his arm and hand. The very action of the artist in applying paint to canvas gave rise to the term *action painting* that characterizes the gestural painters of Abstract Expressionism. The result in Pollock's case is an image of expansive elegance, a kind of calligraphy without text that seems a logical development of the rougher, graffiti-like line of *The Moon-Woman*.

After 1950, having created a body of work that eliminated figuration, Pollock returned to embedding figures in his swirling lines. He produced a group of black paintings, primarily executed in black lines on a white ground. His technique remained the same, with the addition of basting syringes to squirt the paint onto the canvas. In *Portrait and a Dream* of 1953 (fig. 4.16), executed three years before his death in a car crash, Pollock created a diptych (two-part painting) juxtaposing black lines with a colorful embedded face. The face, although quite general, has been read as that of the artist,

and it does indeed resemble one of Pollock's early self-portraits. It might even be possible to discern elements of a human body in the black image, but, as in dreams and the signs surrounding Moon Woman, it eludes our grasp. The black image corresponds to the unformed and unstructured character of unconscious thinking, whereas the face, like verbal associations to dreams, is structured in conscious language.

Pollock was well aware of the dichotomy between conscious and unconscious thinking and of their interplay in creating art. In an interview in 1956, the year of his death, Pollock said:

> I'm very representational some of the time, and a little all of the time. But when you're painting out of your unconscious, figures are bound to emerge.[2]

Pollock's career exemplifies the myth as well as the reality of the struggling American artist during the first half of the twentieth century, and it also resonates with the lives of significant artists of the past. Like most talented artists, Pollock had some formal training and a good art teacher who took an interest in his work and influenced him. And, like the greatest artists, he surpassed his teacher and went on to develop an important and innovative individual style. He did so without institutional patronage (aside from his work for Roosevelt's Works Progress Administration (WPA), but he worked within the self-imposed context of the New York School of Abstract Expressionism.

4.16 Jackson Pollock, *Portrait and a Dream*, 1953. Oil on canvas, 58⅛ in. × 11 ft. 2½ in. (1.48 × 3.42 m). Dallas Museum of Fine Arts, gift of Mr. and Mrs. Algur H. Meadows and the Meadows Foundation, Inc.

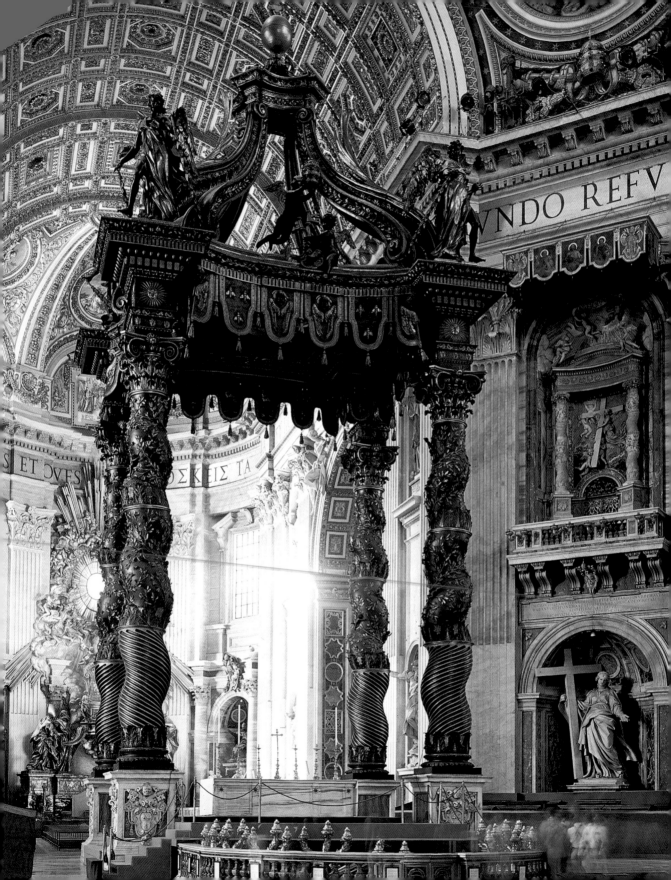

5

THEMES
OF ART

ALTHOUGH, as we have seen, artists work in cultural and aesthetic contexts, there is nevertheless a persistence of themes that transcend such boundaries. This persistence, it seems, must be attributed to the human condition and to certain preoccupations that appear in many, if not all, cultures. We are thus not surprised to find that images of gods and rulers are produced in very different societies. Likewise in architecture, certain structural systems such as the arch and the column persist cross-culturally, although their individual elements may vary. Even pure geometric forms such as the circle, square, and triangle can have similar meanings in diverse contexts.

In this chapter, we consider three types of artistic themes: formal, structural, and iconographic. Our formal theme will be the circle, our structural theme will be the column, and our iconographic themes will be twofold—the mother/child relationship on the one hand, and the death of the artist on the other.

THE DIVINE CIRCLE

Throughout the world's cultures, the circle has been associated with divine space and endowed with sacred meaning. One reason for this is the fact that circles have no beginning and no end, which makes them seem eternally continuous. In addition, the sun and moon, which were viewed as gods in the ancient world, appear to be perfect circles. The ancient Greek

OPPOSITE
Gianlorenzo Bernini, baldacchino, 1624–33 (see also fig. 5.17).

5.1 Calendar Stone, Tenochtitlán, Mexico, c. 1502–20. 11 ft. 10 in. (3.60 m) in diameter. Museo Nacional de Antropología, Mexico City.

philosopher Pythagoras, to whom is attributed the maxim "Man is the measure of things," argued that the harmony of the universe was based on regular shapes such as the circle and the square. Plato believed that the circle was the ideal shape because it was imbued with divine qualities. He discussed the beauty inherent in symmetry and proportion, which he related to the perfection of human proportions. The Greek oracle at Delphi was known as the *omphalos*, or navel, of the world, conveying the notion of centrality and a natural affinity for formal regularity and symmetry.

The cosmic associations of the circle and its relation to time are reflected in the great sixteenth-century Calendar Stone of the Aztec Mexica (fig. 5.1). The face at the center has been variously identified as the daytime sun, the night sun, and a dangerous female earth monster. It is represented frontally with the four dates of previous world destructions in pictorial form. The central image is the date of the final destruction, when the sun is destined to crash down on the earth (hence its reading as both the sun and the earth). Around the face are several sets of circles with symbols—the twenty days of the calendar, serpents, and glyphs signifying important Aztec dates. These include the name of Montezuma II and the date marking the onset of the Aztec migrations. The Calendar Stone is thus a cosmic representation of time according to Aztec myth and, as with sundials and clocks, is given concrete form as a circle.

Another example of the circle in relation to time and cosmic order can be seen in Buddhism. In 537 B.C., the Indian prince Siddhartha attained enlightenment during a period of meditation and became the Buddha. When he preached his first sermon at the Deer Park in Sarnath, he set in motion the Wheel of the Law (the *Dharmachakra*), denoting both a new philosophical order and a way of life based on truth.

A number of Western philosophers have also taken the circle as a metaphor for time and history. Vasari used a similar image to explain the decline of the visual arts at the end of the Roman Empire. "Fortune," he wrote in his preface to the *Lives*, "when she has brought men to the height of her wheel, is wont, whether in jest or in repentance, to throw them down again."[1]

In the Middle Ages in Europe, the entire universe was conceived of as a circle that God drew with a compass (fig. 5.2). In Gothic architecture, the notion of the divine circle is embodied in the huge round rose windows over the main portals of cathedrals. The north rose window at Chartres (fig. 5.3), over 42 feet in diameter, conveys the monumental power of the circle as a form. It is combined with other regular shapes arranged in sets of twelve around the center, reinforcing the sense that a compass was used in creating the design.

The small central glass circle contains an image of the seated Virgin Mary with the infant Christ on her lap. Appearing to radiate from this circle and to revolve around it are five sets of twelve shapes that lead the eye toward the large outer circle. They contain images that allude to the coming of Christ—the dove of the Holy Spirit, ancestors of Christ, and Old Testament prophets. Being twelve in number, these shapes also signify the twelve apostles, who surrounded Christ during his lifetime. The ring of fleurs-de-lis in quatrefoils (the four-leaf-clover shapes) refers to the French royal family and to the fact that the queen mother, Blanche, financed the window.

Five tall lancet windows below the rose window function visually as supports, containing depictions of Christ's precursors. The rose window seems to float above them, like a halo crowning the head of a divine personage. In the central lancet, Saint Anne carries the infant Mary, and on either side are Old Testament kings and priests, David and Melchizedek to the left and Solomon and Aaron to the right. The arrangement of these windows and their imagery projects the Christian conception of a divine plan in which the Old Testament and the time before Christ were a foundation and forerunner of the New Testament. The divinity of Christ (and of Mary) is reflected both in the grand design of the Christian universe and in the circular arrangement and subject matter of the cathedral rose windows.

5.2 *God As Architect (God Drawing the Universe with a Compass)*, mid-13th century. Illumination from the *Bible moralisée*, Reims, France, fol. 1v, 8⅓ in. (21.2 cm) wide. Österreichische Nationalbibliothek, Vienna.

5.3 Rose window and
lancets, c. 1220. Stained
glass. North transept,
Chartres Cathedral, France.

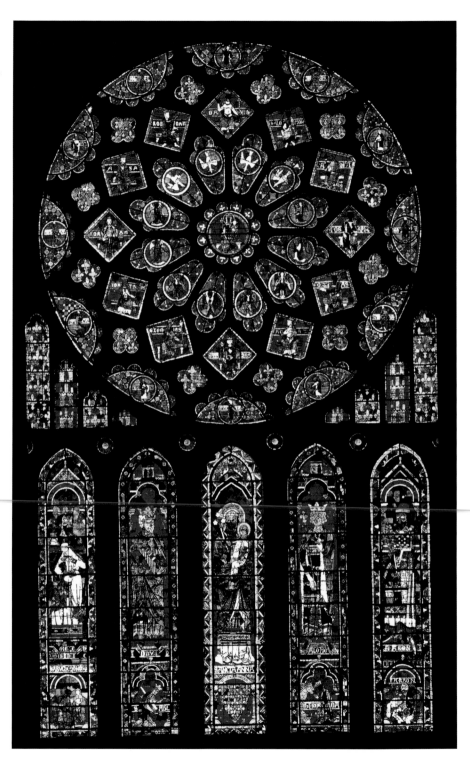

During the Italian Renaissance, as in ancient Greece, man was conceived of as the center of the universe because his form and character were endowed with a divine dignity. Leonardo's drawing *Vitruvian Man* (fig. 5.4) illustrates the observation of the Roman architect Vitruvius that if a circle is drawn around a man whose arms and feet are extended to the circumference, his navel will coincide with the center of the circle. The drawing also shows that the same relation of center to edge occurs in a square. By such associations to regular shapes, especially the circle, man was considered a reflection of cosmic harmony. It is interesting to note, in this connection, that the human field of vision is itself a circle, a fact that reinforces our natural identification with circular form.

In the early fourteenth century, at the dawn of the Renaissance in Italy, Vasari reports that the celebrated fresco painter Giotto di Bondone (c. 1267–1337) received a visit from a messenger sent by Pope Benedict IX. In his search for the greatest living artist, the pope wanted a work from every painter. On learning this, Giotto took a piece of paper and a brush dipped in red paint, stiffened his body, extended his arm, and drew a perfect circle. He gave it to the astonished messenger, who delivered it to the pope. When the pope saw the circle, he recognized Giotto's genius, brought him to Rome, paid him 600 gold ducats, and lavished honors on him.

A subtext of this anecdote is the dignity of the artist in relation to his work. In drawing the circle, Giotto replicates the action of God in the medieval manuscript illumination (cf. fig. 5.2), heralding the High Renaissance notion of the divine artist. By making his body a compass capable of drawing a perfect circle, Giotto exemplifies the Pythagorean maxim and becomes his own instrument of draftsmanship. Vasari notes that this incident became the source of the proverb "You are rounder than Giotto's 'O,'" which had a double meaning—"tondo being used in Tuscany, both for the perfect shape of a circle and for slowness and grossness [referring to the mesenger] of understanding."[2]

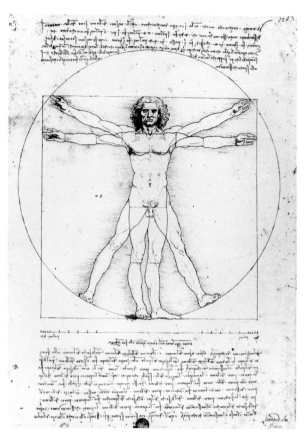

5.4 Leonardo da Vinci, *Vitruvian Man*, c. 1485–90. Pen and ink, 13½ × 9⅝ in. (34.3 × 24.5 cm). Gallerie dell'Accademia, Venice.

5.5 Aerial view of
Stonehenge,
c. 3000–1500 B.C. Stone,
diameter of cromlech:
c. 97 ft. (29.6 m). Salisbury
Plain, Wiltshire, England.

THE CIRCLE AS A SIGN OF BURIAL

Throughout Western history, circular form defines the memorial quality
of certain burials. One of the most impressive expressions of this from the
early Neolithic era are the cromlechs, or circles of stones, that dot the British
Isles and other parts of northern Europe. The most famous cromlech is Stone-
henge (figs. 5.5 and 5.6), located on Salisbury Plain in Wiltshire, England.

Stonehenge

Built over a period of some twelve hundred to fifteen hundred years by
the Men of Wessex, who inhabited southwestern Britain in the Neolithic era,
the original site of Stonehenge was chosen around 3000 B.C. This con-
sisted of a circular earth mound showing evidence of burials. As in other
Neolithic burials, skeletons were arranged in a fetal position facing east, the
direction of sunrise, which suggests a belief in rebirth. The mound was marked
out on a flat expanse of plain devoid of hills and trees, indicating the
original importance of the site. Recognizing this, the British government has
declared Stonehenge a national monument and has preserved an uninter-
rupted view of the structure.

Added to the circular mound in the later Neolithic period was a central cromlech, which conforms to the original shape of the mound. The cromlech is constructed of an outer ring of upright megaliths (large stones) attached by a series of horizontal lintels placed on top of them. Inside the outer ring is a horseshoe-shaped wall composed of smaller upright monoliths framing a group of five individual, and larger, trilithons (two vertical stones supporting a horizontal one). Finally, inside the five trilithons is a second horseshoe-shaped configuration of individual uprights, and lying on the ground is a single stone, the so-called altar stone (although there is no evidence of sacrificial rituals associated with actual altars).

It is not known precisely what the purpose of this remarkable monument was, but scholars think it may have been associated with agricultural rituals of the New Stone Age. Since the cromlech, as well as the original mound, is circular, Stonehenge has been compared to a sundial, with the upright stones casting shadows as the position of the sun changes. By reading the position of the stones in relation to the sky, it is possible to predict celestial phenomena such as solar and lunar eclipses and the appearance of Halley's Comet. As a result, scholars have hypothesized that an elite class of priests may have known how to predict these events and that the cromlech, like the Aztec Calendar Stone and Buddha's Wheel of the Law, was endowed with cosmological significance.

5.6 Plan of Stonehenge.

The Stupa

The connection of the circle with burials recurs in other cultures throughout the world. There is, for example, an ancient tradition of the divine circle in India, one expression of which can be seen in the Great Stupa at Sanchi of the third century B.C. (figs. 5.7 and 5.8).

When the emperor Ashoka (ruled c. 273–232 B.C.) embraced Buddhism and proclaimed it the official religion of India, he commissioned the Sanchi stupa, along with other works commemorating the Buddha's life. According to tradition, the Buddha died at the age of eighty, and after his cremation his ashes glistened like pearls—the last great miracle of his life. In recognition of this event, Ashoka is said to have divided the ashes and buried them in eight stupas; later legend extends the number to 64,000.

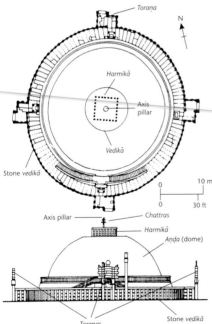

Torana

N

5.7 Great Stupa at Sanchi, Shunga and Andhra periods, 3rd century B.C. with additions made in the 1st century A.D. Shrine: 50 ft. (15.25 m) high, diameter 150 ft. (45.70 m). Madhya Pradesh, India.

Harmikā

Axis pillar

Vedikā

Stone vedikā

0 10 m

0 30 ft

Axis pillar — Chattras

Harmikā

Anḍa (dome)

Toranas Stone vedikā

5.8 Plan and elevation of the Great Stupa.

Stupas, like Stonehenge, were originally circular earth mounds derived from earlier burial mounds. At a later date, stone or brick was placed over the mound, and a circular stone balustrade (the *vedikā*) decorated with sacred carvings was erected around the stupa. Four gates (*toranas*) marked the cardinal points of the compass, reflecting the cosmological significance of the stupa, which represented the world mountain. At the top of the large dome, which was equated with the cosmic egg and the dome of heaven, was a square platform (the *harmikā*) inside a circular railing. Marking the center is the axis pillar of the world, which supports the *chattras*, an umbrella-shaped royal symbol of the Buddha.

In addition to the plan, symmetry, and rounded features of the stupa, the notion of the circle was an essential aspect of Buddhist ritual. Worshipers circumambulate (walk around)

the stupa in a clockwise direction, which is a symbolic spiritual journey. In making this journey, each worshiper participates in the cosmic harmony produced by circular form and movement.

Other Developments in the West

The type of large, round architectural tombs of ancient Greece (mausolea) were adapted in the Early Christian period and extended to the martyria built over tombs or relics of martyrs. An example of the latter is Bramante's Tempietto of around 1502–3 (fig. 5.9) in Rome, commissioned by Queen Isabella and King Ferdinand of Spain for the traditional site of Saint Peter's martyrdom. The symmetry, regularity, and circular form of the main part of the building are enhanced by the crowning dome. The center of the plan marks the spot where Saint Peter's cross, on which he was crucified upside down, was believed to have been inserted into a rock.

In the course of the Renaissance, the ideal of the circle was extended to urban planning. Associating the dignity of man with the divine circle, ideal town plans in the Renaissance were circular, generally radiating from a central point. One example is the plan of Sforzinda (fig. 5.10). Working for the Sforza rulers of Milan in the 1460s, Antonio Averlino (c. 1400–1469), the architect known as Filarete, designed an ideal city, named for his patron's family, which would have radiated from a central marketplace. Because of economic and political unrest, however, Sforzinda was never built. The first town of this type in Italy was realized only in the sixteenth century. More recent urban planning, inspired by the

5.9 (*above*) Donato Bramante, Tempietto façade, c. 1502–3. San Pietro in Montorio, Rome.

5.10 Antonio Averlino (Filarete), plan of Sforzinda, from his architectural treatise, c. 1461–62.

notion of the circle's perfection and in which streets radiate from a central point, can be seen in the designs of nineteenth-century Paris and of Washington, D.C.

THE COLUMN

The column is the vertical element of the post-and-lintel system of elevation. This is a basic unit of construction of the type seen in Neolithic form at Stonehenge, where each individual trilithon comprises a single unit. Despite the conceptual simplicity of this system, it has developed into structures in which the post evolved into a column, becoming more complex in both form and meaning.

Persia

The vast audience halls (apadanas) of ancient Persian palaces contained columns consisting of a circular base, a vertical shaft, and a capital at the top. In the palace of Darius I, begun around 520 B.C. at Persepolis, in modern Iran, the one hundred columns in the apadana were designed with capitals in the shape of the front part of double bulls facing away from each other (fig. 5.11). The forelegs are tucked underneath the bodies, closing space and monumentalizing the figures.

At Persepolis, columns projected an image of royal power. The apadana was an enormous room where the king received tributes and foreign delegations; it thus represented his international as well as his domestic importance. In the ancient world, bulls stood for the might and fertility of the king. By placing the bull at the top of the column, literally at the capital (from *caput*, meaning "head" in Latin) of the column, the Persians proclaimed the king's power both at home and abroad. In addition, the capitals reflected the king's position as "head" of state.

5.11 Bull capital, 6th century B.C. Apadana of the palace of Darius I, Persepolis (in modern Iran).

Egypt

In ancient Egypt, columns were designed in the form of plants growing along the Nile. Because prosperity depended on the annual flooding of the Nile, vegetation was paramount in the cultural consciousness. In the Nineteenth Dynasty mortuary temple of Rameses II (fig. 5.12),

5.12. Mortuary temple of Rameses II, Nineteenth Dynasty, c. 1260 B.C. Thebes, Egypt.

in western Thebes, for example, the capitals represent open and closed papyrus buds. The natural association with the shaft is thus the stalk of the plant, which makes the temple a metaphor for fertility. The presence of such columns in a mortuary temple also alludes to Rameses' afterlife, in which he will enjoy the fruits of wealth and prosperity.

Greece

The ancient Greeks viewed their columns in relation to human form and scale. This was consistent with the Greek view of man's centrality in the cosmos. Two principal Orders of architecture, the Doric and the Ionic (fig. 5.13), were developed; the capitals of their columns, in contrast to Persian and Egyptian capitals, are composed of geometric sections, arranged according to a proportional system. These, in turn, follow an "ordered" relationship of parts to each other and to the whole.

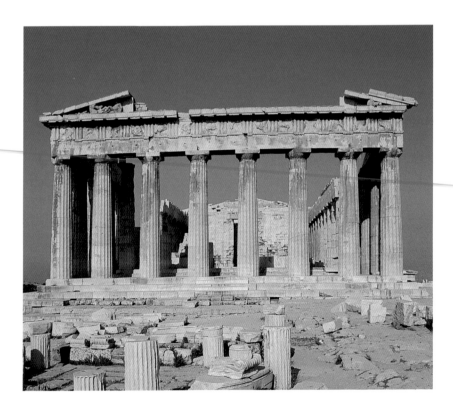

Cornice

Triglyph

Metope

Capital

Shaft

Column

Base

Stylobate

Stereobate

Doric Ionic Corinthian

The most famous Doric temple is the Classical fifth-century-B.C. Parthenon, in Athens (fig. 5.14). The individual sections of the Order are arranged in complex geometric relationships, while the overview of the building—despite extensive damage—projects an imposing image of stability and power as well as harmonious repose. A slight bulge in the shaft of the Doric column, called *entasis* (Greek for "stretching"), is a reminder that columns were conceived of organically.

Ancient Greeks also thought of Doric, which originated on the mainland and was the oldest of the Orders, as having a sturdy, masculine quality. One scholar has convincingly argued that the Greeks related rows of Doric columns to phalanxes of soldiers.[3] He points out that the Greeks strove

5.13 Diagram of the Doric, Ionic, and Corinthian Orders of architecture.

5.14 Iktinos and Kallikrates, east wall of the Parthenon, 447–438 B.C. Pentelic marble, 111 × 237 ft. (33.80 × 72.20 m). Athens.

for the same order, regularity, and strength in their armies as in their temple architecture. Ionic columns are more graceful than Doric columns; their shafts are tall and slim, and their capitals are dominated by elegant, scroll-shaped volutes. The Ionic Order originated in Ionia, in eastern Greece, and was associated by the Greeks with the opulence and luxury of the East. Temples with Doric columns on the exterior and Ionic columns in the interior, according to this view, conformed to the cultural reality that Greek men led public lives whereas the women spent more time inside the house. Corinthian columns, with foliate capitals, were a later development.

5.15. Trajan's Column, A.D. 113. Marble, 125 ft. (38.0 m) high. Trajan's Forum, Rome.

The Freestanding Column

The ancient Romans adapted the colossal freestanding column from the Hellenistic Greeks and they were erected in the forum of a particular emperor. These had been commemorative, but the Romans added a spiral frieze that recorded the triumphs of the relevant emperor. Figure 5.15 is a view of Trajan's Column, dedicated in A.D. 113, which commemorates the emperor's victories over the Dacians, a tribe famous for its goldwork that lived in what is now modern Romania. Trajan invaded Dacia, looted the gold, and used the proceeds to build retirement colonies for his armies.

The huge column, faced with marble, rests on a rectangular podium containing the ashes of Trajan. An interior spiral staircase rose to the top of the column, which supported a gilded bronze statue of the emperor; this was later replaced by a statue of Saint Peter. The height of such freestanding columns was symbolic: it stood for the power and triumph of the Roman emperors.

In 1810, Napoleon appropriated the colossal freestanding column as part of an art program aimed at projecting his imperial image. He commissioned a Doric column for the Place Vendôme, in Paris, which rested on

a base in the shape of a laurel wreath (fig. 5.16). Accentuating the triumphal meaning of the column, Napoleon had the weapons of his defeated enemies—Austrians and Prussians—melted down to be used for the frieze. Inspired by Trajan's narrative, Napoleon's frieze depicts his military campaign of 1805.

The Persistence of the Greek Orders

As with the Classical style in sculpture, the Orders of architecture established in ancient Greece have had a long and persistent impact on the history of Western art. During the Renaissance, the use of the Greek Orders was part of a self-conscious revival of antiquity; but they were often arranged in combination, and the shafts of the columns, which had been fluted (grooved), were now smooth.

Another variation developed in seventeenth-century Italy, seen in the spiral columns of Bernini's baldacchino in Saint Peter's, in Rome (fig. 5.17). Formally, such columns were consistent with the

5.16 Charles Percier and Pierre F. L. Fontaine, Place Vendôme Column, 1810. Marble with a bronze frieze. Paris.

5.17 Gianlorenzo Bernini, baldacchino, 1624–33. Gilded bronze, c. 95 ft. (29 m) high. Saint Peter's, Rome.

Italian Baroque taste for animated, curved wall surfaces. But from the point of view of meaning, the spiral column was associated with the origins of the Church. It was believed that King Solomon had used spiral columns for his temple in Jerusalem and that Constantine had imported them for reuse in Old Saint Peter's.

Bernini's columns support a lintel in the form of a bronze fabric canopy surmounted by a Cross on top of a globe. Related to canopies carried over reliquaries in religious processions, Bernini's baldacchino combined the early history of the Church with the ongoing ritual that makes it live in the present.

Classical revival styles have insured a continuing role for the Greek Orders and their columns in Western architecture. Palladianism in England; Neoclassicism in France, Germany, and elsewhere; and Federalism in the United States; all assimilated the Greek Orders. For example, in the capitol building of Richmond, Virginia, Thomas Jefferson used Greek temple fronts in the Ionic Order with smooth-shafted columns (fig. 5.18). The order, symmetry, and repose of the capitol, which overlooks the city from an elevated site, was intended to evoke the long-lasting character of Classical style associated with the democratic tradition of fifth-century-B.C. Athens and the Roman Republic.

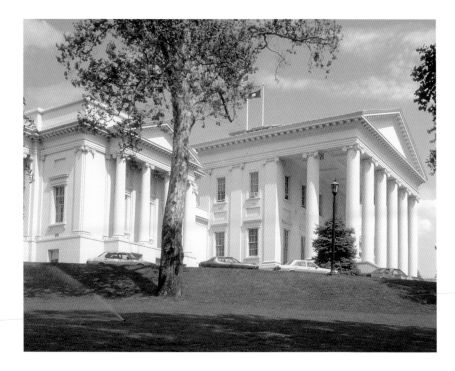

5.18 Thomas Jefferson, State Capitol, 1785–89. Richmond, Virginia.

5.19 Constantin Brancusi, *Gate of the Kiss*, 1938. Stone, 17 ft. 3½ in. × 21 ft. 7⅛ in. × 6 ft. 1½ in. (5.27 × 6.58 × 1.87 m). Tirgu Jiu, Romania.

5.20 Constantin Brancusi, *The Kiss*, 1912. Stone, 23 in. (58.4 cm) high. Philadelphia Museum of Art, Louise and Walter Arensberg Collection.

Brancusi's Gate of the Kiss

The early twentieth-century avant-garde attempted to liberate itself from the Western Classical tradition. In 1935, Constantin Brancusi (1876–1957), a Romanian artist working in Paris, was commissioned to create a memorial to those who had died in World War I. It was to be located in Tirgu Jiu, his native town; the main structure was the *Gate of the Kiss*, in which the column has become a solid supporting block (fig. 5.19).

At first glance, Brancusi's supports appear to be purely geometric verticals containing a split circle. In fact, however, they are abstractions of the artist's signature sculptures of *The Kiss* (fig. 5.20). The 1912 version, illustrated here, shows an embracing couple executed in a style derived from Cubism. Both figures are rectangular, the female distinguished from the male only by a slightly curved contour and long, wavy hair. The couple is connected formally by the closeness of the figures and by their merged arms and lips. The profile eyes meet to form an oval, combining a frontal with a profile view.

The vertical supports of the gate contain remnants of the figures in *The Kiss*. The eye, which is repeated on all four sides of the

5.25 Henry Moore, *Mother and Child*, 1936. Ancaster stone, 20 in. (50.8 cm) high. British Council, London.

this case, the mother is the artist, and the infant is her daughter, Julie. Not being a royal mother and child, these figures share the intimacy of the natural mother-child relationship. They do not address the viewer directly, as do the Egyptian and Christian figures, nor are they cultural icons, as is the Afo sculpture. Morisot gazes quietly on the sleeping infant, their closeness reflected in the correspondence of their gestures. We, as viewers, follow Morisot's gaze through the translucent covering of the cradle, which blurs the infant slightly. As a result, the child appears less differentiated—her clothing blends somewhat with the whites of the sheets—than the mother, whose black dress is defined by relatively sharp edges.

Whereas Morisot manipulates paint, color, pose, and gesture to create the natural intimacy of mother and child, the twentieth-century English sculptor Henry Moore used new formal ideas to achieve a similar effect. His *Mother and Child* of 1936 (fig. 5.25) portrays the symbiotic merger of mothers and infants. In contrast to the gestural echoes of Berthe Morisot and Julie, Moore's figures are undifferentiated from each other. The stone flows smoothly between them, uniting mother and child into a single volumetric unit. Physically as well as psychologically, the infant is just beginning to emerge as an individual, its identity still engulfed by the mother's form.

When artists depict the mother-child relationship—or any relationship, for that matter—they inevitably call on their own experience. In order to evoke a response in the viewer, the artist, like an actor or an author, has to identify with his or her characters. In images of gods, kings, queens, and ancestor figures, there is an overlay of convention that determines aspects of form and content. In the Morisot, on the other hand, the artist is shown as literally present, for she has painted her self-portrait as well as a portrait of her daughter. At the same time, the specificity of *The Cradle* reflects the nineteenth-century interest in everyday experience rather than in cultural and historical icons.

The Artist Confronts Death

Another theme, at the opposite end of the life span, that has preoccupied artists in both personal and culturally determined ways is death. In some cases, such as Titian's *Pietà* (fig. 5.26), which was his last painting, personal subtexts and cultural contexts are merged. Painted for his own tomb, the *Pietà* clearly had personal meaning for the artist. The conventional

an ancestor; the well-developed breasts of the nursing baby indicate that the image is symbolic. As an ancestor, this particular mother creates a transition between past and present, between the spirit world and the real world. Likewise, the nurture of a real mother produces the transition between infancy and adulthood, literally providing and maintaining life. The Afo image of nurture reflects the notion of the ancestor-mother's generosity in feeding her entire people; and her generosity is increased by the presence of a second child behind her head.

As with the Egyptian and Christian versions of the divine mother, the features of the Afo figure convey her hierarchical importance. With Ankhnesmeryre and the Virgin, rank is shown by monumental scale; in the Afo sculpture, rank (and the identity of her people) is indicated in the scarification patterns on the body. The Afo ancestor-mother also shares with the Egyptian queen and the Virgin Mary a transcendence of time and place.

The Cradle of 1873 (fig. 5.24) by the French artist Berthe Morisot (1841–1895) depicts a secular version of the mother-child dyad. In

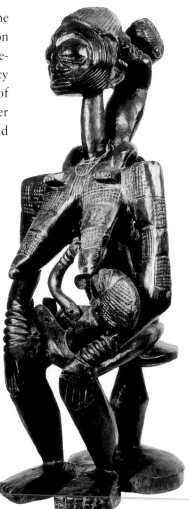

5.23 (*above*) Afo *Mother and Child*, before 1900. 27½ in. (69.9 cm) high. Nigeria. Horniman Museum, London.

5.24 Berthe Morisot, *The Cradle*, 1873. Oil on canvas, 22½ × 18½ in. (57.0 × 47.0 cm). Musée d'Orsay, Paris.

5.22 Cimabue, *Madonna Enthroned*, c.1280–90. Tempera on wood, 12 ft. 7 in. × 7 ft. 4 in. (3.84 × 2.24 m). Galleria degli Uffizi, Florence.

The concept of the royal baby recurs in the Christian image of the enthroned Virgin with the infant Christ on her lap. In Cimabue's late thirteenth-century monumental *Madonna Enthroned* (fig. 5.22), a host of angels surrounds the throne, which appears to rise upward. Old Testament prophets below the throne signify the Old Dispensation, on which the New Dispensation is built. Mary, like the Egyptian queen, is an imposing figure with her son on her lap. Christ, like Pepy, is a miniature man; he has adult proportions and behaves like an adult. With his right hand he blesses, and with his left he holds a scroll of prophecy.

Both Christ and Pepy are extraordinary babies; they are infant god-kings destined for greatness. They possess unusual intelligence and are advanced for their respective ages. Mary, like Ankhnesmeryre, is a queen and a mother; she is also her son's throne. There is, of course, psychological truth in the unusualness of such babies and their mothers. Nearly every baby boy is a king and a genius to his mother, and every mother a queen to her son. Hence Freud's allusion to "his majesty the baby" and Buckminster Fuller's declaration that "all of humanity is born a genius."

Both images refer to the future, as well as having an impact in the present. After his death and resurrection, Christ will crown Mary Queen of Heaven, and they will rule together for eternity. According to pyramid texts of a later period, when the pharaoh climbs onto his mother's lap, he prefigures his ascension to heaven after his death. Timelessness is thus an aspect of both the Egyptian and the Christian image, achieved in the former by the static rectangularity of the figures, and in the latter by the flattened gold background that removes the figures from natural, worldly space.

Another type of mother-child image having religious implications can be found in the Afo sculptures of Nigeria (fig. 5.23). Here the mother is

gateposts, has been enlarged, but the blocks themselves are pure rectangles that no longer suggest human form. The horizontal lintel is decorated with a series of incised geometric shapes related to the motif of *The Kiss*. Here the message is political, although Brancusi's obsession with the theme of the kiss has personal meaning as well. The image of the kiss on Brancusi's *Gate* has become the supporting element; what it supports is a repeated image of embracing couples intended as an architectural metaphor of world love and peace.

THE ICONOGRAPHIC THEME

Mother and Child

Iconographic themes are themes of content, although, as is clear from the above discussion, form and structure also have content. The first theme we consider is that of mother and child, a universal subject found in the art of most of the world's cultures. The meanings may change according to a particular society, but they are usually related to a psychological aspect of the real mother-child dyad.

5.21 *Queen Ankhnesmeryre II and Her Son Pepy II*, Sixth Dynasty, c. 2245–2157 B.C. Alabaster, 15⁷⁄₁₆ × 7 × 9¹³⁄₁₆ in. (39.2 × 17.8 × 24.9 cm). Egypt. Brooklyn Museum of Art, New York, Charles Edwin Wilbour Fund 39.119.

In the Sixth Dynasty of Old Kingdom Egypt, a court artist carved the well-known alabaster statue of *Queen Ankhnesmeryre II and Her Son Pepy II* (fig. 5.21). This shows Pepy, the future pharaoh, in miniature. He wears the royal (trapezoidal) *nemes* headdress and the protective uraeus (the cobra on his forehead). He is seated on his mother's lap, and both are represented according to the superimposed rectangular grid used to determine ancient Egyptian proportions in art. Queen Ankhnesmeryre II wears the vulture headdress associated with the vulture goddess, Nekhbet, signifying her role as the king's divine mother. It is possible that she is shown here as regent since Pepy became pharaoh as a boy and then ruled for sixty-four years.

Apart from his small size, Pepy does not look or act much like a baby in this sculpture. He is, however, supported by his mother, and he uses her lap as his throne, both being part of every child's reality. Pepy is not an ordinary baby, but rather a symbolic baby; he has the accoutrements of kingship and is shown in the traditional Old Kingdom pose of the pharaoh. The Egyptian artist has thus conflated the reality of early childhood with an image of royalty.

Pietà represents the dead Christ lying across his mother's lap, a motif that brings the scenes of the enthroned Madonna with the infant Christ full circle. In Titian's painting, Mary and Christ occupy an abbreviated apse with a phoenix, representing resurrection, in the semidome. Flying overhead, an angel carries a lighted torch, which is a symbol of rebirth and eternal life.

At the left, Mary Magdalen raises her right hand as if to protest the death of Christ in a vain appeal to the viewer. At the right, Joseph of Arimathea (who embalmed Christ's body) kneels before Christ. These four central figures create a diagonal that sweeps across the picture plane, and is countered by the angel with the torch. On either side of the apse are stone statues alluding to the past—Moses with the Tables of the Law at the left and the Hellespontine Sibyl pointing prophetically to the Cross at the right. Both stand on lion pedestals, which probably refer to Christ's ancestor, King Solomon, who sat on a lion throne.

The living figures are shown as flesh and blood as well as in color, whereas the statues are of stone. Christ is also a flesh-and-blood figure, but he is devoid of color, signifying his recent death. The most prominent color is the red drapery worn by Joseph of Arimathea, actually a self-portrait of the artist. Titian's personal preference for the color red makes Joseph's drapery a kind of chromatic signature, just as the self-portrait is a visual signature.

As a cultural image, Titian's *Pietà* is imbued with traditional content. The two Marys and Joseph of Arimathea participate in the biblical texts describing the death of Christ; Moses is a tradi-

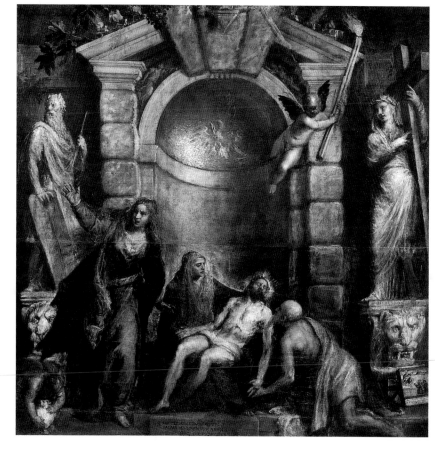

5.26 Titian, *Pietà*, begun c. 1570 and completed by Palma Vecchio after Titian's death. Oil on canvas, 11 ft. 6⅜ in. × 12 ft. 9¼ in. (3.51 × 3.89 m). Gallerie dell'Accademia, Venice.

5.27 Pablo Picasso, *Self-Portrait*, 1972. Wax crayon on paper, 25⅞ × 20 in. (65.7 × 50.5 cm). Zervos XXXIII, 435. Courtesy Fuji Television Gallery, Tokyo.

tional precursor of Christ, and the sibyl's prophecies were interpreted as foretelling the coming of Christ. As a personal image, on the other hand, the painting is about the death of the artist. He turns his back to the viewer and gazes on the face of death in the person of Christ.

In the Titian, we do not confront the artist's face directly as we do in one of Picasso's last self-portraits (fig. 5.27). This is a powerful image of the artist face to face with his own death. In contrast to Titian, who turns from the viewer and locates himself in a familiar narrative, Picasso faces both the viewer and death directly; he is riveted and appalled by his own death head gazing back at him.

In July 1972, at the age of ninety-one, the artist showed the drawing to his biographer, Pierre Daix, and said that it was unlike anything he had done before. The combination of frontality and the close-up is unusual in Picasso's self-portraits. It forces us to confront Picasso's confrontation with death. The head is in the shape of a skull and has a gray-green pallor. Red lines emanating from the back of the head suggest blood draining away, leaving traces in the right eye, the eyebrows, and the mouth. The agitated black lines around the chin, neck, and shoulders reveal Picasso's anxiety, as does the asymmetry of the features.

An entirely different reaction to death can be seen in Rembrandt's *Self-Portrait As Zeuxis* of about 1669 (fig. 5.28). Rembrandt was his own most frequent model. He painted himself repeatedly in various guises, for which he kept a supply of costumes in his studio. This picture is a late, if not his last, self-portrait; it is the last showing himself as a painter. He holds a painter's stick, and the painting he is working on is visible at the left (it has been overpainted and probably slightly cut down). X-ray analysis has revealed that at an earlier stage Rembrandt showed himself in the act of painting the picture-within-his-picture.

Rembrandt's choice of Zeuxis reveals himself. A Classical Greek painter known for his illusionistic wit and his sense of value, Zeuxis was reputed to have stolen the art of his masters. Money was important to him, as it was to Rembrandt, being, for both artists, intricately tied to reputation. Zeuxis reportedly became so rich that he displayed his name

embroidered on a robe in gold letters at Olympia. He gave away his works because they were beyond price. Rembrandt preferred not to work for patrons, but to value his pictures as "Rembrandts" rather than as works made on commission.

Pliny says Zeuxis painted grapes so accurately on a stage set that birds tried to eat them and then painted a child carrying grapes. When birds tried to eat these, Zeuxis was disappointed; had his child been as well painted as the grapes, he said, he would have scared away the birds. Another anecdote relates that Zeuxis painted Helen of Troy as a courtesan and then charged admission to view the picture.

In these accounts, reality and visual fiction are in a continual dynamic interplay. Real birds enter the fictive realm of painting and participate in its illusionism. The painting of Helen becomes a prostitute because money is paid by the viewer for the pleasure of seeing her image. According to Karel van Mander, the sixteenth-century Dutch biographer of artists, Zeuxis died laughing while painting an ugly old woman.

5.28 Rembrandt, *Self-Portrait As Zeuxis*, c. 1669. Oil on canvas, 32½ × 25⅝ in. (82.5 × 65 cm). Bredius 61. Wallraf-Richartz-Museum, Cologne.

In the *Self-Portrait As Zeuxis*, Rembrandt has appropriated several of his Classical predecessor's traditional qualities. The thick, impasto application of paint creates a convincing illusion of wrinkled flesh. The attention to gold—the rich yellow light, the old woman's chain, and the costume of Rembrandt himself—has a double significance. As the real source of Rembrandt's money, painting was his gold, and gold was also a favorite subject and texture in his paintings. Both literally and figuratively, therefore, Rembrandt painted gold. By 1669, when the artist was sixty, he apparently sensed that time was running out. In this self-portrait, he turns from the old woman, who seems to emerge into a real, rather than a painted, space and gaze down at the artist. Rembrandt shows himself, like Zeuxis, laughing at the world he is to leave behind, laughing himself into death.

6

ART IN AND OUT
OF CONTEXT

CONTEXTS FOR WORKS of art range from the refrigerator door, to the walls, ceilings, and floors of buildings, to video and computer screens, to urban and rural spaces. This chapter considers some of these contexts, their meaning, and their impact on the viewer. Often the original site of a work changes over time; occasionally it remains as it had been intended by the artist. Stonehenge, for example, retains its original context because the British government has decided to preserve it. A cathedral that would have dominated a medieval town, however, might now be surrounded by modern high-rise buildings that diminish its original impact.

In all cases, the location of a work affects the viewer's reception of it. Compare the experience of watching epic films such as *The Birth of a Nation* or *Gone with the Wind* in a theater with seeing them at home on videotapes made for television. There is a difference of scale that affects our relation to the images. They are much bigger in a theater and they dominate us as we sit in the dark, sharing the experience with a group of people who have gathered to watch the same film. We can lose ourselves more easily in the theater and enter the story more completely than at home, where there are distractions.

NARRATIVE CONTEXT

As with a film, when painted images are fixed to a wall in a narrative sequence, their context can be essential to following the story. One of the best-

OPPOSITE
Nam June Paik, sketch for
Modulation in Sync at the
Solomon R. Guggenheim
Museum, 1999 (see also
fig. 6.8).

known examples of an intact painted narrative is found in the Arena Chapel, in Padua, where Giotto, in the early fourteenth century, painted frescoes illustrating the life of Christ. In these images, each scene has an individual meaning and is related to the entire cycle.

Consider the two panels, the *Lamentation* (fig. 6.1) and the *Noli Me Tangere* (fig. 6.2), which are placed side by side in Giotto's narrative. If we know the story of Christ's life and were to see the pictures in another context, we would probably recognize the scenes individually. But we would lose the effect of their juxtaposition on the wall.

In the *Lamentation*, we see a group of mourners surrounding Christ after he has been taken down from the Cross. The sky is filled with grieving angels, and a lone bare tree stands on the rise of a rock to the right. If we are familiar with Christian symbolism, we know that the dead tree alludes to Christ's death. We also know that Mary, Christ's mother, is the figure

6.1 Giotto, *Lamentation*, c. 1305. Fresco. Arena Chapel, Padua.

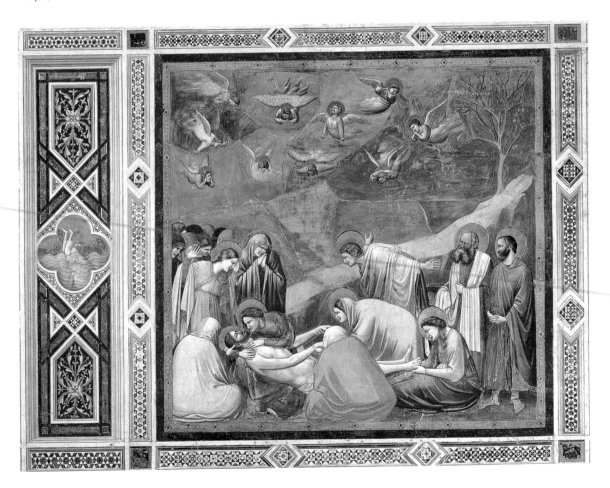

in blue holding Christ across her lap and that Mary Magdalen, her long hair a sign of penance, sits at Christ's feet. The young man in pink who extends his arms behind him is Saint John the Apostle, who was present at the Crucifixion. Reading the figural arrangement formally, we notice that it forms a near-circle around Christ. And we know that the circle is a divine shape, in this case signifying the future Church and Christ's centrality in its doctrine.

Now if we look at the *Lamentation* in the context of the next scene, we see that its meaning is enriched by their juxtaposition. The rock continues as if behind the painted frame separating the scenes, which accentuates the simultaneity of place. In contrast to the preceding scene, the *Noli Me Tangere* is calm, and the sky is empty. The figures sleeping before Christ's tomb are Roman soldiers who oversaw the Crucifixion and are now oblivious to what is happening. Seated on the tomb are two angels, one who directs

6.2 Giotto, *Noli Me Tangere*, c. 1305. Fresco. Arena Chapel, Padua.

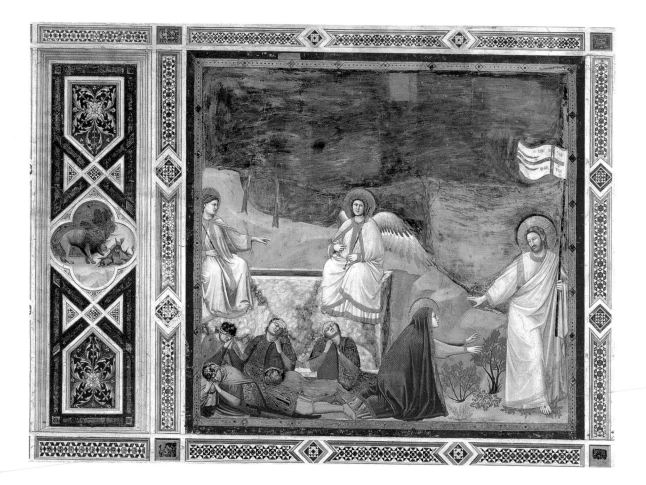

our gaze with a pointing finger and the other whose wing follows the edge of the rock toward the confrontation at the right.

The trees at the left, which have been painted over, were originally green, signifying Christ's resurrection and the tradition that nature revived with his rebirth after death. This is not, however, a Resurrection scene. It is an event that occurs after the Resurrection, when Mary Magdalen catches sight of Christ and reaches out to see if he is real. His reply "Do not touch me" (*Noli me tangere* in Latin) is the conventional title of the scene.

Giotto, who was a particularly psychological painter, depicted the tension between Christ and Mary Magdalen that is a result of their confrontation. She is still of this world, whereas Christ, as is indicated by his white robe and banner, has transcended materiality, conquered death, and entered a new, spiritual state of being. At the same time, however, Christ is shown as human in his ambivalence, for though he turns to leave, he also turns to Mary. Two of his drapery folds point directly at her outstretched hands. Giotto thus contrasts the frustrated embrace of Mary Magdalen at the right of the *Noli Me Tangere* with the physical embrace of Christ's mother at the left of the *Lamentation* scene. He also depicts Christ as both divine and human.

Following the narrative across these two frescoes, we can discern the shifting moods of the figures. They begin with the agitation of loss experienced in the *Lamentation*, becoming calm (the angels), empty (the sky), and oblivious (the sleeping soldiers) in the *Noli Me Tangere*. Then, at the far right, the tension rises as Christ prepares to depart toward his future role as the eternal God, while Mary remains in her human condition on earth.

ARCHITECTURAL CONTEXT

Another example of a work that has remained in its original setting is Bernini's *Ecstasy of Saint Teresa* (fig. 6.3), located in the Cornaro Chapel in the church of Santa Maria della Vittoria, in Rome. In this case, the artist designed the chapel's architecture as well as its sculpture. He thus created a sacred environment in which to locate the main work—Saint Teresa of Ávila (1515–1582) and the angel piercing her with a golden arrow.

In figure 6.3, we view the sculpture out of context. It could just as well be in a museum or in the home of a collector. We recognize that the saint is in a state of ecstasy. We also see that she appears to be supported by a formation of clouds, indicating that she is levitating, as she described in her mystical writings. But we do not see her in context, as we do in figure 6.4. Now that we see the work in its original architectural setting, we notice that

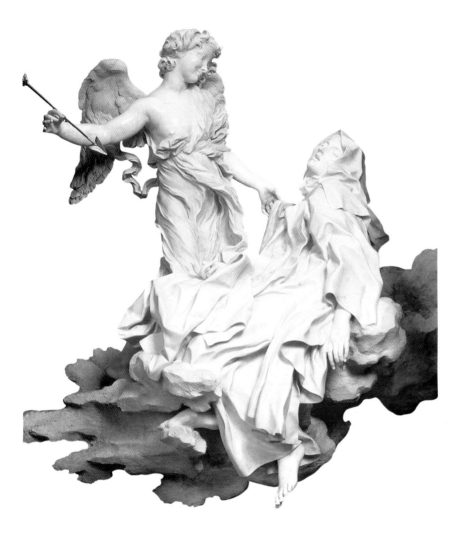

6.3 Gianlorenzo Bernini, *Ecstasy of Saint Teresa*, 1640s. Marble, 11 ft. 6 in. (3.51 m) high. Cornaro Chapel, Santa Maria della Vittoria, Rome.

it occupies a niche behind the altar and that golden rods representing rays of light appear to descend from heaven. Heaven itself, dominated by the yellow light surrounding the dove of the Holy Spirit, is depicted above a window in the dome of the apse. The animated Baroque wall of the chapel seems to respond to the saint's ecstatic state. Flanking the niche are mottled black-and-green marble Corinthian columns with foliate capitals, which support a curved, broken pediment. These curvilinear architectural forms repeat the rhythmic curves of the clouds and the figures' drapery folds. The dark color of the columns contrasts with the gleaming white surface of the saint and angel, which accentuates their divine state.

Bernini's chapel shows as viewers the family of the patron as well as visitors to the church. On the side walls, he has placed sculptures of mem-

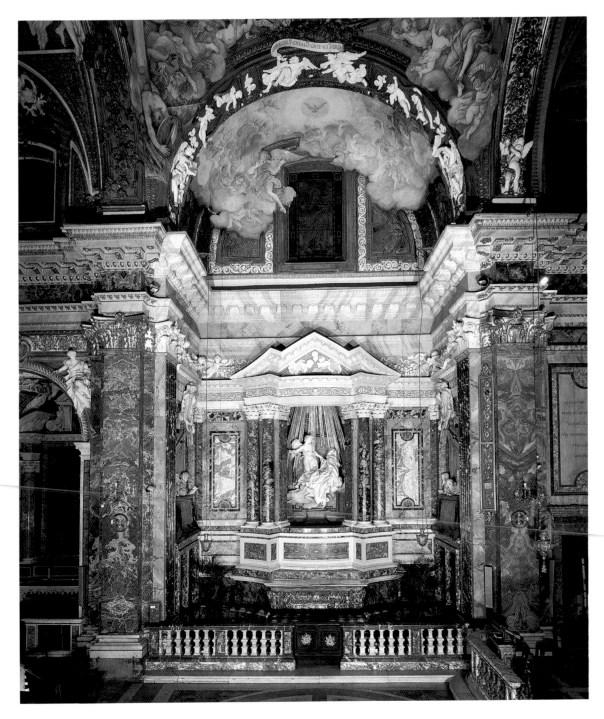

6.4 Gianlorenzo Bernini, Cornaro Chapel, 1640s,
Santa Maria della Vittoria, Rome.

bers of the Cornaro family, who seem to be gazing at Saint Teresa's ecstatic experience, which they discuss in an animated way. They are placed behind *prie-dieux*; but rather than praying, they are reacting to the ecstasy of the saint. There are thus several levels of viewing in this work. From the ceiling, all of heaven, including the stucco angels on the frieze, seems to be gazing down on the chapel and rejoicing. And we the viewers watch the Cornaro family on the side walls watching the event taking place behind the altar.

There are also a number of temporal levels in the very conception of the chapel. Heaven represents eternity, which can only be indirectly experienced on earth. Through the intermediary of the heaven-sent angel, Saint Teresa's mystical experience creates a temporary union with the divine. The Cornaro family, carved in stone, gazes on the saint for as long as the original context of the chapel remains intact. Visitors to the chapel, on the other hand, are transitory and exist in the present only. Bernini has thus created an enduring tableau, part sculpture, part architecture, part Christian miracle, and part theater.

THE MUSEUM AS CONTEXT

Museums are complicated institutions. The term itself comes from *mouseion*, referring to the home of the nine Muses of Greek mythology. Since the Muses were goddesses of arts and history, their "home"—the museum—is the residence of the arts and their history. Museums as we know them today are relatively recent, although the notion of artistic monuments on public display is not new. For example, the second-century-A.D. bronze statue of Marcus Aurelius (fig. 6.5), which was originally gilded, was one of many public equestrian portraits commissioned by the emperors in ancient Rome. This is the only one to have survived, apparently because in the Early Christian and

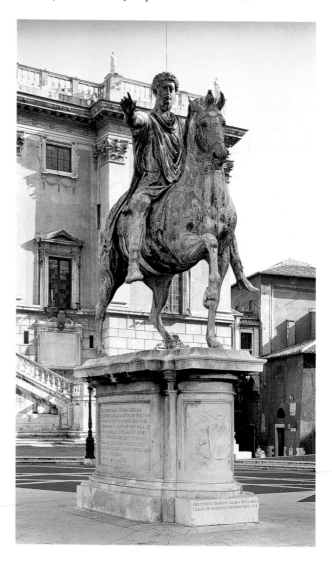

6.5 *Marcus Aurelius*, A.D. 164–166. 11 ft. 6 in. (3.50 m) high. Piazza del Campidoglio, Rome. Marcus Aurelius (ruled A.D. 161–180) was a Stoic philosopher and author of *Meditations*, as well as being a Roman emperor and statesman.

6.6 View of the Capitoline Hill, Rome.

medieval periods it was thought to represent Constantine. During the Renaissance in Italy, the statue became an inspiration to artists seeking to revive antiquity. Not only were they interested in Roman naturalism, but they were drawn to the sense of human power and dignity conveyed by the statue.

In 1536, Pope Paul III commissioned Michelangelo to renovate the Capitoline Hill, which had been the site of a temple dedicated to Jupiter in antiquity (fig. 6.6). The equestrian portrait of Marcus Aurelius was elevated onto a pedestal and placed at the center of Michelangelo's elaborate oval design on the pavement. Surrounding the trapezoidal space on three sides are government buildings; pedestrians approach from street level by ascending the imposing staircase at the shorter end of the trapezoid. The top of the staircase, at the entrance to the square, is flanked by statues of the Dioscuri (twin sons of Zeus), who were famous mythological horse tamers.

Believing the *Marcus Aurelius* to represent the emperor Constantine, Pope Paul III wanted the statue for the centerpiece of the Campidoglio. In that context, had the statue actually represented Constantine, it would have stood as a tribute to Rome's conversion from a pagan city to a Christian one. Today the statue's location has again been changed; it has been restored and moved to the Museo Capitolino, the building to the left of the stairway. A replica has been placed outside to preserve the original significance of the site.

During the seventeenth century, the absolute monarchs of Europe collected art and hired artists to work at their courts. Some of these royal collections, notably those amassed by Philip II of Spain and Louis XIV of France, were essentially private museums with access restricted to members of the court and their visitors. Eventually, both collections became the basis of national public museums—the Prado in Madrid and the Louvre in Paris.

Today, crowds of visitors attend museum exhibitions, and most of the world's major cities have at least one important museum. We tend to forget, however, that nearly every work of art now in a museum once had another context. Consider, for example, the *Madonna of the Rocks* of around 1483–85 (fig. 6.7) by Leonardo da Vinci, in which Mary, with the infants Christ and John the Baptist and an angel, are represented in a rocky cavern. Now in the Louvre, this was commissioned in 1483 for the chapel belonging to the Confraternity of the Immaculate Conception in the church of San Francesco Grande, in Milan. In its original setting, the work was part of an altarpiece containing side panels by two other artists. It would have been viewed in the darkened atmosphere of a chapel, illuminated mainly by candlelight.

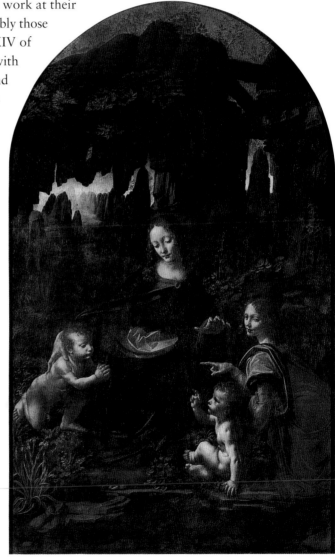

6.7 Leonardo da Vinci, *Madonna of the Rocks*, 1483–85. Oil on wood, transferred to canvas, 6 ft. 6½ in. × 4 ft. (2.00 × 1.22 m). Musée du Louvre, Paris.

A Renaissance observer would have recognized the rocky background of the painting as a symbolic extension of the chapel's architecture. Visually echoing the metaphor in which the Church is the Rock of Ages, Leonardo's picture has a timeless quality more evident in its original context than on a museum wall. Furthermore, the extension into the background space, to which the viewer is led by a stream, opens up into a misty sky and suggests a world beyond the chapel itself. Leonardo's characteristic subtle yellow lighting illuminates the figures, who thus create a transition from the dark space of the chapel to the distant painted light.

The original setting of Leonardo's enigmatic *Mona Lisa* (see fig. 1.12) is not known. Presumably, the *Mona Lisa*'s first context was Leonardo's studio, where he reportedly tried to keep his sitter amused. But, rather than deliver the picture to its patron, Leonardo took it with him when he went to the French court of Francis I. Leonardo died at Cloux, just outside Francis I's court at Amboise, and the *Mona Lisa* remained in France. In the seventeenth century Louis XIV brought the painting to Versailles, and in 1800 Napoleon hung it in his Paris bedroom. Four years later, the *Mona Lisa* was transferred to the Louvre, where it hangs today—behind bullet-proof glass.

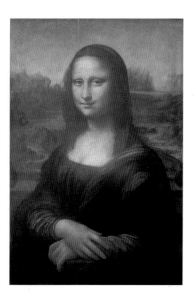

Leonardo da Vinci, *Mona Lisa*, c. 1503–5 (see also fig. 1.12).

But that is not the end of the story, for in 1910 an Italian housepainter became offended by the French context of the *Mona Lisa*. He thought its rightful context was Florence, where it had been painted, and that it was an Italian national treasure. Accordingly, he stole the picture, took it to Florence, and hid it under his bed. The theft was discovered in 1911, the police subsequently recovered the work, and in 1913 it was placed on temporary exhibit at the Uffizi, the preeminent art museum in Florence. Record numbers of people visited the Uffizi to view the *Mona Lisa*, after which the painting toured other Italian art museums before returning to France.

In 1963, the *Mona Lisa* traveled to the United States for a seven-week visit. Exhibited at the National Gallery in Washington, D.C., and at the Metropolitan Museum of Art in New York, she attracted some 1.6 million viewers. In 1974, at the Tokyo National Museum and at the Pushkin Museum, in Moscow, over 2 million people flocked to see Leonardo's enigma. Today there is a *Mona Lisa* "Timeline" on the internet with links to the account of the theft, to interpretations of Mona Lisa's identity, to the myths that have evolved about her, and to Leonardo's painting techniques.

Having said that museums house works of art out of context, it is necessary to point out that some modern museums have themselves become

original contexts for temporary exhi-
bitions. In such cases, the interior
space and design of the museum
set the stage on which the artist cre-
ates a kind of performance. Exem-
plifying this practice was the exhi-
bition in the year 2000 of *The Worlds
of Nam June Paik* at New York's
Guggenheim Museum.

Paik (born 1932) used the inte-
rior rotunda of Frank Lloyd Wright's
building as the main space for a com-
plex installation of videos and lasers
accompanied by music, images of
dance, light displays, and various
tableaux. On the floor, 100 televi-
sion monitors broadcast Paik's
constantly changing video images.
Larger screens along the sides of the
spiral ramp circling the rotunda
related the television images to laser
projections. On the ramp itself, Paik
installed earlier works from the
1960s, and a screening room showed
collaborative projects with other
artists.

Figure 6.8 is Paik's sketch for

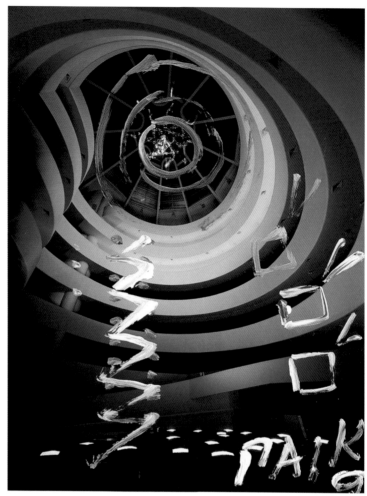

6.8 Nam June Paik, sketch for
Modulation in Sync at the
Solomon R. Guggenheim
Museum, 1999. Acrylic on
color photograph, 24 × 20 in.
(61.0 × 50.8 cm). Collection
of the artist.

the installation entitled *Modulation in Sync*. In the open space of the museum's
rotunda, he used acrylic to paint the lasers, which in the actual installa-
tion were continually moving, zigzagging images. At the right, he indicated
the location of the large-scale screens, and on the floor, he depicted some
of the smaller television monitors. Even from a reproduction such as this,
it is clear that Paik conceived of the imposing architectural space of the
museum as the aesthetic context of his images. In addition to synchroniz-
ing space and form, Paik synthesized light and color. The illumination of the
ramp, which changes at different levels, corresponds to the painted colors of
Paik's brushstrokes. In the final exhibit, the different media, including dis-
crete works arrayed along the ramp, produced an elaborate and impressive
display of Paik's title—*Modulation in Sync*.

THE ARCHAEOLOGICAL DIG AS MUSEUM AND CONTEXT

Whereas Paik's installation used an existing museum as an artistic environment, the Chinese have transformed a unique archaeological dig into a museum.

In 1974, two Chinese farmers in Shaanxi Province found broken pieces of terra-cotta on their land. Shortly thereafter, the tomb of the Chinese emperor Shihuangdi (ruled 221–210 B.C.) was opened, and excavations began. Known as the First Emperor of Qin, Shihuangdi unified China (named for *Qin*) and established a code of laws, a writing system, an artistic canon, and standardized measurements. He commissioned monumental works of art and architecture, built roads throughout the country, and defended its borders by extending and completing most of the Great Wall.

When he died, Shihuangdi had decided, he would take life with him. So he assembled over 7,000 life-size terra-cotta soldiers and horses to guard him after death (fig. 6.9). Most were arranged in rows, like military batallions, standing at attention in trenches. Other are shown kneeling and holding the reins of the horses. The figures were constructed in sections—torso, limbs, and head—on a base; their remarkably lifelike appearance was achieved by the use of different paint and slight variations in the features. This impression of naturalism was considered necessary by Qin to insure the effectiveness of his bodyguard. It was not for public viewing, for Qin had no idea that his soldiers would be excavated, photographed, replicated in various sizes for sale, and exhibited throughout the world. As with all burials, the terra-cotta army was not intended to be seen by the living.

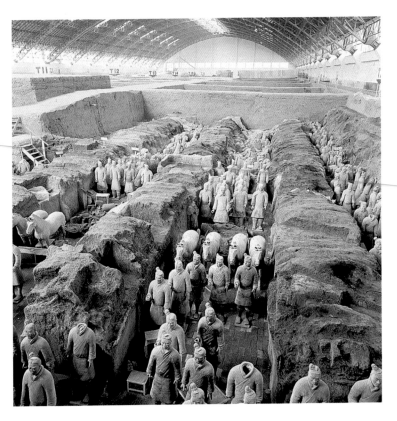

6.9 View of the body guard of Emperor Qin, Qin Dynasty, 221–206 B.C. Terra-cotta, life-size. Lintong, Shaanxi Province, China.

Qin's bodyguard was buried in a colossal grave mound at Lintong, near modern Xi'an. Since its discovery, the terra-cotta army has become an international attraction, and visitors to China regularly include Xi'an in their itineraries. As a result, the Chinese authorities have enclosed the entire site under a huge dome and provided an elevated walkway permitting visitors to circle the site and view the figures from above. At the same time, archaeologists continue to excavate, photograph, clean the warriors, and piece the broken ones back together. Although people throughout the world have now seen reproductions and even originals of the sculptures on loan to other museums, there is no substitute for the astounding impact made by on-site viewing of Qin's army.

THE NATURAL CONTEXT

We have considered Stonehenge as an example of a monument constructed in a natural context. Stonehenge and other Neolithic monuments served a cultural, usually a religious, purpose. As such, they were integrated into an existing society and were not originally considered art in the modern sense. In contrast, more recent artists have created site-specific works of art located in the natural environment.

An example of so-called site sculpture was created in the 1970s by Walter de Maria (b. 1935) in a sparsely populated area of New Mexico (fig. 6.10). Rather than encouraging public viewing, the *Lightning Field* is

6.10 Walter de Maria, *Lightning Field*, 1971–77. 400 stainless steel poles; average height: 20 ft. 7 in. (6.27 m); ground area: 5,280 × 3,300 ft. (1,609 × 1,006 m). Quemado, New Mexico.

in an isolated area, and visitors must make an appointment with the work's sponsor, the Dia Foundation, to see it. In fact, part of the work's aesthetic is its remote location, requiring viewers to make a kind of artistic "pilgrimage" to the site.

The entire work has an area of around one mile by three-fifths of a mile and is surrounded by mountains visible in the distance. Four hundred stainless steel poles, 2 inches in diameter and, on average, 20½ feet high, are arranged in a grid pattern. There are 16 rows of 25 poles, separated by spaces of 220 feet. Since the land is slightly uneven, there are variations in the height of the poles so that their tops remain level.

During the day, the poles are barely visible because they are washed out by the bright sun; but at sunset and at dawn, they act as reflectors. During the electrical storms that are common in the desert, the poles conduct electricity, creating patterns of the kind visible in the photograph. In this work, de Maria has created a monumental installation in which the changing aspects of nature, combined with modern technology, continually alter our relationship to landscape.

THE URBAN CONTEXT: SITE, POLITICS, ECONOMICS, AND CHRISTO AND JEANNE-CLAUDE

With the work of Christo and Jeanne-Claude, the meaning of context is expanded. Their sites include the urban as well as the rural environment, and their projects involve the social, political, and economic pressures on the authorities whose permission is needed to realize them. In cities, the Christos have wrapped three buildings and other structures, and in nature they have arranged enormous amounts of fabric in startlingly original ways. They have wrapped trees in Switzerland, walkways in Kansas City, Missouri, and a section of the Australian coast, and run a fabric fence through two California counties.

In contrast to the *Lightning Field*, the Christos' large-scale projects encourage viewers by the thousands, both during the production stages and for a period of time afterward. In contrast to stone structures such as Stonehenge and long-term installations such as the *Lightning Field*, the Christos' work is intentionally temporary. After being on view for a short period—usually two weeks—all materials are removed and recycled, and the site is returned to its original condition. All financing for the projects is provided by Christo and Jeanne-Claude, rather than by outside patrons or

foundations. And the locale chosen for the project usually profits economically both from the employment of a large number of workers and from visitor traffic. Many such projects have been realized, while others either are pending or have been abandoned. In each case, the preliminary work is recorded through preparatory drawings and models, and, if it has been realized, it is filmed and published as a book.

An example of one of the many projects that have been rejected to date is entitled *The Gates, Project for Central Park, New York City*. In 1980,

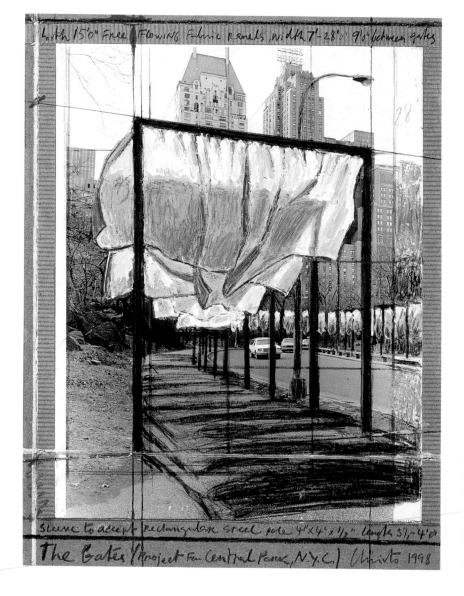

6.11 Christo and Jeanne-Claude, *The Gates, Project for Central Park, New York City*. Collage 1988, 11 × 8½ in. (28 × 21.5 cm). Pencil, enamel painting, wax crayon, and tape on brown cardboard.

the project was described as follows: Along the borders of walkways in Central Park, steel gates of various widths are placed at intervals of 9 feet (2.74 m). Hanging from the top horizontal bar of each gate is a rectangle of orange or yellow fabric, which reaches downward to around 6 feet (1.83 m) above ground level. The designated season for the project, planned to last two weeks, is fall, when light winds will cause the fabric to flutter and the colors will contrast with the fading greens of the grass and trees.

As can be seen in one of the preparatory drawing studies for the project (fig. 6.11), the gates are aligned with the surrounding buildings visible from inside the park. In this view, the bright orange of the gates creates a striking impression and to the right, we can see cars driving through the park. The gates are designed to accentuate the existing topography of the park, creating new patterns of light, shadow, and color. Depending on wind and air currents, colorful orange and yellow rectangles of fabric are in continual motion, in contrast to the static, gray buildings in the distance.

The artists met with their attorney, members of various city councils, representatives of the arts, ornithologists, ecologists, and sociologists. They explained that tests had been carried out on the structural soundness of *The Gates* in a windy area of Colorado. They offered to assume all liability for the project and assured the authorities that wildlife, trees, and soil would not be disturbed. In fact, they argued, improved soil would be used to replace any that was removed by inserting the poles into the earth. In addition, the project would provide jobs and unify disparate parts of the community in a celebration of aesthetics and civic pride.

In February 1981, New York Community Boards 7, 10, and 11 voted for the project, Board 5 voted against it, and Board 8 refused to meet with the artists. The commissioner of the Department of Parks and Recreation published his *Report and Determination in the Matter of Christo: The Gates*, a 185-page reply denying permission for the project. The following year, a *Human Impact Study* produced by the office of the sociologist Dr. Kenneth Clark argued that the wealthy residents around the park opposed the project, whereas other areas of the city were in favor of it. Clark's office believed that the project would have been an artistic vehicle whose effect would have been to unify diverse cultural groups in the city.

Christo and Jeanne-Claude are still working toward the acceptance of *The Gates*. But, in the meantime, they have pursued environmental projects elsewhere, producing *Surrounded Islands* in 1983, surrounding eleven islands in Biscayne Bay, Florida with more than 6 million square feet of floating pink fabric; *The Pont-Neuf Wrapped* (1985) in Paris; *The*

Umbrellas, Japan–USA (1991), in which a total of 3,100 umbrellas were opened simultaneously in California and Japan; and the *Wrapped Reichstag, Berlin* (1995), completed after three rejections and twenty four years of negotiations with the German authorities.

From the point of view of the art-viewing public, the projects of Christo and Jeanne-Claude must be experienced not only in context, but also within a limited period of time. Their temporary nature compresses the time of their viewing, which in turn intensifies the experience. This becomes a kind of dramatic "happening," to be enjoyed in the present but not in the future. And although the choice of a site, such as the Reichstag or the Pont-Neuf, may have historical meaning, the aesthetic impact of the work is in the here and now. Once the designated time period of the projects has ended, they exist only in pictures, in models, in books, and on film. Christo and Jeanne-Claude invite the world to watch their projects in the making, to experience the climax of their realization, and to remember (read about or see on film) them once they have ended. As such, their work is theater as well as art, and its context is the world.

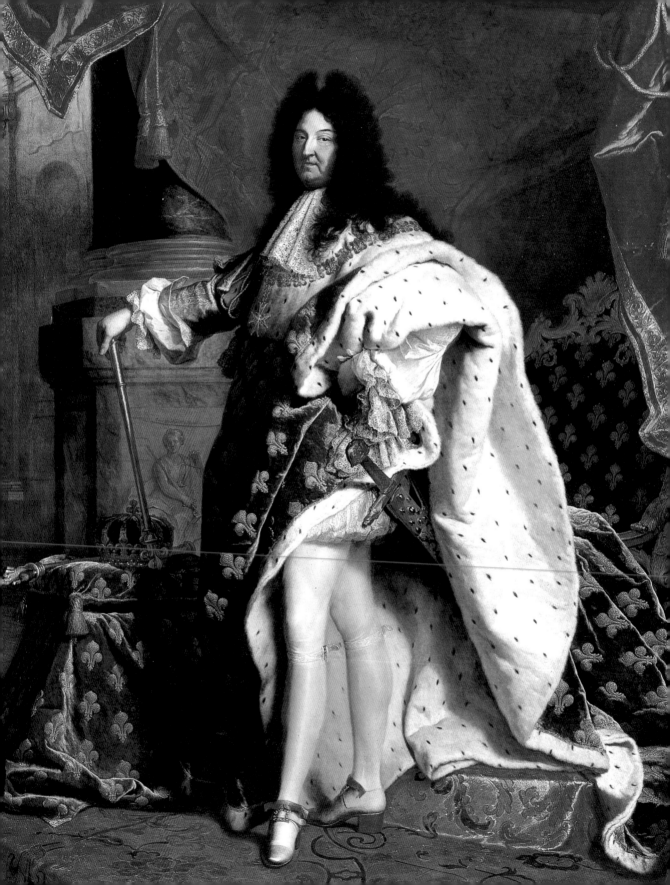

7

APPROACHES
TO ART

I T IS A TRIBUTE to the multivalent character of images that a single work of art can be read in different ways and that these are not necessarily mutually exclusive. This, in turn, is another explanation of the power that imagery can exert over us. Such readings are influenced by the viewer's notion of context, which is related to interpretative preference. Just as beauty may be in the eye of the beholder, so one's view of artistic significance can vary according to a theoretical bias. Depending on one's approach to the subject of creativity, one can read works from the point of view of their social, political, gender, economic, intellectual, or aesthetic context.

The different ways of approaching art are known as the methodologies of art-historical analysis, and they generally include formalism, iconography, Marxism, feminism, semiotics, biography and autobiography, and psychoanalysis. In this chapter, a still-life painting, dated March 1888, of wooden clogs (fig. 7.1) by van Gogh—along with a few other images of shoes—is considered from different methodological viewpoints.

FORMALISM

In Chapter 3, we discussed works of art in formal terms, according to the elements of the artist's visual language. The formalist approach considers images from the point of view of line, shape, color, and so forth, and of the aesthetic effect of their arrangement. Applying this method to van Gogh's

OPPOSITE
Hyacinthe Rigaud,
Louis XIV, 1701.
(see also fig. 7.7).

7.1 Vincent van Gogh,
A Pair of Wooden Clogs,
Arles, March 1888.
Oil on canvas, 12¾ × 16 in.
(32.5 × 40.5 cm).
F 607, JH 1364.
Rijksmuseum Vincent van
Gogh, Vincent van Gogh
Foundation, Amsterdam.

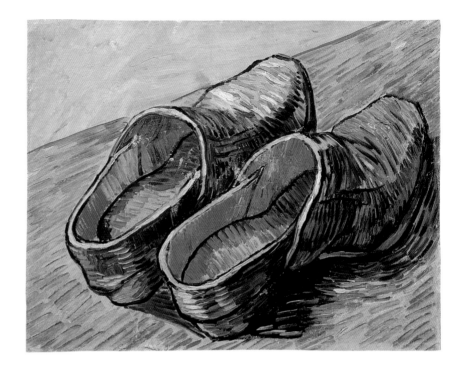

painting of a pair of clogs, we notice that the surface on which the shoes rest tilts upward, forming a prominent diagonal plane. The surface is a rich yellow-orange, and the background is a light yellow-green. The shoes themselves are depicted in varying tones of gray and cast shadows ranging from gray to black to green. The unifying color is yellow, a component of green and orange. Blacks, whites, and grays, which are not part of the spectrum (see Chapter 3), accentuate the areas of color by contrast.

Each shoe is roughly oval, and the pair is enclosed by a surface in the shape of an irregular pentagon. The light green background is triangular and echoes the tilt of the shoes. The strong outline around the sections of the shoes and along the edge of the surface on which they rest provides a contained framework for exuberant color. What is particularly characteristic of van Gogh's visual language in this painting is the use of individual, intensely chromatic, thick, prominent brushstrokes animating the painted surface of the canvas. The forceful brushstrokes and the sense of order and control in their structure convey the artist's determined commitment to his work. One might also say that the force of van Gogh's line is consistent with the notion of hard peasant labor implied by the clogs. Likewise, his bright color can be associated with the effects of outdoor light, which interested the nineteenth-century Post-Impressionists.

ICONOGRAPHY

The power of an image resides in its ability to communicate in an aesthetic as well as a meaningful way. If the image is an effective one—and van Gogh's images are effective—form and meaning reinforce each other. Iconography refers to the meaning of content and subject matter; as such, it is a method more often used in reading figurative than nonfigurative works. The traditional iconographic reader assumes that there is a text, generally a written text, on which an image is based. In the case of van Gogh's paintings of shoes, of which he made several, there is no known written text other than what van Gogh himself said about the subject. And what he said would be read according to a biographical/autobiographical approach, which is discussed below.

One could, however, remove van Gogh's shoes from the personal context to the broader thematic context of what shoes have meant in cultural and artistic history. In other words, one might engage in an iconographic study of shoes. This would be a lengthy task since shoes are imbued with multiple meanings and there are enormous numbers of shoe images throughout the world. So in what follows, we engage in a mini-discussion of shoe iconography.

7.2 *Palette of Narmer*, from Hierakonpolis, c. 3100 B.C. Slate, 25 in. (63.5 cm) high. Egyptian Museum, Cairo.

An Iconographic Excursion into Shoes and Feet

We know that Muslims remove their shoes when they enter a mosque. The antiquity of the notion that shoes must be removed when one stands on holy ground is clear from the predynastic Egyptian *Palette of Narmer* (fig. 7.2), which dates to around 3100 B.C. This was a ritual object found in a temple but is of a type used by Egyptian women to hold cosmetics. Carved in low, flat relief, the pharaoh Narmer (also known as Menes), who united Upper and Lower Egypt, is shown protected by the gods as he sub-

dues his enemies. Standing behind him is the small figure of his servant, who holds his sandals. Narmer himself is barefoot, indicating that he is in a sacred space. The vulture god, Horus, protects the head of the king, and two Hathor heads (the horned cows) at the top of the palette guard the sign of the palace and the name of the king.

Shoes are related to feet, which in most cultures are endowed with symbolic meaning. In Christianity, feet and shoes can be associated with pilgrimage, a religious journey undertaken on *foot*. In Buddhist art, a pair of footprints refers to the first steps of the baby Buddha, related to an earlier belief in a god-king who encompassed the entire world in a few steps. In nineteenth-century European painting, reflecting various cultural constructions of childhood, the subject of a child's "first steps" became a popular iconographic theme (one example of which was painted by van Gogh).

Traditional Chinese culture considered women with large feet unattractive—hence the custom of footbinding. Dainty feet are also considered an asset for Western women, reflected in the irony of the old song "My Darling Clementine," about a lost love whose shoes were "number nine." The erotic associations of shoes and feet, which are at the root of such preferences, have been alluded to by many artists. For example, a Hellenistic statue, the so-called *Slipper-Slapper* (fig. 7.3) of around 100 B.C., shows Aphrodite, the Greek goddess of love and beauty, warding off the unwanted advances of a lusty satyr (part goat and part man) with her sandal. The work was found on the island of Delos in a private context—a house where merchants regularly gathered—and has been interpreted in various ways. Some scholars believe that Aphrodite is protecting her virtue, others that she is using the sandal for erotic foreplay. The small figure of Cupid (Eros, in Greek) has been variously read as assisting his mother in her resistance, as encouraging the satyr's advances, and, purely formally, as a link between the two larger figures. So the question remains, is the slipper a weapon or an erotic enticement? In either case, the iconography is sexual, and the shoe plays a prominent role in its sexuality.

To the degree that Aphrodite's sandal is a weapon used to repel an attack, it has phallic quality, and to the degree that

7.3 *Slipper-Slapper*, c. 100 B.C. Marble, height: 4 ft. 4 in. (1.32 m). Museo Archeologico Nazionale, Naples.

it is an enticement, it is a vaginal symbol and has a receptive, seductive quality. This ambivalence is generally characteristic of the different meanings assigned to shoes. In Jean-Honoré Fragonard's (1732–1806) *The Swing* (fig. 7.4), painted in the eighteenth-century Rococo style, the shoe is depicted as an erotic enticement in a garden of illicit romance. A pink shoe has

7.4 Jean-Honoré Fragonard, *The Swing*, 1767. Oil on canvas, 35 × 32 in. (88.9 × 81.3 cm). Wallace Collection, London.

7.5 Eugène Delacroix,
Women of Algiers, 1834.
Oil on canvas, 5 ft. 10⅞ in. ×
7 ft. 6⅛ in. (1.80 × 2.29 m).
Musée du Louvre, Paris.

been casually kicked into the air by the woman on the swing, the mistress of Baron de Saint-Julien, who commissioned the picture. The old man pushing the swing is a cleric, and the youth gazing under the dress of the woman is her young suitor. Three stone Cupids are present, one placing his finger to his lips and two clinging to a dolphin. As in the *Slipper-Slapper*, the Cupids signify romance.

In Eugène Delacroix's (1798–1863) *Women of Algiers* (fig. 7.5) of 1834, the setting is a North African apartment decorated with Moorish patterns. Three seductive women, one of whom is smoking opium, seem to be awaiting male company, while a black African turns in a dancelike motion. The reclining figure at the left occupies a pose intended to be enticing—an invitation issued to a male visitor. Reinforcing the invitation is the empty shoe with a deep red interior that is placed at the edge of the carpet. Its

diagonal plane draws the viewer's gaze into the picture space and directs it toward the woman. Another shoe points to the opium pipe.

The underlying text of Titian's *Rape of Lucretia* (fig. 7.6) is derived from Roman tradition. Lucretia was the wife of Collatinus, who described her virtues and incited the passion of Tarquin, son of the Etruscan king. Tarquin raped Lucretia, who killed herself rather than live in dishonor. In Titian's picture, Tarquin brandishes a knife as he threatens Lucretia; a servant

7.6 Titian, *Rape of Lucretia (Tarquin and Lucretia)*, 1568–71. Oil on canvas, 6 ft. 2⅓ in. × 4 ft. 9¼ in. (1.89 × 1.45 m). Fitzwilliam Museum, Cambridge.

looks on from behind the curtain. In contrast to the overpowering violence of the attack, Lucretia's empty shoes stand quietly at the lower right corner of the picture. Their significance is confirmed by the fact that one bears Titian's signature, which is the same rich red as Tarquin's costume. The predominance of reds, not only here, but also in *The Swing* and *The Women of Algiers*, has a sexual meaning and thus merges color with iconography.

Another cultural aspect of the shoe is its relationship to male power. In parts of Africa, shoes were a royal prerogative. In Dahomey, the king's sandals were made from the skins of leopards and lions, whose dangerous power was transferred to the king when he wore them. Among the Asante of Ghana, the king's elaborate sandals were decorated with gold; his feet were not allowed to touch the ground lest they pollute it. His subjects, on the other hand, went barefoot.

7.7 Hyacinthe Rigaud, *Louis XIV*, 1701. Oil on canvas, 9 ft. × 6 ft. 4⅜ in. (2.77 × 1.94 m). Musée du Louvre, Paris.

In the case of the seventeenth-century French king Louis XIV, shoes served another purpose. They elevated him, literally and figuratively. For a king of France who had declared himself the personification of the state ("L'état, c'est moi!"), it would not have been seemly to be short—which he was. So, as is evident in Hyacinthe Rigaud's (1659–1743) portrait of the king (fig. 7.7), Louis designed platform shoes with thick red heels and a red strap, which he wore on state occasions. He also donned them when he posed for his portrait, in this case wearing white silk stockings and displaying his legs as well as his shoes. The artist has carefully arranged the voluminous ermine and velvet robe so that it flows around, indeed frames, the king's elegant legs. Echoing the red of the shoes is the red curtain that has been pulled aside to reveal the king in all his splendor.

Shoes, as we have seen, can have both male and female significance and they embody various meanings attached

to gender and rank in different societies. The combination of a shoe and a foot has an erotic meaning, evident in foot fetishism, that is reflected in the story of Cinderella. When Prince Charming finds Cinderella's glass slipper, he decides to marry its owner. That is, he recognizes it as a metonymy (part for the whole) and, as such, it stood for his perfect mate. Cinderella's sisters had feet that were too big—that is, not sufficiently feminine. So when Cinderella finally tries on the slipper and "the shoe fits," she is symbolically prepared for her wedding night with the prince.

MARXISM

The Marxist approach to works of art considers them in the light of economic factors affecting their production and iconography. Marxist art historians follow Karl Marx's view that society is divided into a working class (the proletariat) and a ruling class (the bourgeoisie). In the case of van Gogh's *Pair of Wooden Clogs*, we might note that they are peasant shoes and, therefore, tied to the proletariat. Van Gogh, in fact, painted many pictures of working-class figures and associated clogs with them. (So did the eighteenth-century English author Oliver Goldsmith, who wrote in *Distresses of a Common Soldier*, "I hate the French because they are all slaves, and they wear wooden shoes.") Van Gogh was himself financially dependent his entire life, often lacking the money to buy paint and canvas. As a result, he was unable to pay for models, and shoes don't charge for posing.

If we consider the other "shoe" pictures in this chapter from a Marxist point of view, it is clear that economic factors can be brought to bear on them. Tarquin was the king's son and, therefore, of higher social status than Lucretia. Both Rigaud's *Louis XIV* and Titian's *Rape* were commissioned by kings, the latter by Philip II of Spain. Fragonard's *The Swing* was commissioned by a French baron, and the *Palette of Narmer* shows the might of the Egyptian pharaoh. In each case, economic power lies with a royal or aristocratic patron. But van Gogh had no patrons; no one bought his work during his lifetime, and his resulting poverty exemplifes the economic hardships suffered by nineteenth-century artists lacking financial resources.

FEMINISM

Feminist readings of art share with Marxism an interest in social and economic factors, particularly the way in which such factors relate to women

as both subjects and viewers of art. Van Gogh's clogs could belong to a man or a woman, which would be less true of upper-class shoes. Gender, in this case, is thus related to class, which merges a feminist reading of *A Pair of Wooden Clogs* with a Marxist one. One might argue that in van Gogh's painting class takes precedence over gender.

Van Gogh's shoes do not appear to have erotic meaning unless one reads them as inviting because they are open to the viewer's gaze. But this seems far-fetched. Not so, however, with the other shoe images illustrated here. Feminist readings of those works might focus on the notion of the male gaze and of the woman as its passive object. In *The Swing*, the woman is actively enjoying herself, but she is the man's "object" from four different viewpoints: of Fragonard (the painter), of Baron de Saint-Julien (who wanted the picture for his private pleasure), of the old cleric (pushing the swing), and of the suitor (looking up her dress). *Her* power, on the other hand, resides in her seductiveness, which is displaced onto her shoe and thus is not as permanent as the man's power. For having been kicked into the air, the shoe must fall. And in so doing, it becomes a metaphor for the proverbial "fallen woman."

Lucretia, in contrast to Fragonard's "swinger," preferred death to "falling" and thus felled herself but remained morally upright. Titian's Lucretia is shown as the victim in several ways: she is nude; she is flailing helplessly before an overpowering force; she is unarmed (Tarquin wields a knife); and she is being pushed backward, prefiguring her "fall." In the *Women of Algiers*, the three seated women are shown as passive. In the absence of men, they have nothing to do but wait, pacifying themselves—and making themselves passive—with opium. The space of the room and the women are in one respect identified with each other: both, like the red shoe, are receptacles.

Where, one might ask, are the women in the two images of kings discussed above? Clearly, they are marked absent, except in mythological or allegorical form. In the *Palette of Narmer*, the dominant female image is the pair of frontal Hathor heads flanking the sign of the king's name and palace. Hathor is a cow goddess and, therefore, female, but much of her power comes from her male attributes—the horns. The sphinx may be female, but this is not explicit; and even if it were, it would not be a real female but an imaginary one whose power is largely derived from her leonine component.

In Rigaud's *Louis XIV*, there is no queen, but a seated woman is shown in relief on the base of the large column behind the king. Like the females in Narmer's palette, she is not a real woman, but an allegory—in this

case, of France. As such, she is removed in time and space from Louis' present, which in this painting is all about himself—and his shoes.

SEMIOTICS

First introduced as a system of structural linguistics, semiotic readings have been applied to works of art. The basic unit of semiotics is the sign, which is composed of a signifier and a signified. The former is the material substance of the sign, either the letters comprising a word or the medium of an image. The latter is the mental concept attached to the signifier. So in the word *shoe*, the letters *s-h-o-e* comprise the signifier and our mental image of a shoe is the signified. According to structural linguistics, the connection between signifier and signified is purely arbitrary.

In semiotics as applied to the visual arts, there has been some softening of the insistence on arbitrariness. One would have to agree that van Gogh's painted clogs resemble our mental image, or idea, of clogs more closely than the letters *c-l-o-g-s*. Nevertheless, it is also true that the components of van Gogh's picture—namely, the individual brushstrokes—bear no resemblance to clogs. It is rather their arrangement that creates an *illusion* of clogs.

In Structuralist analysis, which is a category of semiotics, attempts are made to demonstrate cultural, literary, or artistic patterns (or structures). This approach has been applied to myth patterns, advertisements, menus, fashion, and other cultural expressions. Thus, van Gogh's shoes could be read semiotically as images intended to impart a message—for example, of poverty, of hard work, of durability, and so forth. The shoes depicted in the *Slipper-Slapper*, *The Swing*, the *Rape of Lucretia*, and the *Women of Algiers*, on the other hand, are erotic signs. Louis XIV's shoes are signs of his vanity—and also of his ingenuity.

Some semiologists read artistic signs in terms of developing genres and styles. In that case, *A Pair of Wooden Clogs* could signify nineteenth-century developments in still life. The tilting surface on which they rest might be a sign of the progressive flattening of space in Impressionism and Post-Impressionism. Likewise, the prominence of the brushstrokes signifies an artistic trend in which the artist's medium and process were becoming subjects of art and of art criticism. In Structuralism, therefore, meaning is conferred not so much by the artist (or author) as by the cultural system enclosing the work.

In contrast to the closed systems of Structuralism, Post-Structuralism—especially as practiced by the French philosopher Jacques Derrida—becomes a deconstructive system—that is, it opens up structures. Derrida's method of

7.8 Vincent van Gogh,
Two Shoes, 1886.
Oil on canvas, 14¾ × 17⅞ in.
(37.5 × 45.5 cm).
Vincent van Gogh Museum,
Amsterdam.

Deconstruction asks questions and pursues associative links among words, ideas, and images.

Derrida, addressing another painting by van Gogh of leather shoes with laces (fig. 7.8), got into a scholarly quarrel with the American art historian Meyer Schapiro and the German philosopher Martin Heiddeger.[1] Without going into the extensive political ramifications of the argument, suffice it to say that much of the discussion revolved around the nature of the shoes. Were they city shoes or peasant shoes? And were they, in fact, a *pair* of shoes, as both Schapiro and Heiddeger had asserted? Van Gogh didn't say, for he entitled the picture *Two Shoes*.

BIOGRAPHY AND AUTOBIOGRAPHY

The biographical method of reading art, as opposed to semiotics, insists that the authors/artists confer meaning on their works. Among the earliest examples of this method in Western art writing is Pliny's *Natural History*, discussed in Chapter 5 in connection with Rembrandt's *Self-Portrait As Zeuxis*. Pliny recorded many anecdotes about ancient Greek artists, such as Zeuxis, that revealed aspects of their personalities. The systematic and comprehensive biographies of artists in Vasari's *Lives* were written to preserve the lives, as well as the works, of Italian Renaissance artists. Earlier, in fifteenth-century Italy, artists had begun writing the first-known Western autobiographies of artists, which also became a genre of art writing.

When works of art are interpreted from a biographical viewpoint, their imagery and technique are read in light of the artist's life. Delacroix, for example, traveled to North Africa, where the rich Moorish colors, Arab horsemen, and perfumed harems captured his imagination. Rigaud was

Louis XIV's portrait painter and thus was bound by his patron's wishes. In that case, the picture reveals more of Louis' personality than that of the artist. In the case of Narmer's palette and the *Slipper-Slapper*, nothing is known of the artists, and early Egyptian art was so tightly controlled by royal convention that it is usually impossible to elicit the personality of either an artist or a patron.

A great deal is known about van Gogh's life not only because he is a fairly recent artist, but also because he regularly wrote letters to his brother Theo, describing his life and art. Those letters, like the pictures themselves, reflect van Gogh's interest in, and identification with, peasants and workers. In one letter, paraphrasing Millet, who also painted peasants, van Gogh wrote: "I'll get by alright since I am wearing clogs." This identification on van Gogh's part is an example of a myth-making convention of artists' biographies and autobiographies exemplified by Vasari. In the *Lives*, he described the humble origins of many Renaissance artists, their subsequent discovery by a wealthy or noble patron, and their consequent rise to fame.

According to Vasari, Giotto was a shepherd boy drawing a sheep on a rock when Cimabue happened by. The older artist, at that time the most famous living Byzantine painter in Italy, immediately recognized Giotto's genius. Cimabue then obtained the permission of Giotto's father to take on the boy as an apprentice. Similarly, in Vasari's life of Castagno, the artist is described as a shepherd who scratches out images on rocks and walls in the countryside. A member of the powerful Medici family hears of Castagno and searches him out. He is duly impressed and brings Castagno to Florence for formal training as a painter. Van Gogh did not become famous during his lifetime and was never recognized or encouraged by any patron, let alone a wealthy one. Nevertheless, when he called himself a "peasant painter," having the double meaning of being a peasant himself and of painting peasants, he was engaging in a tradition of artistic myth-making.

Van Gogh was no peasant. His father was a minister, and he himself studied for the ministry. He was fluent in English, French, and German as well as Dutch; he read widely, was highly literate, and taught school in England. He also worked for a time at branches of his uncle's art dealership in The Hague, Belgium, and Paris. In addition, van Gogh was a serious student of the history of art; he studied the old masters in the Louvre and Japanese woodblock artists, and made copies of their work. And although he had painted many pictures of peasants in his native Holland, he did not paint shoes until he moved to France. In order to pursue a biogra-

phical reading of van Gogh's shoes further, we turn to the psychoanalytic method of analysis.

PSYCHOANALYSIS

Psychoanalysis takes the methods discussed so far to a deeper, unconscious level of interpretation. The first application of psychoanalysis to an artist was published by Freud in 1910. It dealt with the life and work of Leonardo da Vinci, proposed a reading of the *Mona Lisa* based on a childhood memory recorded by the artist, and has been the subject of methodological disputes ever since. There are several schools of psychoanalysis whose adherents have written on art, and psychoanalytic theory has infiltrated modern art-historical thinking.

More psychological studies have been published about van Gogh than about any other artist. His paintings of shoes have been read as reflecting his wish for twinship with Theo, who was an art dealer; it was not until van Gogh moved into Theo's apartment in Paris that he painted his first still life of shoes. The subject of shoes preoccupied van Gogh over the course of his short life, and it resurfaced again when he lived briefly with the French artist Paul Gauguin in Arles. On that occasion, as with his brother, van Gogh was attempting to bond by forming a kind of twinship with another man. At the same time, however, van Gogh also struggled to have a normal relationship with a woman—to make a pair. This he never achieved, for his choices were consistently unsuitable, either because his affections were unrequited or because he insisted on trying to reform prostitutes. A psychoanalyst would wonder about the deeper meanings of van Gogh's personal choices, and here one is assisted by biographical information.

Van Gogh's birth occurred exactly one year after the birth of his stillborn brother, also named Vincent. The second Vincent's mother remained depressed by the death of the first Vincent and was emotionally remote. From his window, van Gogh could see the grave of his dead brother, which almost certainly evoked a sense of guilt for having survived. His younger brother, Theo, was not born until four years later, by which time Vincent had been traumatized by a depressive, aloof mother and a stern father who was a Dutch Reform pastor. Van Gogh's search for twinship with another man combined his wish to revive the dead Vincent, to continue the close childhood friendship he had had with Theo, and to bond with a loving and supportive father. After Theo married and began a family of his own, it was difficult for him to give Vincent the attention Vincent craved, although Theo continued to

support his brother financially and emotionally throughout their lives.

Van Gogh's shoes embody two themes in his lifelong efforts to make relationships. On the one hand, a pair of shoes is a double; as such, it makes visible the wish for another self, in the form of a dead brother, a living brother, a fellow artist, or a father with whom to identify. On the other hand, insofar as shoes form a pair, they reflect the artist's repeated efforts to join with a woman.

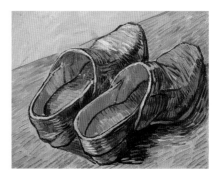

Vincent van Gogh, *A Pair of Wooden Clogs*, March 1888 (see also fig. 7.1).

Other shoes illustrated in this chapter also lend themselves to psychoanalytic analysis. Titian's *Rape of Lucretia* is the most violent of the works that he produced for Philip II of Spain. It can be read as a child's fantasy of a sadomasochistic primal scene, the act of procreation performed by adults. Signifying the child's presence is the servant peering around the curtain, unseen by the protagonists but visible to the viewer. The viewer, like the servant, is in the position of the curious child, riveted by a violent sexual attack.

It would appear from the women Titian painted that he admired them greatly, although virtually nothing is known of his relations with women. In this painting, his identification with Tarquin's passion is suggested by the red costume matching the red signature in the shoe. Titian has sublimated his aggression—not only in the act of painting, but also in the iconography of the painting. If we read Lucretia's shoe as standing for her (it stands in the corner of the picture), then the paintbrush with which Titian signed the shoe may stand for Tarquin's knife, which in turn stands for his aggressive phallus. The other shoe lies on a horizontal, parallel to the bed onto which Tarquin pushes Lucretia.

Vincent van Gogh, *Two Shoes*, 1886 (see also fig. 7.8).

Van Gogh's shoes illustrated here are empty. They do not form part of a visible narrative, and no one is wearing them. Their very emptiness might reflect the artist's loneliness and his feelings of absence in relation to other people. But shoes are also connected to people and may signify van Gogh's wish for connections. Such multivalent readings of van Gogh's shoes are characteristic of the psychoanalytic approach to imagery. Because there is no time in the unconscious, its expressions, like the elements of a dream, can surface out of temporal sequence. As a result, the psychoanalytic method focuses on thematic material as well as on historical narrative, recognizing that the interplay between them is always dynamic in nature.

8

ARGUING
ABOUT ART

I T IS BECAUSE WE IDENTIFY with images that the visual arts have
engendered such a great deal of controversy. In some cases the dis-
putes are purely aesthetic, while in others they are a reflection of religious,
political, and moral concerns. Throughout history, works of art have been
admired, despised, ridiculed, ignored, feared, vandalized, plundered, forged,
and stolen. When artists disrupt our formal expectations, as Kandinsky and
Pollock did by eliminating recognizable subject matter from some of their
work, we can be disturbed by the image. We might even think that the
artist is trying to put one over on us, which would be an affront to our
intellect. Similarly, Picasso's distortions challenged the Classical ideal and
its flattering image of human form. For those of us who like attractive images
of ourselves and our fellow humans, such distortions are an affront to our
narcissism.

Certain works of art have come to represent something beyond
their purely formal qualities and have thus assumed varying degrees of
cultural importance. This becomes apparent when such works are stolen
or vandalized. Imagine, for example, how people in the United States would
react if the Statue of Liberty were stolen, or the Vietnam War Memorial van-
dalized, the Chrysler Building toppled, or the Washington Monument
demolished. These monuments have been imbued with cultural meanings
that give them value beyond their aesthetic appeal. In this chapter, we
consider some of the ways in which works of art have been received by their
audience and some of the effects of that reception.

OPPOSITE
Andres Serrano, *Johnny*, 1990
(see also fig. 8.12).

ART AND POLITICS

In the ancient Mediterranean world, it was standard practice for victorious armies to plunder the art works of their defeated enemies. Because of its enormous amount of plundered works, ancient Rome was known as a city of sculpture. The emperor Titus looted the Temple of Solomon when he sacked Jerusalem in A.D. 70. In the second century B.C., the consul Lucius Aemilius Paullus took so much booty after defeating Macedon that an entire day was required to parade the spoils through Rome.

Hammurabi's Law Code

8.1 Law Code of Hammurabi, c. 1792–1750 B.C. Black basalt, 7 ft. (2.13 m) high. Musée du Louvre, Paris.

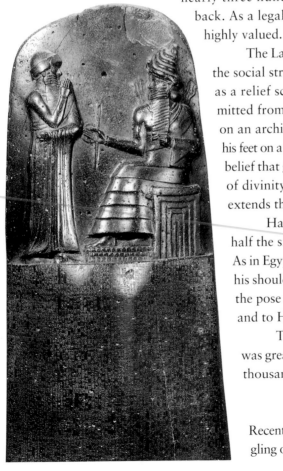

In 1170 B.C., the Elamites stole the Babylonian Law Code of Hammurabi (fig. 8.1), the oldest surviving legal code of the ancient Near East. The object itself is of little material value; it contains a relief sculpture at the top and nearly three hundred statutes in cuneiform text below and on the back. As a legal and social document, however, the Law Code was highly valued.

The Law Code is also valuable to us today as a window onto the social structure of Babylon in the second millennium B.C. and as a relief sculpture. The relief shows legal power being transmitted from the sun god Shamash to Hammurabi. Shamash sits on an architectural throne that signifies the palace, and he rests his feet on a stylized mountain, this latter reflecting the Mesopotamian belief that gods inhabit mountains. Shamash wears a horned cap of divinity, the sun's rays emanate from his shoulders, and he extends the staff and ring of kingship toward Hammurabi.

Hammurabi wears a round cap and a long robe. He is half the size of the god, which indicates his lesser importance. As in Egyptian art, Shamash's head is in profile, his eye is frontal, his shoulders are frontal, and his legs are in profile. In this case, the pose allows the god to relate simultaneously to the viewer and to Hammurabi.

Today, the Law Code is in the Louvre, whose inventory was greatly expanded when the armies of Napoleon plundered thousands of art works from conquered territory.

The Schliemann Treasure

Recently, the plundering of archaeological sites and the smuggling of stolen art objects for purchase by collectors interested

in antiquities, along with the globalization of the planet, have led to debates about cultural property. What constitutes cultural property? When should stolen works be returned? And when are they better off outside of their original context? These are questions that are continually under discussion, and their ramifications can be highly complex. A paradigm for such issues is the case of the so-called Schliemann Treasure.

In the nineteenth century, Heinrich Schliemann, a German businessman-turned-amateur-archaeologist, concluded from reading Homer that the Trojan War had been an actual historical event. He traveled to the archaeological site of Hisarlik, in Turkey, which he believed was the site of Troy, obtained permission to excavate, and promised the Turkish government to share his finds with them. Among the more than 10,000 works that Schliemann removed from the site was the "Treasure of Priam," named for the ancient king of Troy. Also known as "Treasure A" and actually dating to a period some one thousand years earlier than the Trojan War, the hoard consisted of gold, silver, electrum, and bronze objects, tools, jars, and jewelry, totaling over 183 works. But Schliemann failed to share this particular group of objects with Turkey. Instead, he smuggled them to Athens, where he lived with his Greek wife. In 1881, he donated them to Germany.

In 1890, when Schliemann died, parts of Treasure A remained in Athens, but most of it was on exhibit in Berlin. During World War II, the Germans placed their most valued artworks in bomb-proof basements. At the end of the war, Allied forces recovered works looted by the Nazis, but the Schliemann Treasure was nowhere to be found. It was not until 1991 that it was revealed to be in museums in Moscow and St. Petersburg.

In New York in 1997, at an international symposium on issues of cultural property, Turkey, Germany, and Russia each stated the reasons for its claim to the objects. The Turkish delegate argued that his country was the rightful owner of Treasure A because the original site was in Turkey and because the works had been illegally exported in defiance of Turkey's agreement with Schliemann. Furthermore, in the interests of archaeological integrity and historical accuracy, Turkey believed that the world of scholarship would benefit from the return of the hoard to its country of origin.

The German delegate countered
been a gift from Schliem
on displa

any further claim to the treasure. In addition, the Germans said, conventions of war require the return of looted art—in this case, to Germany.

The Russians argued that Russia had been on the winning side of World War II, whereas Germany had not only started the war, but had lost it as well. As a result, Russia felt that the works rightfully belonged in Russian museums. However, the Russian government recognized the importance of international intellectual exchange and agreed to exhibit the works publicly and make the treasure available to scholars.

The Elgin Marbles

In a similar controversy, the fate of the Elgin Marbles has been argued by government officials and archaeologists for years. In the early nineteenth century, Thomas Bruce, seventh earl of Elgin, obtained permission from the Turkish government (then in control of Greece) to remove sculptures from the Athenian Acropolis (fig. 8.2). These included marble sculptures from the Parthenon that had been carved by Phidias during the Classical period. As a result, the works are among the most prized products of ancient Greece. Beginning in 1812, Lord Elgin sent several shipments of sculptures, one of which sank, to England. Four years later, they were purchased by the British Museum, where they remain on exhibit today.

8.2 View of the Acropolis, Athens.

In contrast to the Schliemann Treasure, the Elgin Marbles were legally removed from their country of origin. Their archaeological context is well known and will not be further elucidated by their return to Athens. Nevertheless, Greece has been urging the return of the marbles for years, so far to no avail. The British argue that the cultural heritage of Greece was in no way disturbed by the removal of the sculptures (not counting the shipment that sank) and that the works are readily available for study by scholars. In addition, the British point out that had the sculptures remained on the Parthenon, they would have been either blown up (the Turks used

the Parthenon as an arsenal, which exploded during a bombardment) or ruined by modern air pollution in Athens. The economic advantages of owning the marbles are, of course, obvious, for they are one of London's most visited tourist attractions.

Han van Meegeren and the Forged Vermeers

Another example of the political importance of works of art can be seen in the case of the Dutch painter Han van Meegeren.

During World War II, Hermann Goering, Hitler's Reichsmarschall, had expansionist ambitions similar to those of Napoleon. Not only did he preside over Hitler's plans for world conquest, but he also stole, or forcibly bought at rock-bottom prices, hundreds of millions of dollars in art from Germany's defeated enemies. This was in direct violation of the 1907 Hague Convention, which made it a crime to steal or destroy cultural property in times of war. Hoping to evade detection, Goering hid the art in two separate castles and a bomb-proof tunnel, many of the works taken from the collection of the Rothschilds of France and other prominent Jewish families. Goering's later assertion at the Nuremberg trials that his aim was simply to protect the art from air raids did not impress the prosecutors.

After the Allied army task force had recovered Goering's stash of stolen art, the United States 101st Airborne Division mounted an exhibition of the works. In addition to hundreds of old-master paintings, Impressionist works, and an impressive collection of jewels, there was a Dutch picture variously entitled *Christ and the Woman Taken in Adultery* and *The Adultress* (fig. 8.3). This was signed "I. V. Meer," a signature known as that of Johannes Vermeer of Delft (1632–1675), one of the world's most highly valued artists. The picture depicts Christ admonishing the biblical adultress, who bows her head in shame. In the background, two elders of the Temple look on

8.3 Han van Meegeren, *Christ and the Woman Taken in Adultery*, 1930–44. Oil on canvas, 35½ x 39⅜ in. (90 x 100 cm). Netherlands Institute for Cultural Heritage, Rijkswijk, Amsterdam.

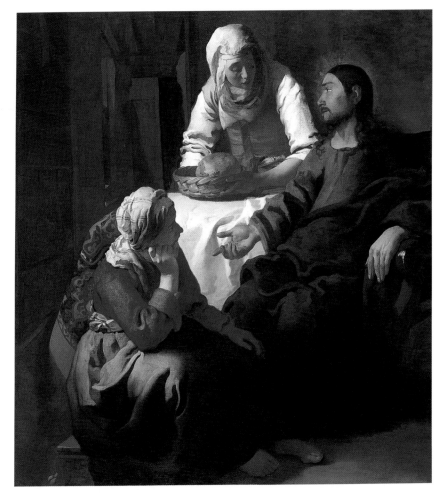

8.4 Johannes Vermeer, *Christ in the House of Mary and Martha*, c. 1654–55. Oil on canvas, 5 ft. 3 in. x 4 ft. 8 in. (1.60 x 1.42 m). National Gallery of Scotland, Edinburgh.

by Vermeer sparked the interest of the international art world. Without the benefit of comparison—Vermeer's known works had been placed in storage to protect them from the Nazis—potential buyers had to rely on their recollections and on reproductions of authentic pictures. *Christ and the Woman Taken in Adultery* did not resemble Vermeer's signature style, which consists mainly of genre interiors, one street scene, and a large-scale *View of Delft* (now in the Mauritshuis in The Hague). However, an early painting in the National Gallery of Scotland, *Christ in the House of Mary and Martha* (fig. 8.4), was widely believed to date from an early stage of Vermeer's career, when he painted biblical subjects.

In 1937, another work attributed to Vermeer's early biblical period had been authenticated by the esteemed Dutch art critic Abraham Bredius, who was eighty years old and whose eyesight was failing. This painting of

the *Supper at Emmaus* (fig. 8.5), despite the reservations of a number of experts, was eventually sold to the Boymans Museum in Rotterdam for the equivalent of what would today be $500,000. In 1939, the museum acquired two more early "Vermeers," a *Head of Christ* and a *Last Supper*. Other "Vermeers" attributed to the same period were sold to important Dutch collections through respectable dealers.

As with the Elgin Marbles and Schliemann's Treasure A, the works of Vermeer are national treasures. This meant that the recovery of *Christ and the Woman Taken in Adultery* appealed to Holland's patriotic pride at the end of World World II. Determined to find out how the painting fell into Nazi hands, the Allies began to search for the picture's provenance—that is, the record of its previous owners—which they traced through a dealer to one Han van Meegeren.

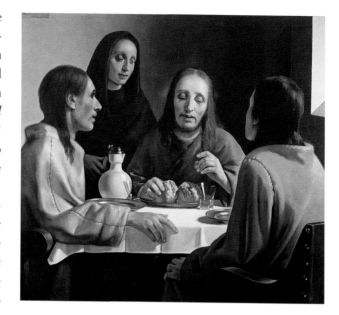

8.5 Han van Meegeren, *Last Supper at Emmaus,* early 1930s. Oil on canvas, 3 ft. 10 in. × 4 ft. 2¾ in. (1.17 × 1.29 m). Collection Museum Boijmans van Beuningen Museum, Rotterdam.

Van Meegeren was a second-rate but popular painter and illustrator in Amsterdam with a reputation for alcoholism and drug addiction. By the end of the war, he had become quite wealthy and owned more than fifty private town houses. The Dutch authorities took dealing with the Nazis seriously and decided to question van Meegeren about the source of the painting. He claimed to have bought *Christ and the Woman Taken in Adultery* from an Italian aristocrat who did not wish to be identified. The following day, the Dutch arrested van Meegeren for selling national treasures to the enemies of Holland.

Brought to trial for treason, van Meegeren did the only thing he could think of to save his life. He confessed to having painted the works himself. This startling announcement met with skepticism, until van Meegeren proved his assertion by painting another forgery und

Supplied with the drugs to wh

#49294 © Highsmith, Ing. 2005

Dutch were so eager to discover new works by Vermeer that they overlooked the warning signs, of which the most obvious is style. Despite the fact that van Meegeren used Vermeer's pigments and some of his still-life details such as the white jug in the *Supper at Emmaus*, his style differs in significant respects from that of Vermeer's *Christ in the House of Mary and Martha*. Van Meegeren's figures, larger in scale than Vermeer's, are never shown below waist level, and the interior spaces they occupy are more crowded. They are closer to the picture plane and are placed in a narrow space as if pushed forward by a wall.

The physiognomies of the figures are also significantly different. Van Meegeren's faces are broader than Vermeer's, and the eyelids droop in a pronounced manner. Vermeer's figures are engaged in moments of tension that are also characteristic of his later works. His Christ leans back toward one of the women as he gestures toward the other. The planar movement created by the diagonals of the three figures is absent in van Meegeren's forgeries. And, finally, the play of light and shadow is far more subtle in Vermeer, which accentuates the sense of a hidden tension between the figures.

In defense of the Dutch who fell for van Meegeren's fraud and failed to read the formal elements of style accurately, it should be pointed out that forgeries are more easily recognized after the fact—usually by about a generation. This is because whatever van Meegeren's contemporaries responded to in Vermeer was shared with van Meegeren himself. The reception of imagery is, to a large degree, culturally determined, and hindsight is 20/20, a fact that is further apparent from the history of aesthetic arguments.

AESTHETIC QUARRELS

Western art history is fraught with aesthetic quarrels that have sparked intensely passionate responses from adherents of one side or another. During the Renaissance in Italy, artists and critics discussed the merits of sculpture versus those of painting. Leonardo argued that painting was superior because it was the more gentlemanly pursuit. He noted that when sculptors work, they become covered in marble dust and create a huge racket with hammers and chisels; but painters can work calmly and quietly, dress well, and listen to music.

Vasari, in his preface to the *Lives*, elaborated on the quarrel between the merits of sculpture and painting. According to the sculptors, he wrote,

God made the first man in the form of a statue. They argue the superiority of sculpture over painting on the grounds that statues are made of durable materials such as bronze and marble. To this the painters point out that, although sculptures may last longer than paintings, this is not necessarily a virtue. "If length of life were to give nobility to souls," they say, "the pine, among the plants, and the stag, among the animals, would have a soul more noble beyond compare than that of men."[1] Furthermore, the painters note, they are able to make corrections in their work more easily than the sculptors can. Citing an example from antiquity, the painters point out that the brush has "this advantage over the sculptor's chisels, that it not only heals, as did the iron of the spear of Achilles, but leaves its wounds without a scar."[2]

In response to the sculptors' argument that, because they use costly materials, their work is more expensive than paintings, the painters cite the example of Alexander the Great. So much did he admire the paintings of Apelles, the only artist permitted to paint his portrait, that Alexander gave him his beloved mistress, Campaspe. "Let them [the sculptors] find a greater price," challenge the painters.[3] With regard to the debate over value, the painters also note that the Golden Fleece, "however celebrated it may be, none the less covered nothing but an unintelligent ram."[4]

To the sculptors' claim that their physical labor is more intense than that of the painters, painters argue that their work relies on the intellect. To emphasize the ingenuity of painters, Vasari also cites the example of the Venetian painter Giorgione da Castelfranco, who painted a picture to demonstrate that viewers could see as much in a painting as in a sculpture. Giorgione's picture showed a figure with his back turned, his front being reflected in a pool of water and his side views in mirrors on either side of him. Such arguments, designed to illustrate the intellectual character of painting, reflect the Renaissance struggle to elevate painting from its medieval status as a craft to that of a Liberal Art. Opponents of the idea claimed that because painting was made with one's hands, it was manual labor and, therefore, not an intellectual pursuit. Vasari himself finally attempted to solve the controversy between painting and sculpture by concluding that they are sisters.

In the nineteenth century, photography ran into a similar problem. Was it art or simply mechanical reproduction? In this case, those opposed to according photography the status of art did so because it was *not* made by hand. They considered photography useful for journalism, science, and industry, but not an artistic medium. Today, most people would agree that

photography is an art, although there are related arguments over the merits of so-called high art and low art. What seems to be a matter of great moment to one generation, therefore, may be taken for granted by a succeeding one. Another good example of changing tastes can be seen in the various responses to the 1913 Armory Show.

The Armory Show

In 1913, the general public in the United States had not yet been exposed to European abstraction. The armory of the Sixty-ninth Regiment of the National Guard in New York City mounted an exhibition of 1,200 modern European works, along with some by avant-garde American artists. Judging from the critical response, the exhibit was a shock to New Yorkers, many of whom responded as if they were being asked to wear the emperor's new clothes.

Writing in the Sunday *Times* on January 26, before the show opened, photographer and avant-garde art dealer Alfred Stieglitz had optimistically described it as follows:

> The dry bones of a dead art are rattling as they never rattled before. The hopeful birth of a new art that is intensely alive is doing it. A score or more of painters and sculptors who decline to go on doing merely what the camera does better, have united in a demonstration of independence.[5]

But not all viewers were as pleased with the Armory Show as Stieglitz was. Journalists criticized the thickly painted surfaces of Post-Impressionist paintings and the jumbled geometric forms and spaces of Cubist works. In response to Marcel Duchamp's now famous painting of 1912 entitled *Nude Descending a Staircase No. 2* (fig. 8.6), the following appeared in the February 23 edition of the *Sun*:

Nude Lady Descending Staircase

O lady fair,
As down the stair
You trip, your air
Enthralls my being!
Ah, could you wis
The sense of mys-

Tery, the bliss
With which I'm seeing.

The face unguessed,
The form repressed,
And all the rest
Unseen, I'm chanting
Each curlicue
And whirl of you,
Each splotch and hue
But leaves me panting.

A tear unbid
From 'neath each lid
has downward slid.
Ah, depth of woe! You
Upon the street
Suppose I meet;
I cannot greet
You. I won't know you![6]

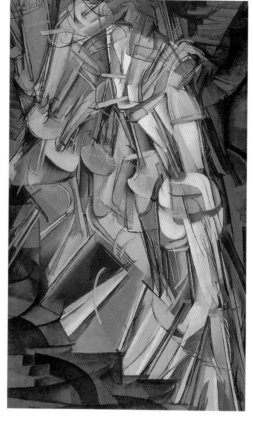

8.6 Marcel Duchamp, *Nude Descending a Staircase No. 2*, 1912. Oil on canvas, 4 ft. 10 in. × 2 ft. 11 in. (1.47 × 0.89 m). Philadelphia Museum of Art, Louise and Walter Arensberg Collection.

Some critics took a dimmer view of the Armory Show, considering it politically subversive and dangerous to the welfare of the country. When the show closed in New York, the *Times* printed an editorial that included the following assertions: "It should be borne in mind that this movement is surely a part of the general movement, discernible all over the world, to disrupt and degrade, if not to destroy, not only art, but literature and society too. ... The cubists and futurists are own cousins to the anarchists in politics, the poets who defy syntax and decency, and all would-be destroyers who with the pretense of trying to regenerate the world are really trying to block the wheels of progress in every direction."[7]

When the exhibition arrived in Chicago, a moral tone characterized the reception of the new work. It was denounced in the *Examiner* on April 1 as "blasphemous." "Our splendid Art Institute is being desecrated," wrote one critic. He identified as "pollution" "several paintings of the nude; portrayals that unite in an insult to the great, self-respecting public of Chicago."[8] A nude by Gauguin was declared "as obscene as it is vice." The president of the Chicago Law and Order League said that it was a "grave mistake to permit these pictures to hang here or elsewhere."[9]

The irony of all this, of course, is that, like Hitler's show of "degenerate art" held on July 19, 1937, twenty-four years later, the Armory Show exhibited the most significant artists of the period. As is often the case, it took about a generation for people to realize the importance of what had on first viewing seemed outrageous. And, as with the recognition of van Meegeren's forged Vermeers, hindsight is generally more discerning than viewing in the present.

Richard Serra and the Tilted Arc

In the United States, as elsewhere, vigorous aesthetic quarrels have arisen over public displays of art. Part of the reason for this is that people who dislike the work feel that it has been foisted on them and that their space has been invaded without their consent.

In 1981, the American sculptor Richard Serra was commissioned by the Art-in-Architecture program of the federal government to create an outdoor sculpture. It had been approved by three art experts and was to be displayed in the plaza in front of the Foley Square Federal Building in New York City. Serra's *Tilted Arc* (fig. 8.7) was a Minimalist sculpture that measured 120 feet long, 12 feet high, and a slim 2½ inches deep. Consistent with the Minimalist style, *Tilted Arc* was made not of traditional media such as bronze, wood, or marble, but of a manufactured, industrial material— Cor-Ten steel. This reflected the Minimalist ideal of eliminating all trace of the artist's presence in a work and of reducing it to simple geometric forms.

Less than two months after its installation, *Tilted Arc* was in

8.7 Richard Serra, *Tilted Arc*, 1981. Cor-Ten steel, 12 ft. (3.66 m) high × 120 ft. (36.58 m) long × 2½ in. (6.4 cm) deep. Destroyed.

trouble. Thirteen hundred government workers signed a petition protesting the sculpture. They felt that it blocked their freedom of movement in the square, forcing them to walk around it when going to and from work. Both the government and the art world, they said, were imposing on them. There was much discussion in the press about the fate of *Tilted Arc*, with the artist objecting to proposals that a new location be found for the work. He considered it "site-specific"—that is, made for that specific location; the work would thus have been out of context, had it been moved. Notwithstanding Serra's assertion that removal of his work amounted to government censorship of the arts, *Tilted Arc* was destroyed in 1989.

ICONOCLASM

The term *iconoclasm* refers to the breaking of images, usually because they strike viewers as dangerous in some way. Serra's *Arc* was considered more of a nuisance than a danger, but it was destroyed nevertheless. In the history of art, iconoclasm has tended to be a result of religious and moral objections to imagery; but, as we will see, these objections can be political as well.

We are familiar with Moses' angry response to the Hebrews' worshiping the golden calf. Moses, like the God of the Second Commandment, objected to idolatry—the worship of idols rather than of God. It is interesting in light of this tradition that in 1978, a painting in the National Gallery in London entitled *The Adoration of the Golden Calf* (fig. 8.8) by the French painter Nicolas Poussin (1594–1665) was vandalized by a man subsequently diagnosed to be schizophrenic. Although at the time the National Gallery and the press offered no reason for this action, it is clear that the image of idolatry disturbed the vandal.[10] The original damage marks indicated that the golden calf sustained the brunt of the attack, suggesting that it, rather than the worshipers, had been the focus of the vandal's hostility.

In the eighth and ninth centuries, the so-called Iconoclastic Controversy erupted with the Iconophiles (mainly in Western Europe) favoring imagery and the Iconoclasts (mainly in Byzantium) opposed to imagery. In the year 730, Emperor Leo III passed an edict forbidding graven images, which partly accounts for the minor role played by sculpture in Byzantine art. In 843, the edict was revoked, which led to an artistic revival.

During the French Revolution, angry mobs smashed the doorjamb statues at Chartres Cathedral because the figures represented royalty. In this case, the iconoclasts misread the sculptures' iconography and did not realize

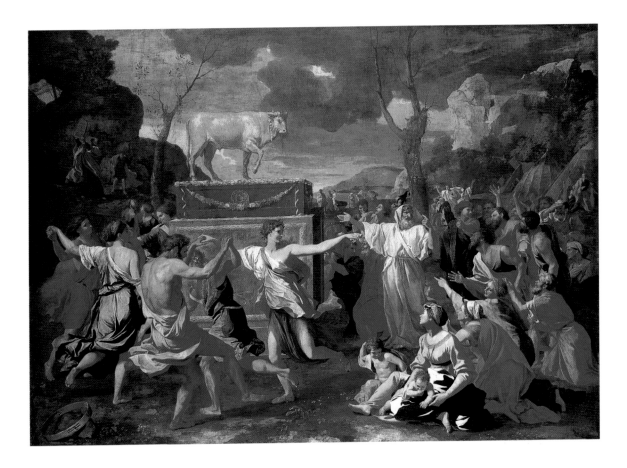

8.8 Nicolas Poussin, *The Adoration of the Golden Calf*, c. 1633–37. Oil on canvas, 60½ × 84¼ in. (154.0 × 214.0 cm). National Gallery, London.

that the kings and queens in question were biblical rather than French. In the 1970s, the Cultural Revolution under Mao Zedong caused thousands of ancient temples, pagodas, and other masterpieces of Chinese art and architecture to be destroyed. And in 1991, when the Communist governments of Eastern Europe fell, statues of former leaders were toppled.

In Islam, as in Judaism, graven images are prohibited as an affront to God. As a result, most Islamic art avoids the human figure. Instead, Islamic artists have developed elaborate calligraphies and patterned designs of great complexity.

An extreme case of Islamic iconoclasm occurred in March of 2001, when the Taliban, the radical Muslim leaders in Afghanistan, ignored pleas from the international art community and breached the 1972 UNESCO World Heritage Convention and the Geneva Convention riders of 1977 and 1997 banning the destruction of cultural property. The Taliban blew up two colossal statues of Buddha in the Bamiyan region of the country because they

were pre-Islamic. Dating to around A.D. 500, these statues were among the greatest pieces of early Buddhist art and had been a significant tourist attraction. Both Buddhas, one measuring 125 feet (38 meters) and the other 174 feet (53 meters) in height, were carved into the rock face of tall cliffs. In the seventh century, a Chinese monk described the larger figure as "glittering with gold and precious ornaments." Having survived the armies of Ghengis Khan and Tamerlane, the Buddhas fell victim to modern explosives and religious fanaticism.

In retrospect, the action of the Taliban was an ominous prelude to the destruction of the World Trade Center in New York City on September 11, 2001. Muslim hijackers gained control of two airplanes and flew them into the twin towers, killing over 3,000 civilians. In addition to the barbaric loss of life, the attack can also be seen as directed against what had been the tallest buildings in the world, representing the heights of international prosperity as well as being icons of American architecture.

8.9 Michelangelo, *Pietà*, 1498–1500. Marble, 5 ft. 8½ in. (1.74 m) high. Saint Peter's, the Vatican, Rome.

Art and Morality

Moral outrage in response to imagery, as we saw in Pope Paul IV's desire to erase Michelangelo's *Last Judgment* and in the Armory Show editorial from the *Chicago Examiner*, can be intense. During the Counter-Reformation in Europe, the Catholic Church underwent a period of internal reform. The Council of Trent, which met in Trento, Italy, from 1545 to 1563, established rules of artistic representation. These were designed to evoke viewers' identification with the suffering of the saints and to emphasize "ethical correctness." The rules of the council were rigorously enforced by the Inquisition.

In 1549, Michelangelo's *Pietà* (fig. 8.9), which had been commissioned by a French cardinal in the 1490s for his chapel in Saint Peter's, was denounced by the Inquisition when a

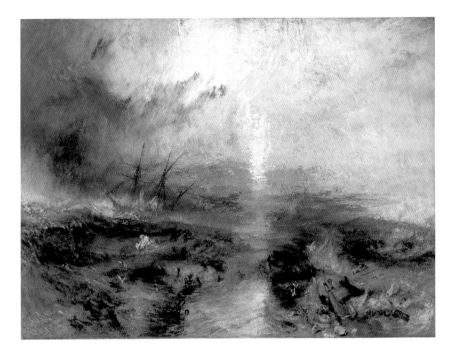

8.10 Joseph Mallord William Turner, *The Slave Ship*, 1840. Oil on canvas, 35¾ × 48¼ in. (90.8 × 122.6 cm). Museum of Fine Arts, Boston, Henry Lillie Pierce Fund.

copy of it was displayed in Florence. Michelangelo had depicted Mary as a youthful figure of approximately the same age as Christ, when in reality she would have been a generation older. This was considered incestuous, and the statue was placed in storage for several years. When Michelangelo was asked about Mary's age, he replied in a suitably pious manner that chastity had preserved her youthfulness. Another, more iconographic, explanation is that the sculpture refers to the future, when Christ crowns Mary Queen of Heaven and they rule together for all time. In that case, Mary's youthfulness would be more, rather than less, seemly and would mitigate the incestuous quality that the Inquisition identified in the work.

Modern viewers flock to the Tate Gallery in London to see the paintings of Joseph Mallord William Turner (1775–1851), especially his dramatic scenes of the sea. The great English art critic John Ruskin championed Turner's work, which he defended in *Modern Painters*. He described Turner's famous *Slave Ship* of 1840 (fig. 8.10) as "the noblest [sea] certainly ever painted by man."[11] For Ruskin, Turner had captured the energy of the sea, the fiery sunset, and the guilty horror of the slave trade. So much did the two men admire each other that Ruskin was named executor of Turner's will. But when Turner died and Ruskin went through his effects, he discovered a hitherto unknown collection of erotic drawings by the artist. In a fit of moral outrage, Ruskin destroyed Turner's work.

Government Funding and Censorship in the United States

In the United States, artistic controversies often involve government fund-
ing. When people object to imagery, they can become particularly angry if
the artist has received government funding. It seems that they feel as if insult
has been added to injury, for not only do they consider such imagery immoral,
but they are enraged that their tax money has been spent on the artist's work.

Exemplifying this issue is the 1987 color photograph by Andres
Serrano (b. 1950) entitled *Piss Christ* (fig. 8.11). It represents a crucifix made
of wood and plastic immersed in a four-gallon Plexiglas tank. As the title
suggests, Serrano filled the tank with urine (his own).

When first exhibited in a New York gallery, viewers responded pos-
itively to the photograph. Nor was the work criticized in Los Angeles or
Pittsburgh. But after an exhibition at the Virginia Museum of Fine Arts in
Richmond, a storm of criticism arose at the insti-
gation of the Methodist minister who had founded
the National Federation for Decency, renamed
the American Family Association in 1977. The
minister's crusade against Serrano's image con-
demned it as obscene, bigoted, and anti-Christian.
Joining him in these views were Senators Alfonse
D'Amato of New York and Jesse Helms of North
Carolina, Colonel Oliver North (who had been
implicated in the Iran Contra scandal), and the
evangelist Pat Robertson. The National Endow-
ment for the Arts (NEA) had funded Serrano along
with two other controversial artists in the amount
of $15,000 each. The awards were given on the
recommendation of a panel of experts. After a
well-orchestrated campaign of letter writing to
Congress, funding to the NEA was cut by $45,000,
equaling the total awarded to the three artists
in question.

Now that we are more than a decade away
from the uproar over *Piss Christ*, we can consider
it with a calmer eye. Serrano was not the first artist
to use urine as a medium, and he was working in
the context of an artistic vogue for body fluids
brought on largely by the AIDS crisis. What some

8.11 Andres Serrano, *Piss
Christ*, 1987. Cibachrome,
silicone, plexiglass, wood
frame, edition of 4, 60 ×
49½ in. (152.4 × 125.7 cm).
Courtesy Paula Cooper
Gallery, New York.

people found particularly offensive in his case was the combination of the body fluids with Christian subject matter.

Serrano's life was threatened by religious fundamentalists, which caused him to avoid the news media for a time. He himself described *Piss Christ* as visually aesthetic, which it is. Without the telltale title, the image would pass as a rather attractive Crucifixion scene. The Cross is a rich, softened yellow, glowing in an atmosphere of red; shooting diagonally across the picture are splashes of bright yellow light. In view of traditional Christian iconography, Serrano may be said to have alluded to Christ as the Light of the World and the redemptive power of Christ's blood. At the same time, however, like many important artists, Serrano pushes the envelope of viewer tolerance, and, as is clear from the title, he also challenges entrenched views of propriety.

Serrano has produced other Christian images dealing with body fluids, some of which are attractive and some of which are disturbing. Concerned with social as well as religious issues, Serrano photographed series of Ku Klux Klan members and the homeless. The portrait *Johnny* (fig. 8.12) depicts a figure reminiscent of a trapper from the Old West. He wears a fur hat pulled down over his forehead, a red-and-black checked shirt under a heavy shearling coat, and a neat, graying beard. Johnny is shown

8.12 Andres Serrano, *Johnny*, 1990. Cibachrome, silicone, plexiglass, wood frame, edition of 4, 60 × 49½ in. (1.52 × 1.26 m). Courtesy Paula Cooper Gallery, New York.

upright, against a smooth gray background, exuding an air of dignity, inner strength, and self-confidence. In this figure, as with the others in the series, Serrano ennobles the homeless while also evoking sympathy with their plight.

By now, it should be apparent that art has the power to offend and disturb viewers as well as to please and inspire them. But the lessons of history are clear: they suggest that we should not jump to conclusions when confronted with new approaches to imagery. This is nowhere better illustrated than in the case of the forged Vermeers, which alerts us to the changing perceptions of style and the development of aesthetic taste over time.

Likewise, if we think about the past consequences of imposing moral standards on imagery created by professional artists, we recognize that we risk losing valuable cultural works. And a lot of "what ifs" come to mind.

What if Leo III's edict against graven images had not been revoked?

What if Savonarola, in his "bonfires of the vanities," had not destroyed works depicting nudes and mythological subjects by important fifteenth-century Italian artists?

Imagine if the Inquisition had destroyed Michelangelo's *Pietà* in Rome or if Pope Paul IV had erased the artist's *Last Judgment* in the Sistine Chapel. (From the pope's point of view, he did the next best thing and had draperies painted over the nude figures. In the recent restoration of the chapel, the draperies were removed and the figures returned to their original nudity.)

What if Daumier's editor had succumbed to Louis-Philippe's fear of political imagery and refused to continue publishing the artist's satirical drawings? Work that today is highly valued might not exist at all. And what of Turner's erotic drawings? Although we might not want our young children to see such pictures, we would have to recognize that they would have been an invaluable resource for scholars interested in Turner's life and work.

What if van Gogh had found a market for his paintings, instead of being totally ignored by the art-viewing public of his time? Might he have been less depressed, not committed suicide at the age of thirty-seven, and lived to produce even more works of genius?

What if Hitler had destroyed the works he considered "degenerate" and if the Taliban had not blown up the statues of Buddha, or the World Trade Center had not been destroyed?

Imagine the loss if the city of Chicago had heeded critics of the 1913 Armory Show. Where would the Art Institute of Chicago be today without its distinguished collection of nineteenth- and twentieth-century paintings?

Imagine if the United States government decided that it was in the national interest to fund the visual arts without regard to moral, political, and religious issues, and to leave the funding decisions to the sometimes flawed aesthetic judgment of art experts. And what if the United States government decided to accord artists, especially the difficult ones, First Amendment protection and stand by that decision in the face of inevitable criticism?

The lessons of history indicate that rather than becoming enraged by what is new, unexpected, not necessarily pretty, and even disturbing, we would be well advised to sit back, relax, wait to see, try to understand, and even to encourage what new generations of young artists produce.

TIMELINE OF WORKS ILLUSTRATED

3000 B.C.

NEOLITHIC
Stonehenge (c. 3000–1500 B.C.)

ANCIENT EGYPT (*c. 3100–2150 B.C.*)
Palette of Narmer (c. 3100 B.C.)
Menkaure and Queen Khamerenebty (c. 2548–2530 B.C.)
Pyramids of Khufu, Khafre, and Menkaure (c. 2500–2475 B.C.)
Queen Ankhnesmeryre II and Her Son Pepy II (c. 2245–2157 B.C.)

ANCIENT BABYLON
Law Code of Hammurabi (c. 1792–1750 B.C.)

1500 B.C.

ANCIENT EGYPT (*c. 1260–1250 B.C.*)
Temple of Rameses II (c. 1260 B.C.)
Vignette from Any's Book of the Dead (c. 1250 B.C.)

PERSIA (*Achaemenid period*)
Bull capital from the Palace of Darius I (6th century B.C.)

500 B.C.

CLASSICAL GREECE
Polykleitos, *Doryphoros (Spear Bearer)* (c. 450–440 B.C., Roman copy of a bronze original)
Iktinos and Kallikrates, the Parthenon (447–438 B.C.)
Theater at Epidauros (4th century B.C.)

HELLENISTIC GREECE
Battle of Issos (2nd century B.C., Roman copy of an earlier Greek fresco)
Capitoline Venus (c. 250–150 B.C., Roman copy of an earlier Greek statue)
Slipper-Slapper (c. 100 B.C.)
Athena Parthenos (2nd-century A.D., Roman copy of an earlier Greek statue)

CHINA
View of the body guard of Emperor Qin (221–206 B.C.)

INDIA (*Shunga and Andhra periods*)
Great Stupa at Sanchi (3rd century B.C. to 1st century A.D.)

1500

NORTHERN RENAISSANCE IN EUROPE
Holbein the Younger, *Anne of Cleves* (1539)

HIGH RENAISSANCE IN ITALY
Michelangelo, *Pietà* (1498–1500)
Bramante, *Tempietto* (c. 1502–3)
Leonardo, *Mona Lisa* (c. 1503–5)
del Sarto, drawing of a man hanging upside down (1530)
Titian, *Venus of Urbino* (c. 1538)
Michelangelo, *Last Judgment* (completed 1541)
Titian, *Pope Paul III* (c. 1543–46)
Titian, *Rape of Lucretia (Tarquin and Lucretia)* (1568–71)
Titian, *Pietà* (begun c. 1570)

AZTEC
Calendar Stone (c. 1502–20)

1600

ITALIAN BAROQUE
Bernini, *Apollo and Daphne* (1622–25)
Bernini, *David* (1623)
Bernini, Baldacchino of Saint Peter's (1624–33)
Bernini, Cornaro Chapel (1640s)
Bernini, *King Louis XIV* (1665)

BAROQUE IN NORTHERN EUROPE
Rembrandt, *Woman Sewing (Titia, Sister of Saskia)* (1639)
Rembrandt, *Self-Portrait at the Age of 34* (1640)
van Campen, Town Hall/Royal Palace, Amsterdam (1648)
Kalf, *Still Life with the Drinking-Horn of the Saint Sebastian Archer's Guild* (c. 1653)
Vermeer, *Christ in the House of Mary and Martha* (c. 1654–55)
Rembrandt, *Self-Portrait as Zeuxis* (c. 1669)

FORGED "VERMEERS"
van Meegeren, *Christ and the Woman Taken in Adultery* (1930–44)
van Meegeren, *Supper at Emmaus* (early 1930s)

FRENCH BAROQUE
Poussin, *The Adoration of the Golden Calf* (c. 1633–37)

1700

Rigaud, *Louis XIV* (1701)

CHINA
Hua Yan, *Conversation in Autumn* (c. 1732)

ROCOCO
Fragonard, *The Swing* (1767)

NEOCLASSICISM
Jefferson, State Capitol, Richmond, VA, (1785–89)
David, *Napoleon at Saint Bernard Pass* (1800)
Percier and Fontaine, Place Vendôme Column (1810)

ROMANTICISM
Delacroix, *Women of Algiers* (1834)
Turner, *The Slave Ship* (1840)

REALISM
Daumier, *Louis-Philippe as Gargantua* (1831)
Daumier, *Freedom of the Press, Don't Meddle with It (Ne vous y frottez pas)* (1834)
Brady, *On the Antietam Battlefield* (1862)

ANCIENT ROME
Roman Patrician with Two Ancestor Busts (1st century A.D.)
Trajan's Column (A.D. 113)
Marcus Aurelius (A.D. 164–166)

BYZANTINE
Court of Justinian (c. 547)
Court of Theodora (c. 547)

ROMANESQUE
Reliquary statue of Sainte-Foy (late 10th to early 11th century)
Eadwine Painting (mid-12th century)

GOTHIC
Chartres Cathedral (c. 1140–1220)
Amiens Cathedral (begun 1220)
God As Architect (God Drawing the Universe with a Compass) (mid-13th century)
Sluter, portal of the Chartreuse de Champmol (1385–93)

LATE BYZANTINE
Cimabue, *Madonna Enthroned* (c. 1280–90)

14th-CENTURY ITALY
Giotto, *Lamentation* (c. 1305)
Giotto, *Noli Me Tangere* (c. 1305)

EARLY RENAISSANCE IN ITALY
Donatello, *David* (c. 1420–40)
Donatello, *Feast of Herod* (mid-1420s)
Castagno, *The Youthful David* (c. 1450)
Piero della Francesca, *Dream of Constantine* (c. 1452)
Averlino (Filarete), plan of Sforzinda (c. 1461–62)
Leonardo, *Madonna of the Rocks* (1483–85)
Leonardo, *Vitruvian Man* (c. 1485–90)

PERSIA
Attributed to Bihzad, *Iskandar and the Seven Sages* (c. 1494–95)

IMPRESSIONISM
Pissarro, *Seine at La Grenouillère* (c. 1869)
Whistler, *Arrangement in Black and Gray (Portrait of the Artist's Mother)* (1871)
Morisot, *The Cradle* (1873)
Monet, *Interior of Saint-Lazare Station* (1877)

NATIVE AMERICAN
Painted War Record (c. 1880)

POST-IMPRESSIONISM
van Gogh, *Two Shoes* (1886)
van Gogh, *Self-Portrait* (c. 1888–89)
van Gogh, *A Pair of Wooden Clogs* (1888)

ART NOUVEAU
Horta, Staircase of the Maison Tassel (1892)

AFRICA
Nail Fetish from the Congo (1875/1900)
Afo Culture, *Mother and Child* (before 1900)

Rousseau, *The Dream*, (1910)

DADA and SURREALISM
Duchamp, *Nude Descending a Staircase No. 2* (1912)
Calder, *The Hostess* (1928)
Picasso, *Bather with a Beach Ball* (1932)
Oppenheim, *Fur-covered Cup, Saucer, and Spoon (Le Déjeuner en Fourrure)* (1936)

EXPRESSIONISM
Kandinsky, *Untitled (First Abstract Watercolor)* (c. 1910–13)

Brancusi, *The Kiss* (1912)

SUPREMATISM
Malevich, *Black Square* (original 1913)

Picasso, *Woman in White (Sara Murphy)* (1923)

AMERICAN REGIONALISM
Pollock, *Camp with Oil Rig* (1930–33)
Benton, *Mural No.2, Arts of the West* (1932)

Moore, *Mother and Child* (1936)

Brancusi, *Gate of the Kiss* (1938)

Picasso, *Jaime Sabartés* (1939)

Pollock, *The Moon-Woman* (1942)

ABSTRACT EXPRESSIONISM
Pollock, *Number 13A, 1948: Arabesque* (1948)
Pollock, *Portrait and a Dream* (1953)

POP ART
Warhol, *Campbell's Soup Cans* (1962)

Albers, study for *Homage to the Square* (1963)

Thompson, *Crucifixion* (1963–64)

PHOTO-REALISM
Hanson, *Artist with Ladder* (1972)

Picasso, *Self-Portrait* (1972)

MINIMALISM
Serra, *Tilted Arc* (1981)

ENVIRONMENTAL ART
de Maria, *Lightning Field* (1971–77)
Christo, *The Gates, Project for Central Park, New York City* (1988)

CIBACHROME PHOTOGRAPHY
Serrano, *Piss Christ* (1987)
Serrano, *Johnny* (1990)

VIDEO
Paik, sketch for *Modulation in Sync* (1999)

ENDNOTES

CHAPTER 1

1. Giorgio Vasari, *The Lives of the Most Eminent Painters, Sculptors, and Architects*, trans. Gaston du C. de Vere, 3 vols. (New York, 1979), III, p. 2226.
2. *Ibid.*
3. Kenneth Clark, *The Nude* (Washington, D.C., 1956).

CHAPTER 2

1. Walter Pater, *The Renaissance* (Berkeley and Los Angeles, 1980), pp. 97–99.

CHAPTER 4

1. Théodore Géricault, cited in Lorenz Eitner, ed., *Neoclassicism and Romanticism 1750–1850* (New York, 1989), pp. 257, 259.
2. From interviews with Pollock at Springs, Long Island, summer 1956; cited in Selden Rodman, *Conversations with Artists* (New York, 1957), p. 82.

CHAPTER 5

1. Giorgio Vasari, *The Lives of the Most Eminent Painters, Sculptors, and Architects*, trans. Gaston du C. de Vere, 3 vols. (New York, 1979), I, p. 30.
2. *Ibid.*, p. 105.
3. See John Onians, *Bearers of Meaning: The Classical Orders in Antiquity, the Middle Ages, and the Renaissance* (Princeton, 1988).

CHAPTER 7

1. See Jacques Derrida, "Restitutions," in *The Truth in Painting*, trans. Geoff Bennington and Ian McLeod (Chicago and London, 1987).

CHAPTER 8

1. Giorgio Vasari, *The Lives of the Most Eminent Painters, Sculptors, and Architects*, trans. Gaston du C. de Vere, 3 vols. (New York, 1979), I, p.14.
2. *Ibid.*, p. 13.
3. *Ibid.*, p. 15.
4. *Ibid.*
5. Cited in Milton Brown, *The Story of the Armory Show* (New York, 1963), p. 152.
6. *Ibid.*, p. 112.
7. *Ibid.*, p. 140.
8. *Ibid.*, p. 174.
9. *Ibid.*
10. See David Freedberg, *The Power of Images* (Chicago, 1989), pp. 420–421.
11. John Ruskin, *Modern Painters*, vol. I, pt. III (1843), p. 571; cited in Quentin Bell, *John Ruskin* (New York, 1978), p. 29.

SELECT BIBLIOGRAPHY

Adams, Laurie. *Art on Trial*. New York, 1976.
—. *Art and Psychoanalysis*. New York, 1993.
—. *The Methodologies of Art*. New York, 1996.
—. *Key Monuments of the Baroque*. Boulder, CO, 2000.
—. *Italian Renaissance Art*. Boulder, CO, 2001.
Alberti, Leon Battista. *On Painting*. Trans. John R. Spencer. New Haven and London, 1966.
Alpers, Svetlana. *Rembrandt's Enterprise*. Chicago and London, 1984.
Ames-Lewis, Francis. *The Intellectual Life of the Early Renaissance Artist*. New Haven and London, 2000.
Barolsky, Paul. *Why Mona Lisa Smiles and Other Tales by Vasari*. University Park, Pa., and London, 1991.
—. *Giotto's Father and the Family of Vasari's Lives*. University Park, Pa., and London, 1992.
Barthes, Roland. *Image—Music—Text*. Ed. and trans. Stephen Heath. New York, 1977
—. *Camera Lucida*. Trans. Richard Howard. New York, 1985.
Beard, Mary, and John Henderson. *Classical Art from Greece to Rome*. Oxford and New York, 2001.
Bell, Quentin. *John Ruskin*. New York, 1978.
Brown, Milton. *The Story of the Armory Show*. New York, 1963.
Cernuschi, Claude. *Jackson Pollock: Meaning and Significance*. New York, 1992.

Clark, Kenneth. *The Nude*. Washington, D.C., 1956.
Collins, Bradley I. *Leonardo, Psychoanalysis, and Art History*. Evanston, Ill., 1997.
—. *Van Gogh and Gauguin*. Boulder, CO, 2001.
Daix, Pierre. *Picasso*. Trans. Olivia Emmet. New York, 1993.
Derrida, Jacques. *The Truth in Painting*. Trans. Geoff Bennington and Ian McLeod. Chicago and London, 1987.
Diebold, William. *Word and Image*. Boulder, CO, 2000.
Edgerton, Samuel Y., Jr. *Pictures and Punishment*. Ithaca and London, 1985.
Eitner, Lorenz, ed. *Neoclassicism and Romanticism 1750–1850*. New York, 1989.
Freedberg, David. *The Power of Images*, Chicago and London, 1989.
Freud, Sigmund. *The Complete Psychological Works of Sigmund Freud*. 24 vols. London, 1953–1973.
Graetz, H. R. *The Symbolic Language of Vincent van Gogh*. London, 1963.
Guggenheim Museum Catalogue, *The Worlds of Nam June Paik*. New York, 2000.
Kemp, Martin, ed. *Leonardo on Painting*. New Haven and London, 1952.
Kris, Ernst, and Otto Kurz. *Legend, Myth, and Magic in the Image of the Artist*. New Haven and London, 1979.
Meredith, Roy. *Mr. Lincoln's Camera Man*. 2nd ed. New York, 1974.
Miller, Mary Ellen. *The Art of Mesoamerica*. London, 1996.
Onians, John. *Bearers of Meaning: The Classical Orders in Antiquity, the Middle*

Ages, and the Renaissance. Princeton, 1988.
Panofsky, Erwin. *Studies in Iconology*. New York, 1962.
Passeron, Roger. *Daumier*. Trans. Helga Harrison. New York, 1981.
Pasztory, Esther. *Pre-Columbian Art*. London, 1998.
Pater, Walter. *The Renaissance*. Berkeley and Los Angeles, 1980.
Pliny. *Natural History*. Trans H. Rackham, W. H. S. Jones, and D. E. Eichholz. Loeb Library Edition. 10 vols. Cambridge, Mass., 1979.
Robins, Gay. *Proportion and Style in Ancient Egypt*. Austin, Tex., 1994.
Rodman, Selden. *Conversations with Artists*. New York, 1957.
Roth, Leland M. *Understanding Architecture*. New York, 1993.
Sabartés, Jaime. *Picasso: An Intimate Portrait*. New York, 1948.
Schapiro, Meyer. *Theory and Philosophy of Art: Style, Artist, and Society*. Vol. IV of *Selected Papers*. New York, 1994.
Simpson, Elizabeth, ed. *The Spoils of War*. New York, 1997.
Vasari, Giorgio. *Lives of the Most Eminent Painters, Sculptors, and Architects*. Trans. Gaston Du C. de Vere. 3 vols. New York, 1979.
Wittkower, Rudolf, and Margot Wittkower. *Born under Saturn*. New York, 1963.
Wittkower, Rudolf. *Sculpture: Processes and Principles*. New York, 1977.
Wölfflin, Heinrich. *Principles of Art History*. Trans. M. D. Hottinger. New York, n.d.; first German ed., 1915.

PICTURE CREDITS

The author and the publishers wish to thank the museums, galleries, collectors, and other owners who have kindly allowed their works to be reproduced in this book. Collections are given in the captions alongside the illustrations. Sources for illustrations not supplied by museums or collections are given below, along with additional information and copyright credits. Numbers are figure numbers unless otherwise indicated.

CHAPTER 1
1.5 Photograph © 2002 The Museum of Modern Art, New York/© DACS 2001
1.6 © Succession Picasso/DACS 2001
1.7 Photo RMN, Paris - Jean Schormans
1.8 Photo RMN, Paris - Hervé Lewandowski
1.10 © Araldo De Luca, Rome
1.11 © Studio Fotografico Quattrone, Florence
1.12, pages 32 & 126 © Studio Fotografico Quattrone, Florence
1.14, page 8 © Christies Images Ltd, 2002
1.15 Soprintendenza per i Beni Ambientali Architettonici Artistici e Storici, Arezzo
1.16 Photograph © 2002 The Museum of Modern Art, New York
1.17 © Vincenzo Pirozzi, Rome fotopirozzi@inwind.it
1.18 © RMN, Paris/© ADAGP, Paris and DACS, London 2001

CHAPTER 2
2.1 Bastin & Evrard sprl, Brussels/© DACS 2001
2.2 © Paul M.R. Maeyaert, Mont de l'Enclus (Orroir), Belgium
2.3, page 28 © Fotografica Foglia, Naples
2.4 Nippon Television Network Corporation, Tokyo
2.5 Library of Congress, Washington D.C.
2.6 Photograph John Bigelow Taylor, New York City
2.7, page 84 © Fotografica Foglia, Naples
2.8 © Araldo De Luca, Rome
2.9, 2.10, 2.11 © Angelo Hornak, London
2.12 © Paul M.R. Maeyaert, Mont de l'Enclus (Orroir), Belgium
2.13 © CAMERAPHOTO Arte, Venice
2.14 © CAMERAPHOTO Arte, Venice
2.15, page 85 Photo RMN, Paris - Arnaudet/J.Schormans
2.16 © Paul M.R. Maeyaert, Mont de l'Enclus (Orroir), Belgium
2.17 © 1997 The Detroit Institute of Arts
2.18 Craig & Marie Mauzy, Athens mauzy@otenet.gr
2.19 Index, Florence
2.20 © The Andy Warhol Foundation for the Visual Arts, Inc./ARS,NY and DACS, London 2001. Trademarks licensed by Campbell Soup company. All rights reserved.

CHAPTER 3
3.1 © Foto Nationalmuseum, Stockholm
3.2, frontispiece Photograph © 2002 The Museum of Modern Art, New York/© ARS, NY and DACS, London 2001
3.3, 3.4, 3.5 © Scala, Florence
3.10, page 63 © 2002 Board of Trustees, National Gallery of Art, Washington D.C.
3.15 © Tate, London 2002/© DACS 2001
3.20 © Scala, Florence
3.24 Robert Harding Picture Library, London/© Nigel Francis
3.25, 3.30 From Laurie Adams, *Art Across Time*. New York, 1999.
3.26 © Craig & Marie Mauzy, Athens mauzy@otenet.gr
3.27 Hirmer Fotoarchiv, Munich

CHAPTER 4
4.1 © British Museum, London
4.4 © Fotografica Foglia, Naples
4.5 The Metropolitan Museum of Art, Rogers Fund, 1951; acquired from The Museum of Modern Art, Lillie P. Bliss Collection (53.140.4). Photograph © 1994 The Metropolitan Museum of Art/© Succession Picasso/DACS 2001
4.6 © Photo Photographic Archive of the Museo Picasso, Barcelona/© Succession Picasso/DACS 2001
4.7 © Estate of Duane Hanson/VAGA, New York/DACS, London 2001
4.8 Courtesy the Master and Fellows of Trinity College Cambridge, England
4.9, page 72 © Angelo Hornak, London
4.10 Photo RMN, Paris
4.11 © Paul M.R. Maeyaert, Mont de l'Enclus (Orroir), Belgium
4.12 Photo by Arthur Evans/©T.H.Benton and R.P.Benton Testamentary Trusts/VAGA, New York/DACS, London 2001
4.13 Courtesy Jason McCoy Inc, New York/© ARS, NY and DACS, London 2001
4.14 Photograph by David Heald © The Solomon R. Guggenheim Fondation, New York/© ARS, NY and DACS, London 2001
4.15 Yale University Art Gallery. Gift of Richard Brown Baker, B.A. 1935/© ARS, NY and DACS, London 2001
4.16 © ARS, NY and DACS, London 2001

CHAPTER 5
5.1 The Art Archive/National Anthropological Museum Mexico/Dagli Orti
5.3 © Angelo Hornak, London
5.5 Robert Harding Picture Library, London/© Adam Woolfitt
5.6, 5.8 From Laurie Adams, *Art Across Time*. New York, 1999.
5.7 Ann & Bury Peerless, Birchington-on-Sea
5.9 © Vincenzo Pirozzi, Rome fotopirozzi@inwind.it
5.11 Photo RMN, Paris - Lwandowski/Raux
5.12 Hourig Sourouzian, Cairo
5.14 Sonia Halliday Picture Library, Weston Turville, England
5.15 © Scala, Florence
5.16 © Paul M.R. Maeyaert, Mont de l'Enclus (Orroir), Belgium
5.17, page 92 © Scala, Florence
5.18 Courtesy Virginia Tourism Corporation
5.19 The Art Archive/Nicolas Sapieha/© ADAGP, Paris and DACS, London 2001
5.20 ADAGP, Paris and DACS, London 2001
5.22 © Studio Fotografico Quattrone, Florence
5.24 © Paul M.R. Maeyaert, Mont de l'Enclus (Orroir), Belgium
5.25 The work illustrated on page 112 has been reproduced by permission of the Henry Moore Foundation
5.26 © CAMERAPHOTO Arte, Venice
5.27 © Succession Picasso/DACS 2001
5.28 Rheinisches Bildarchiv, Cologne

CHAPTER 6
6.1 © Scala, Florence
6.2 © Scala, Florence
6.3 © Araldo De Luca, Rome
6.4 © Vincenzo Pirozzi, Rome fotopirozzi@inwind.it
6.5 © Scala, Florence
6.6 © Vincenzo Pirozzi, Rome fotopirozzi@inwind.it
6.7 © Photo Josse, Paris
6.8, page 116 Photograph by Ellen Labenski © The Solomon R. Guggenheim Foundation, New York
6.9 Robert Harding Picture Library, London
6.10 Photo John Cliett, © Dia Center for the Arts (LF 122), New York
6.11 Photo Wolfgang Volz, © Christo 1998

CHAPTER 7
7.2 © Jürgen Liepe, Berlin
7.3 Craig & Marie Mauzy, Athens mauzy@otenet.gr
7.4 By kind permission of the Trustees of the Wallace Collection, London
7.5 © Photo Josse, Paris
7.7, page 134 © RMN, Paris

CHAPTER 8
8.1 Hirmer Fotoarchiv, Munich
8.2 Craig & Marie Mauzy, Athens mauzy@otenet.gr
8.6 Photo by Graydon Wood, 1994/© Succession Marcel Duchamp/ADAGP, Paris and DACS, London 2001
8.7 Photo courtesy the artist © Glenn Stiegelman Inc, Photography/© ARS, NY and DACS, London 2001
8.9 © Araldo De Luca, Rome

INDEX